DISCARD

Licensing
Photography

*Richard Weisgrau
and
Victor S. Perlman*

Copublished

Society

of

Media

Photographers

**ALLWORTH
PRESS**
NEW YORK

The authors wish to thank ASMP for allowing them to include and adapt materials that they originally created for ASMP.

© 2006 Richard Weisgrau and Victor Perlman

12 11 10 09          5 4 3

Published by Allworth Press
An imprint of Allworth Communications, Inc.
10 East 23rd Street, New York, NY 10010

Cover design by Derek Bacchus

Interior design by Mary Belibasakis

Page composition/typography by Integra Software Services, Pvt. Ltd., Pondicherry, India

ISBN: 978-1-58115-436-8

Library of Congress Cataloging-in-Publication Data:

Weisgrau, Richard.
   Licensing photography/Richard Weisgrau and Victor Perlman.
      p.   cm.
   Includes index.
   ISBN 1-58115-436-4 (pbk.)
1. Photography—Business methods.   2. Copyright licenses—United States.   3. License agreements—United States.   I. Perlman, Victor.   II. Title.

   TR581.W45 2006
   770'.68—dc22

                                                                    2005022411

Printed in the United States of America

# CONTENTS

## CHAPTER 4
### Effective Licensing Agreements . . . 69

Get It in Writing • When Do Contracts Exist? • Letter Agreements •
Forms • Specifying Usage • A Note About Digital Media • Terms
and Conditions • Indemnification Agreement • Independent
Contractor's Agreement • Estimate • Assignment Confirmation •
Invoice • Schedule of Fees and Expenses • Pre-Delivery Confirmation
Facsimile • Pre-Delivery Confirmation E-Mail • Assignment
Photography Delivery Memo • E-Mail Cover • Stock Photography
Delivery Memo • Stock Photography Invoice • Letter Agreement

## CHAPTER 5
### Licensing in the Digital Age . . . 139

Computer Technology • Photography Processing Software • Pricing
and Licensing Software • Internet-Based Information • Stock
Agencies Online • Fear of Digital • Preying on Fear • Photography
Business Software • Office Software Suites • Word Processor •
Spreadsheet/Database • Tracking Licenses and Uses • Effective
Enforcement • Double Edge

## CHAPTER 6
### Pricing Licenses . . . 161

Stock Means Residuals • Stock Pricing Components • Exceptions to the
Rule • Value versus Price • Exclusive or Non-Exclusive • Stock Price
List or Pricing System? • Developing a Pricing System • Determining
a Base Price and Factors • Assignment Licensing • The 1909 Copyright
Law • Evolution of Assignment Pricing • Characteristics of Assignment
Photography Market Segments • Rights and Market Segments • Usage
and Value • Market Segment Pricing Relationships • Pricing Re-use of
Assignment Images • The Final Step

**CHAPTER 7**

## Negotiating Licenses . . . 181

## Index . . . 196

# INTRODUCTION

What is the quintessential process in the photography business? Some might say that it is marketing and promotion. Others might profess that it is the creative process. Still others might point to sales or financial planning. Personally, we, the authors of this book, believe that licensing copyright rights, i.e., granting permission to use your photographs, is the very core of the photography business.

Photographers make photographs because they love it. The reward for doing it for its own sake is psychic income—the joy. Photographers engage in business because they need and want to make money. The reward for doing it is monetary. Licensing plays a key role in establishing and maintaining the monetary value of professional photography in the marketplace.

While effective market research, promotion, sales, and sound fiscal management are critical to business success, they do not establish the value of a photographer's images. The fee a photographer receives for the acquisition and/or use of his images is the determining factor of the photograph's value. The words "acquisition" and "use" have very different meanings. People can acquire (come into possession of) an image in a variety of ways. You might sell a copy to them. They might find it in a magazine or on a greeting card. It might be a gift from someone who bought it from you. But possession of an image only gives the possessor the right to look at it and show it privately, not publicly. If the possessor of the image wants to make a public display of the image, reproduce the image in print or electronic form, modify it to make a new image, or make copies of it to give away or sell, he must obtain permission to do so. That permission is known as a "license," and the type and amount of use determines the value of the license.

Successful businesspersons understand that they have to maximize the value of their products or services. Failing to do that will almost certainly lead to an erosion of value, and that almost inevitably results in financial decline because revenues drop below a point that makes conducting business worthwhile. Revenues are the reason that professionals become professionals.

Amateurs do it solely for the joy of it, and professional do it for money while, hopefully, enjoying it.

Here is the logical progression that makes our point. Value is created by use. Value is expressed as revenues. Licensing regulates use; therefore, it regulates revenues. Licensing and revenues are inextricably locked together in the professional photographer's business life. For that reason, every photographer ought to have a comprehensive understanding of how to license photography. Effective licensing means you make more money. Effective licensing requires that you understand how to do it. As we write this book, we know of no other book that is dedicated to helping the photographer understand and employ the principles and practices of licensing. If you want to make money in photography, read this book.

# CHAPTER 1

## Licensing Concept and Reality

This book was written with one important assumption in mind—you want to make money from your photography. The fullest value in your photographs resides in the copyright that protects them from use by others without your permission. Copyright is a bundle of rights that can be granted by a copyright owner to another person or entity individually, partially, or in total. If you think about a dollar, you can envision it as four quarters, ten dimes, twenty nickels, one hundred pennies, even one thousand mills—that is, tenths of a penny. As you will learn as you read this book, a copyright can be divided into many component parts. Each of those parts has value. Licensing lets you extract the value from each part. Mathematically, the sum of the parts equals the whole. But copyright is not mathematics. Common experience has taught experienced licensors of photography that selling the parts is often much more lucrative than selling the entire copyright. The fact is that the stock photography business, which represents more than one third of all photography revenues, was built on the basis that selling one right to use a photograph at a time could be very profitable. History has proved that to be true. The lesson for us is the more rights we can license individually, the more money we will make. So the question is "How do we license individual rights?" Now, let's answer that question.

### WHAT IS A LICENSE?

When we think of a license, our thoughts usually focus on things like driver's licenses, hunting or fishing licenses, or any of the many other officially issued licenses that legally authorize us to do something very specific. A license is permission to do something. In fact, in the publishing trade the words "license" and "permission" are often used interchangeably. Publishers speak of getting permission or acquiring a license to use a copyright protected work. To make

it easier to understand this book's message, we will use this definition of licensing: the act of granting permission to use a copyright-protected photograph in a manner specified by you, the copyright owner.

That definition is pretty simple to understand, but licensing properly is not as simple to do as it is to define. Done properly, a license is a legally binding permission. If the terms of a license are violated, the copyright owner can bring a legal claim against the licensor, the party receiving permission. Violation of the terms of a license is generally a copyright infringement. Infringements must be prosecuted in the federal courts because the copyright law is a federal statute, so states' courts have no jurisdiction over copyright infringements. Chapter 2, "Understanding Copyright," will explain what you need to know about the legal aspects of copyright. It is important that you understand copyright because licensing is nothing more than granting permission to use your photographs in the ways you are permitted to under the copyright law.

Now that you understand that a license is nothing more or less than a legally binding permission to use your photography according to terms you set, we can move on and examine the concept of licensing and the reality of applying that concept in the business of photography.

## THE LICENSING CONCEPT

The copyright law puts you in exclusive control of your photographs, whether they are taken for personal or commercial purposes. The law says that no one can use any photograph to which you own the copyright unless you permit its use. But the law is no fool. It understands that many copyright owners want to give broad permission, while others want to restrict permission with narrow limits.

You have made a set of photographs of your child's birthday party. You have pictures of your child and all her friends and maybe a few parents, too. Generously, you make extra prints of the photographs for the families of those who attended the party. When you give them away, the recipients automatically acquire permission to do certain things with them. The recipients are allowed to show those pictures to others and to display them in their homes, offices, or other personally inhabited spaces. The law allows a person to show a copyrighted photograph to a limited circle of family, friends, or associates without having an express permission. An express

permission is one granted conversationally or in writing. Certainly that makes sense. Why have photographs that capture a special moment if you can't show them to anyone. When you hand over copies of your photographs to another person, you are effectively giving him permission to show it to others.

However, the law does not give the recipient of the prints the right to make a public display of or to publish the photographs you provided. So, if the recipient shows the picture of his son at your daughter's birthday party to his colleagues at work, it is OK. But if he makes the picture into a large print and hangs it in the lobby of his offices where persons come and go, he has made both a copy and a public display of the work, and he needs a license to do that. If he sends the copies of the picture that you gave him to his brother and sister, it is OK. But if he distributes copies of the picture by printing it in his company newsletter, he has published the photograph without a license.

Two key words in licensing are "public" and "publish." Public means exposed to general view. Publish means to make generally known. The word "general" is a keyword in those definitions. General means without specific limitations. What are specific limitations? No one can answer that question with more than "it depends." It depends on circumstances. If I place a photograph in my window so everyone who walks by can see it, I have not placed any limitations on visibility of the display. That would be a public display. If we put a photograph in this book, as we have done, and the book is for sale to the general public, as this book is, then the photograph is published.

The concept of licensing is deeply rooted in the display and publication of photographs. In chapter 2, you will learn that other uses of your photographs that involve neither public display nor publication also require a license. These other uses are important to understand, but they are not the uses that most often are licensed by photographers. As a photographer, you are primarily interested in the public display and publication of your photographs.

## THE LICENSING REALITY

Having a concept of licensing is like having a concept of a photograph that you want to make. The concept is an idea, and the photograph is an expression of an idea in tangible form. Licensing may be conceptual, but a license

expresses permission in concrete—that is, trade—terminology. To have a realistic grasp of licensing in practice, you have to understand what can be governed by a license.

A license usually defines parameters of use. Those parameters are normally carved out by circumstances. Circumstances are defined by circumstantial questions; namely, who, what, when, where, why, and how. These questions help you decide what the terms of a license should include. That is important. A true-to-life example of what can happen when you do not understand the realities of licensing follows.

A photographer was commissioned by a client to make photographs for a brochure. From a day of shooting, the photographer delivered twenty-six photographs to the client. Included with the photographs was an invoice for his fee and expenses. The invoice also included a license to use the photographs. It stated "For brochure use."

The client used several of the images in a brochure that was published shortly after the photographs were delivered. A few months later the client used some of the photographs in a different brochure. A few months later a third brochure surfaced, then another, and another. Over a period of three years, the client published the images in twenty-six brochures. The photographer became aware of the additional brochures and protested to his client that they were exceeding the license. He believed that he had only given permission to use the photographs in a single brochure that they had discussed before the assignment was awarded. Conceptually he was correct, because no mention of other brochures had been made at the time he received the assignment. But the reality was different. As copyright owner, he issued a license that allowed the client to use the photographs in any brochure at any time, because he did not place any limitations on the words "For brochure use." The net result was that the photographer was paid once, and the client got twenty-six times the value because the photographer did not have a good understanding of licensing in the world of business and law. What you conceive will usually be different from the reality when you fail to deal with the details.

## IT'S ABOUT MONEY

If you want to increase your revenues, avoid being exploited, and control your business, you will have to learn to issue licenses that are specific about permitted uses. The good news is that it is not difficult to do proper

licensing, and this book is going to make it easier for you to do it. That means your purchase of this book is an investment because it is going to return value to you in excess of its purchase price.

Effective licensing makes money for a copyright owner. It not only makes money from the sale of the immediate license, but it also reserves rights that the copyright owner can license later to the original or other parties. These reserved rights are called residual rights. They reside with you and under your control so you can grant permission to use them at will. While the immediate licensing of original rights makes money, the licensing of residual rights can make a photograph more profitable.

As you read chapter 2, "Understanding Copyright," you will learn that copyright is all about commerce. Copyright rights can be very valuable, if the photograph they protect is commercially viable. Here's an example.

Figure 1 is a black-and-white rendition of a color photograph that I made on an assignment from a magazine to illustrate an article about

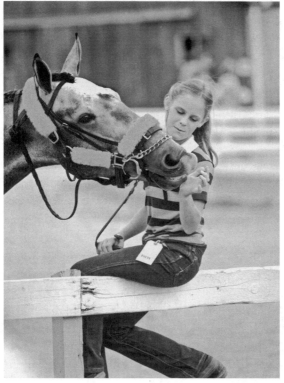

© Richard Weisgrau 2005

**FIGURE 1**

horse shows. It was originally selected to be published as a color cover illustration in a magazine that targeted show horse owners. The license I issued to the publisher was carefully crafted to meet its needs. It stated:

> Any photograph produced and delivered as part of this commission may be used one time only in one specific issue of *Show Horse Magazine* to be published within six months of the date of this license and may be used inside the magazine only and in accord with agreed space rates. Use of any image on the cover of the magazine requires additional payment to be negotiated and agreed. All other rights in all the images are reserved and require a written license to be obtained and exercised.

A month after delivery of the work the photo editor called me to say that some of the pictures would run in the next issue, and that they were very pleased with them. He then explained that they were going to use the photograph in Figure 1 on the cover of a new magazine that was to be called *Horses for Teens*. I reminded him that the publisher did not have the rights to do that because my original license limited publication to *Show Horse Magazine*. After a brief and futile attempt to get the new use covered by the original license, the editor soon gave up trying to save money and began to negotiate in earnest for the right to use the photograph on the cover of the new magazine. Understand that the publisher was about to launch a new magazine, and my photograph was to be on the cover of the premier edition of that magazine. To me "premier" issue meant "premier" rates, not the standard space rates that I had agreed upon for the original assignment. After a bit of horse-trading, we agreed to a price for the intended use. I issued the following license:

> For use only on the cover of and on any blow-in subscription card or other subscription offer contained within the premier issue of the magazine titled *Horses for Teens* and to be published within twelve months of the date of this license. This cover usage right shall be exclusive for a period of five years from the date of this license and does not extend to any use of the cover other than within the premier issue of the magazine. All other rights are reserved.

Three months later I received a solicitation in the mail from the publisher. I usually subscribed to publications to which I licensed a lot of work. It kept me up to date on what they were publishing, and it allowed me to police unauthorized use of my photographs. As a subscriber to *Show Horse*, I was on the mailing list for promoting the new magazine. The solicitation I received was a direct-mail advertisement for *Horses for Teens*. It contained a full-size reproduction of the cover of the premier issue, and so it was an unauthorized use of my photograph. Later, when *Show Horse* magazine arrived in the mail, it contained an advertisement for the new magazine, again featuring the cover with my photograph on it.

I now found myself in the position of being owed money for two unauthorized uses of my cover image by the publisher. The license I had issued restricted use of the photograph and of the cover containing the photograph. The publisher had now made two national advertising uses of my image without my permission. Those unauthorized uses were copyright infringements, and prosecutable under the law. After some discussions with the publication's managing editor and attorney, they were convinced that they had violated the license and were legally liable. As a result of an intense negotiation, we agreed to a payment amount for the two unauthorized uses. I earned as much from the unauthorized uses as I would have by shooting five assignments for the magazine each year for the next seven years. And the good news is that they acknowledged that they were wrong in doing what they did. Accordingly, they continued to use my services for some years thereafter.

That is not the end of the story, however. The incident mentioned above happened more than twenty years ago. In that time, because I carefully licensed that image, limiting its use and reserving all rights not specifically granted, I have licensed that image dozens of times for many thousands of dollars. It is a timeless image with a universal theme. It will go on making money for me because I have protected the value of my rights in the image by making sure that no one can use it in a way that it becomes useless to others. Effective licensing is one route to increased profitability in your business.

## AVOIDING MISTAKES

The most common mistakes made by photographers when licensing their work fall into two categories: omission of details and erroneous use of terminology. The brief tale above about brochure use is a perfect example

of insufficient details in a license. Here is an example of erroneous use of terminology. It is a good example of a common mistake.

A photographer licensed a stock photograph to be used to promote a product. The immediate uses were to be a brochure and a press release. The photographer did not intend to license the use of the image in advertisements. The license issued stated that the photograph could be used for "promotional" purposes. That imprecise language coupled with the definition of the word "promotional" cost the photographer many thousands of dollars in both lost fees and for the money paid to an attorney to prosecute a copyright infringement case.

The photographer decided on the use of the term "promotional" based upon a glossary in a then very popular photographers' reference book on business practices. That glossary defined "promotional" as uses intended to sell a product by means other than an advertisement. So a brochure, poster, press release, calendar, etc., seemed to be promotional and not advertising. But the client did not see it that way, as it chose to use the image in a series of regional magazine and newspaper advertisements. The photographer sued for copyright infringement when his client refused to pay for the regional advertising uses.

At trial, the photographer presented the glossary of the trade practices book as evidence of the righteousness of his claim. Unfortunately, the court was unconvinced. The judge rejected the assertion that a glossary of photographers' trade terms should be the determining factor in the case. She pointed to the fact that the client was not a photographer and did not use the same book in determining the definition of words. Instead, she opined, the client would reasonably turn to a dictionary to define a term. Horror of horrors, the photographer's position was destroyed because the applicable dictionary definition of "promotional" is "furtherance of the acceptance and sale of merchandise through advertising, publicity, or discounts." Additionally, the judge referred to the dictionary definition of "advertising," which is "to make something known to the public." The photographer lost the case and lots of money.

The moral of the story is that you want your licenses to detail what use can be made and restrict any other use ("all other rights reserved"). Use the dictionary and avoid friends' or organizations' definitions. Judges don't care about what you think a word means. They only care about what the experts think, and Webster is a good expert. If you do not have a good, up-to-date dictionary, get one, and learn to use it when licensing your work.

# LICENSING CIRCUMSTANCES

Earlier in this chapter we referred to the circumstantial question and how those questions form the basis for any license you might want to issue. The words who, what, when, where, why, and how will reveal all you need to know to compose a license when it comes to defining the parameters of a prospective licensee's needs. Below we will take you through a series of questions you should ask to determine what must be included in your license. Each question is explained so that you will understand what information you are trying to uncover by asking it. Remember that attention to detail is a critically important part of licensing effectively.

## Who

Who is the licensee? In some cases, this will be obvious. If a magazine wants to use your image to illustrate an article, it is obvious that the magazine is the licensee. But when a creative agency seeks a license it is usually acting as an intermediary for the actual advertiser or end user. In other words, Big Noise Advertising, Inc., may be representing Silver Silence Hearing Aids, Inc. To whom should you issue the license, the agency or the principal company that has hired the agency? Normally you would license the principal because it is the end user. In some cases you might find that an agency wants the license issued to it with an agreement that it can re-license the image to a client. It's OK to do that, but it is best to limit the agency's right to re-license only to the client they specify.

## What

What copyright rights are you licensing? Copyright owners have the right to control the following uses of their works:

❶ Reproduction—making copies by any means
❷ Derivation—making a new work based on yours
❸ Distribution—publication of your work (distribution to the public)
❹ Performance—showing your work by mechanical means as in an audiovisual
❺ Public Display—exhibition of your work

These are the basic rights you will be licensing as a photographer. They will be conditioned by other factors as determined by the remaining circumstantial questions.

## When

When will the photograph be used? A license should have a term; that is, a beginning and an ending period after which the rights may not be exercised any longer. For example, suppose you shoot an assignment for a magazine that has an embargo period; that is, a period of time you agree to keep the photograph out of use after their initial use. You want to be sure that the magazine's window for the use of the image is clearly stated. Otherwise, if the magazine decided to hold up publication of the image for six months, the embargo starts then. That could force your image out of the market for many more months. This is particularly a problem for current-events shooters, whose photographs generally have a life determined by popular interest in the subject matter.

## Where

Where will the photograph be used? Now we are talking specifics, like names of magazines, titles of books, company and annual reports, or a brochure title or an advertising campaign theme. When you include such information in a license it automatically limits use and at the same time dispels doubts that can lead to misunderstandings at best and, at worst, infringements.

## Why

Why might you want to include specific limitations? Perhaps you have previously licensed the photograph to another client on a limited but exclusive basis, and you now must prevent it from being used in any way that would violate the pre-existing exclusive license. For example, suppose you licensed an image of trout fisherman wading in a stream to a manufacturer of fly fishing rods so that it would have the exclusive right to advertise with the photograph in specialty fishing magazines for one year. Then another company wants to use the same image to advertise its sporting travel services in travel magazines. You can do that without violating the exclusivity you previously granted. But you must be sure to restrict the new licensee's use of the image to assure that no violation occurs, or that if it does, you can prove that you took every effort to protect the exclusive licensee. In such a case, you should specifically restrict the new licensee from using the image in any application for which you have granted an exclusive license that is still in effect. It is not enough to simply spell

out the rights that the new licensee has. You must exercise due diligence by stating exactly what rights they don't have that might conflict with previously issued licenses.

## How

How will the photograph be used? Is it to be used as a promotional illustration or in a textbook? Maybe it is going to be used as corporate wall art or in a documentary film. Some photographs are licensed for multiple uses, especially those used in promotional applications. For example, a photograph might be featured in magazine advertisements, transit posters, on packaging, and as a point-of-purchase display. Knowing how the image is to be used is not only important to assure that your license is complete, but it is also important because how the photograph is used is a key factor in determining the fee that you should charge.

## LICENSING SPECIFICATIONS

Some or all of the specifications listed and explained below usually form the limits of a license. We will explore each one because even though they seem obvious, there is something to be learned about each of them.

## Print

Print includes applications where inks or dyes are laid down on paper, cloth, or other substances. Items like posters, brochures, calendars, billboards, annual reports, magazines, newspapers, books, product packaging, greeting cards, and bank checks are examples. But don't overlook items like T-shirts, scarves, and other merchandise on which photographs can be reproduced.

## Electronic

Electronic applications are those that require electricity (a flow of electrons) in order to operate. Do not confuse electronic with digital. Electronic can be either digital or analog.

## Digital

Digital applications include those that utilize binary computer technology and programming. Some examples are multimedia presentations, computer

games, digital video, and software applications. Most of these applications are usually contained in CD-ROM and DVD disks or are downloadable over the Internet.

## Analog

Analog applications include those data that are represented by continuously variable physical qualities. A silver halide photograph, a motion picture on film, and videotape are all analog since they capture data by variations of physical form. In general, you can assume that if an item is not digital, it is analog by default.

## Audiovisual

Audiovisual applications are simply those that contain both sound and images. A motion picture or videotape with a sound track is a prime example. Remember that audiovisuals can be digital or analog. You want to keep in mind that some applications can be built as both digital and analog. A video is an example. You might have licensed a photograph for videotape use some years ago. Does that mean that the image could be used in digital videotape today? Maybe it does. It depends upon the license you granted. If you limited use to analog videotape, then it cannot be used in digital videotape without a new license. If you did not, it can be used.

## Copying

Copying is the duplication of your work in one or more copies. Reproduction in print or electronic applications is copying, but copying includes much simpler applications, too. Among them are photocopying by machine or camera, scanning, tracing, and art reference; that is, the use of your photograph by an artist as the basis of artwork.

## Display

Displays are the exhibition of your photographs so that people can see them. A framed print on an office wall is a display, as is a mural on the side of a building. We tend to think of display applications as very minor, but that is not always the cases. A photographer licensed a print to a hotel chain for wall display. His license stated the image could be copied and displayed in the hotel. He was thinking it was going to be a framed print in some place like the lobby. Later he learned that the hotel had made 187 copies of the

photograph and framed and placed a copy in each of its guest rooms. It was a very hard way to learn that displays can be in volume, and that you have to license carefully to avoid having your photography used for much more than you are being paid.

## Detailed Application Description

Every application in which your photographs will appear can be described in some detail that narrows permissible use to make it more definable. It is important that you take the pains to do that in a license. If you license a work for use in *SkyHook Magazine*, it is broader than if you license it for use in *SkyHook*'s May edition in a given year. The word "textbook" is narrower than "book." A textbook titled *Biology Is a Blast* is more specific than simply specifying a biology textbook. The more you define the application, the less likely you are to have an experience like that cited above in the tale about the display rights for a hotel.

## Language Limits

Photographs can be used in applications that are done in a variety of languages, particularly publishing applications. For example, some publications have both English and Spanish language editions under the same masthead. Use in two languages is more valuable than use in one because the audience seeing your photograph is greater. A greater audience usually means you charge a greater fee. Usually, if you license more than four languages, the rights are considered to be worldwide.

## Geographic Limits

Geographic rights, often overlooked by photographers, are another key to maximizing your revenue. A photographer who thought that by licensing "English language rights only" he was sufficiently limiting the use of his photograph went on to find that English is the language of the United States, Canada, Australia, New Zealand, the Irish Republic, and the United Kingdom. He also found out that some publishers have English language editions published in countries like Germany, France, and Japan, where English is a popular second language. If you want to control the use of your work you must understand that we live in a global economy and that the geographic barriers that once separated people are coming down, as English has become the international language of business. Usually, if you license for four or more countries, the rights are considered to be worldwide.

## Worldwide Rights

Worldwide rights are sometimes licensed by default. For example, if you license a photograph for use on a Web site, it is going to appear on the Worldwide Web, an Internet accessible facility that demands worldwide rights by its nature.

## Quantity Limits

Limiting the quantity of reproductions of your photograph is another way to assure that the rights you grant will produce maximum value for you. Specifying the number of units of the application that can be produced containing your photograph is the usual way to set the limit. For example, you might state the image can be used in a brochure with a press run of up to 20,000 pieces, or that your images can be displayed in up to 300 hotel rooms. Quantity is one factor in determining the price of a license. The greater the audience for the application, the higher the price for using the photograph should be.

Of course, there are times when quantity is set by default. If you license a photograph for use in a newspaper or magazine, the quantity is their circulation plus some slight overrun. For that reason, the circulation figure of a publication usually has some effect on the prices of a license.

## Time Limits

Time limits are divided into two categories. First is the period of time that the licensee has to use the rights you are licensing. Most photographers set a license to expire one year after the date. That is stated in the terms and conditions of the licensing agreement. Second is the time period for which the licensed photograph may be used. For example, you might limit a hotel to display your photograph for up to three years, or you might give them perpetual rights. Usually when there is a quantity limit, there is no time limit. If you license a brochure for up to 20,000 copies, it is difficult to limit the time the licensee can use the brochure. That is what you would be doing if you only licensed the brochure to contain your photograph for a limited time. The fact is that no licensee is likely to agree to such a term because it would simply make no sense to do that.

## Size

The size at which your photograph is displayed is another factor that influences price and therefore should be included in your license

when applicable. If your photograph covers a full page, it is more valuable than if it covers a half page. That is true whether you are licensing the use of your image in a book, magazine, brochure, Web page, or any other application.

## Placement

Placement of your image in the application is another pricing variable that belongs in your license. You don't want to license an image for use in a magazine under the assumption that it will be used inside the pages to then find it on the cover of the magazine when published. The cover is worth many times more than a full page inside the magazine. Likewise, an image used on the homepage of a Web site is more valuable than one used on a secondary page. Use of an image on the divider page of a book is worth less than a cover but more than a regular page. Value is relative to placement.

## Exclusivity

"Exclusivity" is a simple term with a complex meaning when it comes to licensing copyright rights. Normally, we think of exclusivity as limiting possession or permission to a single party. Indeed it is that, but under the Copyright Act, the words "exclusive rights" take on greater meaning. While we advised that you should use the dictionary to understand the definition of the word that you might use in a license, in the case of the word "exclusive" we have to say that you must understand the meaning of the word as used in the Copyright Act.

When you grant exclusive rights to a licensee, you are effectively giving that party control over the rights granted that is equivalent to that of a copyright owner. Let's say that you license exclusive advertising rights to a photograph. Effectively, you have given the licensee the right to act just as if he owned the copyright to all the advertising rights in the photograph. That means that even you as the licensor cannot use the image or permit others to use it for advertising purposes. Exclusive rights are of the highest value in licensing, because exclusivity takes rights off the market, and you cannot obtain the additional value of those rights from any other client.

Exclusive rights licenses can be limited in different ways because the rights in a photograph are divisible. So you can use that divisibility to limit the scope of an exclusive rights grant to meet the needs of your client and

still preserve the value of the other rights for additional sale. You can also limit the grant of exclusive rights by time period and by geography. To illustrate the way limitations can be placed on exclusive rights we provide the following example.

> Licensee is granted the exclusive right to publish the photograph for advertising use in print media in North America and in the English language only for a period of three years from the date of this license.

That language has precluded the licensee from using the photograph in many ways while giving great latitude to make advertising use of the image.

## Reserved Rights

Except when you transfer the copyright to a photograph, you should reserve all rights not granted in the license by adding the words "all other rights reserved" into the license. By doing so you make the licensee aware that the rights acquired are only those stated in the license. Of course, for reserved rights language to be effective you have to be certain to spell out the rights licensed carefully. Previously we gave examples of poorly constructed licenses giving the licensee tremendous leeway. That is losing money by poor business practices. The details to be covered in a license are listed above. You should always grant rights in detail and reserve any rights not specifically granted.

## BUSINESS MODELS

There are three primary business models in publication photography. Photographers can do assignment photography, stock photography, or both. While the principles of licensing do not change regardless of the model you adopt, the difficulties of licensing do change because licensing assignments is more complicated than licensing stock. Now let's examine the differences between assignment and stock licensing.

Assignment licensing becomes complicated in direct ratio to the type and number of uses to which the photograph will be put. A simple assignment to produce an image for one time use in a publication is at

the easy end of the assignment rights continuum. At the other end is the advertising assignment from which the photograph will be used in magazine ads, point-of-purchase displays, product packaging, a promotional brochure, a press kit announcing the product, and maybe even to illustrate some magazine articles. An assignment can present the simplest or the most complex of scenarios. The complexity is dealt with by being certain that you understand the licensee's usage needs by understanding the types of applications that your photograph will appear in. A good license for assignment photographs will spell out the applications carefully to avoid disputes later down the road. Sometimes the licensee's need might be so vast that you will probably license a broad range of rights, like North American promotional rights in English and Spanish. A broad license gives your client a wide variety of opportunities to exploit the photograph. What you have to remember is that the broader the license, the more the licensee can use the photograph. The more the licensee can use the image, the more you should be paid. We will have more to say about that concept in chapter 6, "Pricing Licenses."

Stock photography is distinguished by the certainty of the use(s) of the photograph licensed. Unlike assignment photography, the stock photography industry has established protocols for licensing. Those protocols are key to establishing the fee for a license. Generally, stock photography licensors take the various factors of an application discussed above into consideration when pricing fees. Since the pricing system is based upon very specific factors related to the use of the photograph, the stock licensor must get details of the intended use in order to calculate a price. Therefore, the details of the license are easily determined. Adding to the ease of licensing stock photography is the fact that licensees are used to providing specific details of usage to obtain a price. Assignment clients often are reluctant or unable to quantify all uses either because they don't want to be pinned down or because they simply are unsure of every way the assigned photograph might eventually be used.

## LICENSING CHECKLIST

This chapter has given you the required insight into the concepts of licensing photography. Yes, it is as simple as this chapter portrays it to be. The more challenging task is transitioning from concept to practice. To do that,

| **LICENSING CHECKLIST** |

**Licensing Circumstances**

1. Who is the licensee?
2. What copyright rights are you licensing?
   A. Reproduction—making copies by any means
   B. Derivation—making a new work based on yours
   C. Distribution—publication of your work (distribution to the public)
   D. Performance—showing your work by mechanical means as in an audio-visual
   E. Public Display—exhibition of your work
3. When will the photograph be used?
4. Where will the photograph be used?
5. Why might you want to include specific limitations?
6. How will the photograph be used?

**Licensing Application**

- Print
- Electronic
- Digital
- Analog
- Audio-visual
- Copying
- Display
- Detailed application description
- Language limits
- Geographic limits
- Worldwide rights
- Quantity limits
- Time limits
- Size
- Placement
- Exclusivity
- Reserved rights

**FIGURE 2**

you don't need to memorize this chapter's information. You only need a list of the licensing circumstances and of the licensing specifications we have provided herein. To make that easy, we have included a licensing checklist that you can copy and use in determining what your license should cover to meet your client's needs while protecting your rights and the value of your photography.

# A PHOTOGRAPH'S USAGE VALUE

That fact is that there is not and never has been an established means of determining the value of a photograph in terms of its use. It is quite simple to determine the production cost of an image. It is quite another thing to determine the value of creativity and the use of that creativity by others who seek to advance their commercial interests. As a professional photographer, you will hear your share of theories and stories about how the value of creativity and usage should be determined. All of them are opinions, not rules or practices of the trade. However, usage can be categorized in a matrix that shows relative values of levels of usage. The chart in Figure 3 shows how major levels of usage differ in value. Later, in chapter 6, "Pricing Licenses," you will see this chart expanded to include multipliers that increase the price of a license as the usage level increases.

In the end there is only one truth: the client determines the value of your photography by its willingness to pay. If you understand that, you understand that the fees for photography are most often determined by the client setting a fee, as in editorial photography, or by the mutual agreement of the parties, as in corporate and advertising photography. In the latter group, the principle of pricing according to "what the traffic will bear" is the norm. For the good salesperson and negotiator this can present the opportunity to make greater revenues. If you are waiting for the industry to adopt some kind of value formula, please practice your sales and negotiating skills while doing so. Some day you will realize that the formula is never going to exist. Then, if you studied and practiced, you will be ready to engage in the business like a businessperson. Then you can start on the path to making more money by working the business rather than having it work you.

| RELATIONSHIP OF RIGHTS AND VALUE | | |
| --- | --- | --- |
| Rights | Restrictions | Value |
| Exclusive | Unlimited | Highest |
| Exclusive | Limited | Upper Middle |
| Non-Exclusive | Unlimited | Lower Middle |
| Non-Exclusive | Limited | Lowest |

**FIGURE 3**

# GETTING STARTED

Maybe you have been doing a less than adequate job when it comes to preparing licenses for your photographs. It's time to change that. The way to change that is to use the licensing checklist the next time you engage in a discussion with a prospective client or licensee. Ask who, what, when, etc., questions. Then go on to ask about the licensing specifications. If the licensee asks why you need the information, tell him that it is to assure that he receives all the rights needed to avoid any future problems or misunderstandings. You don't have to mention that it will also help you place a value on the usage of the photographs. Don't see the licensee's question as a threat. Treat it as a matter-of-fact business question to which you give a matter-of-fact answer. Prospects who have purchased photography from stock agencies or from photographers that license properly are used to answering such questions. It is just routine business. Treat it as such, and you will find that your dealings will be quite orderly and easy to handle.

# CHAPTER 2

## Understanding Copyright

*C*opyright is a creation of the law. When the United States was being formed, patent and copyright laws were considered important enough that they were specifically authorized under the Constitution and were among the first laws created by our brand new Congress. Laws can provide us with great benefits, but they also have considerable limitations. While the language of laws is usually clear and black and white, once those laws are examined closely and/or applied to real-world situations, that apparent clarity usually evaporates. What we are left with is a world of gray, with almost no black or white.

Part of the problem is that every rule has not just one exception, but many. Another part is the fact that laws in a vacuum are meaningless; they become significant only when applied to specific facts. When a judge applies the law to a given set of facts, he or she comes up with a decision or result. When you change only one of those specific facts, even in seemingly insignificant ways, you may get a very different result. In a book like this, we cannot know what all of the facts will be in every situation that you may encounter. That means that we cannot know in advance what the result under the law will be in all of those situations. For that reason, we will be speaking in generalizations, especially when it comes to discussing laws such as copyright. That, in turn, means that you will see us use lots of qualifying language, such as "probably," "generally," "presumably," etc. Those words do not mean that we are trying to be vague or to weasel out of making a definitive statement; they mean that it is simply impossible to make a flat statement that will be universally correct.

Let's get away from generalizations about the law and into the real world. Here is the situation: You took an incredible photograph of a wind-surfer jumping the crest of a wave against a perfect sunset. You put a print in your portfolio and uploaded a copy onto your Web site. You know that

you can convert that photo to money in your bank account, but you aren't sure exactly how to do it or what the details and ramifications are, which is why you bought this book. For you to understand how to proceed, you first need to know the basic operating rules of the world into which you are about to step. At least as importantly, you need to understand the language that the inhabitants of this brave new world speak. That is what this chapter is about. It will provide a very brief and general introduction to what a copyright is. It will also point you to other resources where you can find details and specifics relating to copyrights that are simply beyond the scope of this book.

## WHAT IS A COPYRIGHT?

Without copyrights, there would be no licensing. It is that simple. So what, exactly, is a copyright? Actually, referring to *a* copyright is a bit misleading. A copyright is really a collection or bundle of separate rights that relate to original creations. The Copyright Act refers to those creations as "works," and they include literary, musical, dramatic, pictorial, audio-visual, and other works. Since this is a book about licensing photography, however, we will generally refer to photographs or images, instead of works.

Copyrights are basically limited, legal monopolies that allow the copyright owners to use and exploit or capitalize on their copyrighted photographs and to prevent others from doing so without their permission. There are some exceptions and limitations, which will be discussed later. Generally, only the copyright owners, and people who have permission from them, can legally use copyrighted photographs for any of the basic uses or purposes that relate to photographs and that are specified in the Copyright Act. These are usually referred to as the author's exclusive rights. It is the ability of copyright owners to allow others to exercise those exclusive rights to copyrighted photographs that serves as the basis of licensing.

The exclusive rights that belong to the owners of copyrights in photographs and that are part of the bundle of rights that comprise a copyright are the rights:

❶ To reproduce the copyrighted photographs in copies
❷ To prepare derivative works based on the copyrighted photographs

❸ To distribute copies of the photographs to the public by sale or other transfer of ownership, or by rental, lease, or lending

❹ To display the copyrighted works publicly

❺ To publicly perform certain types of works, including audio-visual works such as movies and multimedia productions.

In practical terms, this means that generally, the copyright owners and people who have their permission (i.e., their licensees) are the only people with the rights to use copyrighted photographs: to make copies of them, to display them to the public (including on the Internet), to sell or otherwise distribute those copies to the public, and to create other works in which the photographs are used or on which they are based ("derivative works"). So, if you own the copyrights to your photographs and someone else wants to (or does) use them to make things like prints, posters, advertisements, calendars, greeting cards, T-shirts, coffee mugs, Internet Web site displays, coffee-table books, audiovisual programs, etc., those people must get your permission and (presumably) pay you for that permission. If they do not, they are probably violating your copyrights and are subject to the remedies and penalties provided in the Copyright Act, which we will discuss later in this chapter.

Copyrights in the United States exist because of a statute, the current version of which is called the Copyright Act of 1976. Its legal citation is 17 U.S.C. (which stands for Title 17 of the United States Code), and it applies to all photographs made from January 1, 1978, to the present (as well as to those earlier photographs that are still under copyright). Even though you may never have wanted to go to law school, you will need to know the basics of what the Copyright Act says, and that means you may actually have to read the thing, or at least some parts of it. Fortunately, unlike the Internal Revenue Code, it is a fairly short document (by legal standards), and most of its language is relatively easy to understand. You can find it at a number of government and other Web sites without cost, but the most useful Web site to use for viewing and downloading the Copyright Act and for getting huge amounts of helpful information and vital forms is the U.S. Copyright Office's Web site *www.copyright.gov*. Print copies of the Act are also available.

In addition to the exclusive rights granted under the Copyright Act, in a token effort to bring the United States in line with the copyright laws of most other countries and meet our obligations under the Berne Convention,

Congress gave photographers and other visual artists some extremely limited rights. These are generally referred to as the moral rights of paternity and integrity. In most European and other countries, artists and other creators have the right to have their works attributed to them (the right of paternity). They also have the rights to prevent alterations of their work and to disclaim affiliation with altered versions of their works (the right of integrity). In the United States, those rights by and large do not exist. The limited exception is contained in the part of the Copyright Act known as the Visual Artists Rights Act of 1990 ("VARA"). Basically, it provides moral rights for your photographs, but only if they are produced in signed and numbered limited editions of 200 or fewer copies. That means, in practical terms, that the United States generally continues to ignore the moral rights of photographers.

## WHAT DOES A COPYRIGHT REALLY PROTECT?

Almost all original photographs are subject to copyright protection, but what does that really mean? To answer that question, we have to think on almost a philosophical or metaphysical level. We have to distinguish between the idea or concept that is embodied in a photograph and that gave rise to it, on one hand, and the individual expression of that idea or concept, which is what you execute when you make a photograph. For example, the windsurfer jumping the crest of the wave against the sunset is the concept; your particular photograph of that concept is your expression of it.

For good and obvious reasons, ideas and concepts may not be copyrighted. Remember that copyrights are monopolies. Can you imagine what the world would be like if people could own monopolies on ideas? For instance, consider the consequences if someone could own a monopoly on all photographs of exhausted soldiers in combat, or of attractive blonde women in red bathing suits, or of executives in business suits shaking hands. It would mean that there would be only a handful of photographers who made the first legal images embodying those concepts, and everyone else would be either infringing their copyrights or paying them royalties. The situation would be even worse in fields other than photography. For example, what would happen to literature if someone had a monopoly on literary works based on the idea of unrequited love; or to physics if Einstein had owned a monopoly on the general theory of relativity?

While copyrights cannot protect ideas or concepts, what they do protect are the individual *expressions* of those concepts. For this reason, copyright lawyers talk in terms of the "idea-expression duality," which is legalspeak for the fact that you cannot copyright the idea of a photograph of the Eiffel Tower, but you can copyright your particular photograph of it because it contains not just the concept, but your individual expression of that concept. Since the concept cannot be copyrighted, it is those elements of your individual expression that are protected by copyright.

Distinguishing between an idea and the expression of that idea can be difficult. Often, the nature of a particular subject or idea can be expressed in so few ways that the distinction between it and the expressions of it becomes impossible. In legalspeak, when that happens, the idea and the expression are said to "merge." That is, some ideas are such that every expression of it *has* to look substantially similar to every other expression of it. Therefore, if copyright protection were granted to any one of that kind of photograph, it would be the practical equivalent of granting a monopoly on not just the expression, but also the idea itself. As we discussed above, that is something that copyright law will not allow.

For example, if you were to look at all of the photographs of the Grand Canyon taken from a specific location, such as one of those "scenic view" highway stops, they would all look pretty much alike. While all of those photographs are probably protected by copyright, the protection of the copyright has to be pretty limited (what copyright lawyers call "thin"), or else the first person who got there with a Kodak Brownie would have owned a very valuable monopoly, and everyone who came afterwards would have to be either a copyright infringer or a licensee. Obviously, that would not be a desirable result, and it is not a result that the law allows. As we said, those photographs are probably copyrightable, but the copyright protection would extend only to those aspects or elements of each of those photographs that are unique to them; the choice of exposure, film, lens, camera angle, etc., would probably be protected by copyright, but the typical elements in the photograph such as the blue sky, sun, and the Canyon itself, would probably not.

## WHAT DOES IT TAKE TO BE COPYRIGHTED?

Earlier, we referred to original creations. Exactly how much originality and creativity does it take, and what else is required, for a photograph to be eligible for copyright protection? Sadly, the Copyright Act does not define

originality. Fortunately, at least as far as photography is concerned, the answer is, "not much." Under the 1976 Act, copyright protection exists in "works of original authorship fixed in any tangible medium of expression, now known or later developed, from which they can be perceived, reproduced or otherwise communicated, either directly or with the aid of a machine or device." That means that most photographs become copyrighted the moment they are created, as long as they have been captured in some storage medium. For example, as soon as the shutter opens and closes and a latent image is captured and stored in some medium, such as unprocessed film or any digital storage medium, that photograph is generally copyrighted. Conversely, you can make the greatest photo on earth, but if there is no film or digital storage medium, there is no copyright (and no photograph, either, for that matter, just the proverbial fish that got away).

We said that *most* photographs are copyrighted as soon as they are created. The reason for the "most" is that there is also the requirement of "original authorship." Fortunately, the threshold of required originality is very low. While it is possible to make photographs that do not meet the originality requirement, they are rare. Typically, they are photographs of basic design elements, such as repeated patterns of light, or copy photography that simply makes an exact duplicate of another work. For our purposes, we will assume that just about every photograph that you make is copyrighted, as long as there was film or digital media that captured the image.

You may have noticed that nothing was said about registration at the Copyright Office as a requirement for copyright protection. In fact, registration is *not* required for copyright to exist for a photograph. However, there are lots of good reasons why you should register your copyrights (and register them as early as possible), and there are situations where you will have to register your copyrights. We will say more about those things later in this chapter.

## WHO OWNS THE COPYRIGHTS?

Let's assume that you are a freelance photographer. It does not matter whether you are an amateur or a professional, or whether you are working on an assignment, building a stock photo library, or just shooting for personal fulfillment. Unless and until you enter into some kind of an agreement that

changes things, you start out owning the copyrights to your photographs. It's that simple. As we suggested, it is possible to have changed that status by contract, but the usual situation is that freelance photographers start out owning the copyrights to the photographs that they make. We should note that, under the Copyright Act of 1909, which was in effect until January 1, 1978, the result was often quite different.

What if you are a staff photographer? In that case, your photographs fall into a category in the Copyright Act called "work made for hire." If you are an employee who makes photographs as part of your regular duties ("within the scope of your employment"), then your photographs are works made for hire, and the result is just the opposite from the free-lancer's situation: your employer is considered the copyright owner from the outset. In fact, you are not even considered the creator ("author," in the language of the Copyright Act) of the photographs—your employer is the creator. In that case, you may not make *any* use of those photographs, such as including them in your portfolio or Web site, without your employer's permission.

These results are not carved in stone. It is always possible to enter into agreements that change those consequences, so that a freelancer can end up producing photographs that are considered works made for hire or otherwise transferring the full copyright to the client. Conversely, a staff photographer can have a contract with his or her employer that would make the employee the copyright owner. We will discuss the mechanics of granting rights relating to copyrighted works (the heart of licensing) in a later chapter. For now, it is enough to note that ownership of copyrights can be completely transferred and that all that is required is that the transfer be: (1) in writing, and (2) signed by both of the parties.

On the subject of ownership, what happens when you sell prints or other copies of your photos? Does the buyer of the prints get any kind of ownership of the copyrights, not just ownership of the prints? Fortunately for photographers, the answer is No. The Copyright Act clearly and directly states that ownership of copyrights is completely separate and distinct from ownership of copies, and that ownership of one does not have any effect on ownership of the other. Again, it is possible to change that result by agreement, but the starting concept is that buying copies has nothing to do with buying copyrights or copyright licenses, and vice versa. That is why most reputable labs will not make duplicate prints of photos like wedding and school portraits without written permission from the photographer or studio that created those prints.

That is not to say that owners of prints cannot do *any*thing with them. Under something called "the first sale doctrine," the buyers can do almost anything they want with the prints, as long as the things they do are not included in the list of exclusive rights that belong to copyright owners (making copies, etc.).

## HOW LONG DO COPYRIGHTS LAST?

Copyrights generally last for the life of the creator plus seventy years. Keep in mind that we are talking about the copyrights in photographs made under the laws of the United States on or after January 1, 1978. There are lots of rather complex rules about the duration of copyrights in photographs created before then, but we will not try to cover them in this book. Earlier, we mentioned that for works made for hire, the photographer is not considered the creator, the employer is. For that reason, works made for hire have a different copyright life span: 95 years from the date that the photograph is first published or 120 years from the date of its creation, whichever is shorter.

Occasionally, Congress has increased the term of protection for copyrights, most recently a few years ago (which generated a lot of opposition by some groups and some unsuccessful litigation challenging the Constitutionality of the extension and even of the Copyright Act, itself). Whatever the duration may be of your copyrights, the important thing to remember is that they will outlast you by many years and can be a valuable legacy for your family and loved ones. You should give some thought to arrangements for licensing your images after you are no longer able to do it, whether you license them directly or though a third party. While estate planning is outside the scope of this book, it is a subject to which every successful photographer needs to pay attention, particularly with regard to the continued licensing of his or her photographs.

## WHAT IF SOMEBODY USES YOUR PHOTOGRAPHS WITHOUT YOUR PERMISSION?

If someone uses your photograph by exercising any of the exclusive rights granted to copyright owners without your permission, he or she is probably infringing your copyright. In order to prove an infringement, you need to

show only two things: that the unauthorized user had access to your photo and that the unauthorized use bears a "substantial similarity" to your photo. Let's look at those two requirements.

Access is usually easy to prove and is generally presumed for photographs that have been published. An unpublished photo is another story. In that case, you need to be able to prove that the infringer actually had access to your photo in some way. Often, that happens if you sent your photo to a prospective client who then ended up using someone else's photo that looks remarkably like yours, instead. For example, some clients will look at your photo and like it, but decide that your price is too high and go out and hire someone else to create a very similar image for less money. In that sort of situation, you need to be able to prove that you sent your photo to the infringer. For that reason, and for many others if you want to use photography as a business, you should always be in a position to prove that your photos were actually delivered every time you send them out. You should use some kind of delivery service that will provide you with written proof of delivery, and you should keep that evidence in your files, just in case. Also, if your photos are being submitted because the prospective client requested them, it may be important that you be able to prove that fact. You should document that request, usually in the form of a confirming cover letter or delivery memo that mentions the fact that the submission is pursuant to a request by the recipient.

Substantial similarity is usually much harder to prove than access and often requires the testimony of an expert witness to analyze the various elements and similarities in both photographs. If there has not been direct copying (e.g., where your actual photo is scanned or otherwise duplicated), the question of similarity can become quite muddy. Remember that you cannot copyright your idea or concept, you can only copyright your unique expression of that concept. Because of that, what looks like an obvious rip-off of your photo may not be an infringement in the eyes of a judge or jury. We once had a situation where it seemed obvious to us that a photograph of a person in a swimming pool with a distinctive background of blue sky and white clouds had been used as the basis for producing a strikingly similar photo that appeared on a magazine cover. When we met with the magazine's editor, he pulled out a file folder filled with equally similar, but slightly different, images. It became immediately obvious that, if the magazine cover was an infringement of

our photographer's photograph, it (along with our photo) must also have been an infringement of dozens of others.

Once you are able to prove infringement, there are several forms of relief that are available to you. First, you can ask the court for an injunction. That is a court order that tells the infringer to stop the infringing activities, to destroy all infringing copies, and/or take other actions that your attorney and the court may decide are appropriate.

Second, you are entitled to make the other side pay your damages (the extent to which you have been financially hurt by the infringement) plus the part of his net profits that are attributable to the infringement. Those elements, especially the infringer's profits, can be difficult to prove with the precision required by the courts. For that reason, in certain circumstances, the Copyright Act allows you to ask for something called "statutory damages" instead of actual damages and profits. We will tell you more about when statutory damages are available later in this chapter. In the case of statutory damages, you do not have to prove your actual damages and the infringer's net profits from the infringement with any accuracy. Instead, you can leave the question of how much money you receive to the court's discretion.

Generally, courts will try to make the statutory damage award bear some relationship to their reasonable estimate of your actual damages and the infringer's net profits attributable to the infringement. Contrary to the belief of many photographers, the Copyright Act does not provide for any punitive damages, so they will not usually enter into the calculation of either actual damage and profits or statutory damages. However, as of this writing, there is at least one case in the U.S. District Court for the Southern District of New York in which the judge did allow punitive damages as part of the calculation of the award. He noted in his opinion that his actions would be subject to review by higher courts. In our estimation, the odds are that this decision will prove to be a rare exception, at best, and will not provide a reliable precedent for other cases, even if a higher court does not reverse it.

Sometimes, photographers will submit paperwork to their clients stating that unauthorized uses are subject to a multiplier that will be applied to what their usual fees would have been for the same use if the use had been licensed. Unfortunately, a 2004 decision in the U.S. District Court for the Southern District of New York (which is probably where more infringement cases start than anywhere else) ruled that

multipliers may not be taken into account when courts calculate damages. That does not mean that you should not include that kind of provision in your paperwork; it just means that you cannot expect the courts to enforce it.

Under the Copyright Act, statutory damages can be as high as $150,000 for each of your infringed photographs (not for each act of infringement). In some cases, however, that number can be reduced to as low as $200. Because of that, you should always attach a copyright notice to each of your photos. A copyright notice consists of the word "copyright" or the copyright symbol ©, followed by your name, followed by the year that the photo is first published. For example, you will see the photographs in this book noted as something like © Richard Weisgrau 2005. In addition, in order to obtain the maximum protection available under certain foreign copyright laws, many people add the words, "All rights reserved" immediately following the copyright notice.

Until 1989, publication of a photograph without a copyright notice was enough to terminate your copyright and place that photograph in the public domain. Fortunately, copyright notices are no longer required to accompany all published versions of your photographs. However, as mentioned in the preceding paragraph, there are advantages to using a proper copyright notice (not the least of which is the free advertising component), and we urge you to use one whenever possible.

In addition to damages, under some conditions, you may be able to ask the court to make the infringer pay *your* lawyer's fees if you win. That is a very important thing, beyond the money. Legal fees for a copyright infringement case are substantial, usually in the five-figure and often in the six-figure range. Most photographers simply cannot afford to pay fees like that, and you have to have an exceptionally attractive infringement claim (and a wealthy defendant) to convince a reputable copyright attorney to take your case on a contingent fee basis. Even then, you will probably have to pay the costs (separate from the legal fees) as you go, and those costs will usually be thousands of dollars. When expert witness fees are involved, those costs can skyrocket.

Finally, you need to know that there is a three-year statute of limitations for civil actions for infringements. That three-year period is measured from when the claim accrued, meaning roughly from when the infringement took place and you knew, or should have known, that it had.

## WHY, WHEN, AND HOW DO YOU REGISTER YOUR COPYRIGHTS?

Obviously, the ability to ask the court for statutory damages and attorney's fees is a great advantage in a copyright infringement situation, both in settlement negotiations and litigation. So, how do you become eligible for them? The answer is simple: register your copyrights, and register them as soon as possible. Although registration is not necessary to obtain your copyrights (that happens as soon as you make your photos), you have to register before you can sue for infringement. Even more importantly as a practical matter, you are eligible to ask the court for statutory damages and attorney's fees only if you have registered before the infringement or, in the case of published photographs, within three months of the date of first publication. The lesson here is clear: you should register your copyrights, and you should register them as soon as possible after you have made the photos.

The registration of photographs is relatively straightforward, and the fees are inexpensive. As with most procedures controlled by the government, the devil is in the details. Both the Copyright Act and an extensive body of regulations and Copyright Office rules covers registration. The details of registration are beyond the scope of this book. You can find an excellent guide to registration at the Web site of the American Society of Media Photographers (ASMP) at *www.asmp.org*, and you can find the Copyright Act, forms, FAQs, regulations, circulars, bulletins, etc., at the Copyright Office's Web site, *www.copyright.gov*. In addition, you can order forms and other materials from the Copyright Office by calling (202) 707-9100.

Very briefly, you should know that the current fee for registration is only $30 and that there are regulations that permit you to register large groups of photographs under a single registration for a single registration fee. The Copyright Office is extremely user friendly. If you have specific questions about the details of registration in a particular situation, you can call the Copyright Office in Washington, D.C., at (202) 707-3000 and ask to be transferred to the Examining Division of the Visual Arts Section. You can then speak directly to an examiner and get your answers straight from the horse's mouth.

A final note on registration: You may have noticed that the eligibility for attorneys' fees and statutory damages is based in part on the date of

registration in relation to the date of publication. You may also have noticed that a copyright notice calls for inclusion of the year of first publication. Because of factors like these, applications for registration of published photographs require the inclusion of the date of first publication. In fact, when you start looking at applications for registration and the related instructions and other materials, you will find that when you submit more than one photograph in a registration, published and unpublished photographs may not be registered together. Even the requirements for the materials that must be submitted for registration are different for published photographs than for unpublished ones. It is, therefore, crucial that you know which photographs fall into which category at the time of registration.

Exactly what constitutes publication is a difficult question, and there is no definition provided in the Copyright Act. It is far too complex an issue to address here, but you can find helpful materials at both the ASMP and Copyright Office Web sites mentioned earlier.

## WHEN IS AN INFRINGEMENT NOT AN INFRINGEMENT?

Not every unauthorized use of a copyrighted image is an infringement of its copyright. For example, a use can be of such a small part of an image, or can be for such a brief period of time, that it may be too small ("de minimis") to be considered actionable.

A more significant exception falls into a category known as "fair use." There is no hard rule in the Copyright Act as to what constitutes fair use—only some general guidelines. Each use must be evaluated individually to determine whether it is a fair use, and ultimately only the courts can say with any real authority whether a particular use is a fair use.

Generally, the Act says that fair uses are ". . . for purposes such as criticism, comment, news reporting, teaching . . . , scholarship, or research . . ." Those specified uses, however, are just by way of example, and it is possible for other types of uses to qualify as fair uses. In determining whether a use is fair, the Act provides a list of factors that the courts should take into consideration in making their determination:

❶ The purpose and character of the use, including whether such use is of a commercial nature or is for nonprofit educational purposes
❷ The nature of the copyrighted work

❸ The amount and substantiality of the portion used in relation to the copyrighted work as a whole
❹ The effect of the use upon the potential market for or value of the copyrighted work

Again, that list is not comprehensive, and other factors may be taken into account.

Certain educational uses are specifically authorized without compensation under the Copyright Act, and others have led to the creation of formal guidelines for determining when an educational use is a fair one and when it is not. Those guidelines are available through the U.S. Copyright Office. In addition, certain copying by libraries and archives are specifically permitted in the Copyright Act. Most other potential fair uses, however, are undefined and have to be analyzed on a case-by-case basis.

As you wander through the world of copyright, there is a hazard of which you need to beware: the realm is filled with myths, urban legends, and wrong information. For example, many people believe, or at least claim, that all educational uses are fair uses. That is just plain wrong. If it were true, there would be no copyrights on textbooks, and nobody would ever publish any because everyone would be free to photocopy them. Another absurdity that we have heard more than once is that, once a photograph has been published, it has become a public domain work and is available for everyone to use without permission or compensation. A third example is the mistaken belief that mailing yourself a copy of your photograph is an effective substitute for registering it at the Copyright Office. If you believe any of these myths, you need to reread this chapter.

A more insidious hazard is the fact that the Internet is filled with bad information. Often, that kind of misinformation comes from well-intended photographers passing along legal advice. You wouldn't ask your lawyer whether Tri-X is better than T-Max or RAW files are better than JPEGs. You should be equally careful about using legal opinions issued by non-lawyers who are not accountable to you for any bad information that they may unwittingly pass along. In fact, the situation is even worse than that. We have seen Web logs ("blogs") of respectable attorneys that have referred to court decisions that, in reality, simply do not exist. Whenever possible, you should try to rely on resources that are impeccable and authoritative, such as the U.S. Copyright Office, and on

lawyers whom you have hired and who are responsible to you for the accuracy of their advice.

## HOW CAN YOU MAKE MONEY OUT OF YOUR COPYRIGHTS?

Like most legal rights and assets, copyrights can be transferred from the original owner to others. Most of the time, those transfers are accompanied by payments to you. If people want to use your photographs, the law says that they need your permission in the form of copyright transfers or licenses. Those transfers can consist of outright sales of entire copyrights, or they can be transfers of limited aspects of the bundle of rights that make up what we call a copyright. Since this is a book about licensing photographs, we will concentrate on limited transfers, which are what copyright licenses really are. For example, a license can be limited as to the kinds of uses that can be made, the length of time that the permission lasts, whether the license is exclusive (i.e., the person holding the license will be the only person allowed to make the permitted uses for as long as the permission lasts), the geographic areas in which those rights can be exercised, etc. It is important to remember that copyright consists of a bundle of exclusive rights, and that bundle can be divided up in an almost infinite number of ways.

We will talk more about the variations on licensing later in this book. Right now, though, there are some basics about transfers, both complete and partial, that you need to know. Most licenses do not need to be in writing. However, the absence of a written agreement or other document detailing the terms of the license can prove to be a big problem. There are often breakdowns in communication and misunderstandings, especially where both sides are non-lawyers making agreements based on legal rights, which is exactly what happens in most cases when photographs are being licensed. Often, words do not have precisely the same meanings to different people, and differing or incorrect assumptions are frequently made. Also, human memory is marvelous in its limitations, imperfections, and inadequacies.

To make the situation worse, questions about what people agreed to do not usually occur right after the agreement is made; they usually occur months or years later. At that point, it would be the rare case that both sides recalled all aspects of the agreement in precisely the same way. For those

reasons, it is crucial that your copyright licenses be in writing and contain as much detail as possible.

In the last paragraph, we said that *most* licenses do not have to be in writing to be valid. There are, however, some major exceptions. First, remember that in a work made for hire situation, the employer or client is considered the author of the work and the owner of the copyright. The only way to change any aspect of that (i.e., the only way to give the photographer any or all of the copyright rights) is in a written document signed by *both* of the parties. So, if you are photographing under a work made for hire arrangement and you want to be able to use any of your photographs for self-promotion (or any other purpose), you need to get the written permission from your employer or client and have that document signed by both your employer or client and yourself.

Two other kinds of transfers that have to be in writing are the outright transfer of ownership of the full copyright and the license of any right on an exclusive basis. Unlike licenses of a work made for hire, however, these need to be signed only by the person granting the license.

The Copyright Act contains a provision that was intended to benefit freelance creators like photographers. It says that the photographer or his or her heirs can terminate *all* transfers of copyrights, including the limited or partial transfers that we call licenses. The only exception is works made for hire. The termination right has a five-year window in which it can be exercised. That window opens thirty-five years after the date of the grant or license; or if the grant or license allows the work to be published (which is usually the case), the window opens thirty-five years after the date of publication or forty years after the date of the grant, whichever comes first. Exercising the termination right requires a written notice from the photographer or his or her heirs (specified in the Copyright Act) to the holder of the copyright or license.

You may have noticed that we started the last paragraph by saying that the termination right was *intended* to benefit creators. Right now, it appears that its practical effect is just the opposite. Because works made for hire are not subject to the termination right, clients have started to demand work contracts specifying work made for hire arrangements more and more frequently and more and more adamantly. The earliest that the termination right will actually start to be exercised is 2013 (thirty-five years after 1978). As we get closer to that date, we can expect that increasing numbers of users of photography will start to think about the termination right and will start contracting around it by demanding work made for hire

agreements. Unfortunately, the law specifically says that the termination right cannot be waived or changed by contract—the only way around it is through work made for hire. So you should prepare yourself for the prospect of being faced with clients demanding work for hire agreements. Later in this book, the chapter on negotiations will give you suggestions as to how to deal with demands like this. Ultimately, if the client wants more, he should be prepared to pay more.

# C H A P T E R   3

## Making Sure You Can License What You Shoot

*B*efore you try to license the use of any photograph, you need to know whether you have all of the rights and permissions that you will need to license those uses. Otherwise, you can find yourself on the wrong end of a lawsuit and lose a client (or more) in the process.

For example, let's say that you are walking around Daytona Beach on vacation and you spot a seriously tough, mean, dirty, nasty-looking biker sitting on his Harley-Davidson motorcycle. You bang off a couple of quick grab shots, and they turn out great, so good that you put one of them in your portfolio. An ad agency sees it and wants to use it in a national campaign for Honda, which wants to resurrect its old motorcycle ad campaign, "You meet the nicest people on a Honda." Delighted, you sign the various purchase orders and documents presented by your new client and deposit their check.

The ad runs in national magazines, billboards, and dealership displays. Within a few days of the campaign's rollout, some nice men ring your doorbell and ask if you are Pat Smith, the photographer. When you say that you are, instead of asking to see your portfolio, they hand you various documents in blue-backers and tell you that you have been served.

All in all, there are lawsuits asking for temporary restraining orders, preliminary injunctions, permanent injunctions, and all kinds of damages, and the plaintiffs are the bad biker (who turns out to be a cardiologist when he isn't riding his motorcycle) and the Harley-Davidson Motor Company. Eventually, you may also find yourself being sued by your former clients, the ad agency and Honda USA.

When you go to see a lawyer, he looks at the papers and photograph and advises you that the best course of action will be to try to settle all claims on the best terms that he can negotiate. His basic strategy is to hope for

mercy. His assessment is that they have you over a barrel. Your dream has turned into a nightmare, and all because you did not make sure that you had the rights to license what you shot. This chapter will address the primary issues that you have to recognize in deciding whether and for what uses you can license a photograph, and it will provide suggestions on how to get those issues resolved.

## CAN YOU SHOOT IT IN THE FIRST PLACE?

Before you worry about whether you can legally license a photograph for a particular type of use, you need to know whether you can legally make the photograph in the first place. The general rule is, or at least used to be, that you can legally photograph just about anything and anybody that you can see, as long as you are standing on public property when you make the photograph. If a person or object is visible from a place that is available to the public without your taking extraordinary steps (e.g., using a 1,000 mm lens to get a shot through a tiny opening in the closed set of Venetian blinds covering the subject's window), you are generally allowed to make the photograph. Once you step onto or into private property, the rule is generally that the owner of the property gets to make whatever rules he/she/it wants. That is, people can enter private property only with the permission of the owner (that's part of what makes it private), and the owner can impose whatever conditions and restrictions on his visitors he may desire.

When the private property is a home owned by an individual, the chances are that the rules will be pretty clear: you will probably be told specifically and directly if you cannot make photographs. When the private property and/or the owners are bigger or more complicated, there will probably be general rules in place, especially if there are restrictions on making (or using) photographs. You need to be aware that sometimes those rules can lurk in unexpected places, such as ticket stubs and signs, which can occasionally be posted in obscure locations. For example, museums generally will have signs displayed fairly prominently telling you whether you can make photographs, use artificial light, and/or license any photographs that you are allowed to make. However, most retail operations (clothing stores, supermarkets, etc.) do not allow photographs to be made, but there may not be any printed notice of that, and you might not find that out until a manager or security guard comes over to you when you start taking your pictures. If and when that happens, you need to understand that your permission to

be there is conditioned on your behaving in accordance with the owner's rules, whatever they may be and however restrictive they may be.

Things become more complicated when we consider making photographs on public property. You may have noticed that we said earlier that the general rule was that you could generally photograph anybody or anything, or that at least that *used to be* the rule. The reason for that qualifier is that things have been changing drastically ever since September 11, 2001, and the world is far more security conscious than it ever used to be. Legislation like the "Patriot Act," administrative regulations, and discretionary decisions made by law enforcement officers and security guards have all put photographers and others into a state of uncertainty as to what and where they may and may not photograph, even when standing on the sidewalk, doing what tourists do.

The biggest problems seem to arise when you are trying to photograph government buildings and parts of the infrastructure (bridges, tunnels, highways, power lines, oil refineries, office buildings, etc.). The laws regulating the making of photographs of facilities like these are unclear, constantly changing, and sometimes of questionable constitutional validity. Because of those reasons, it is impossible to make any reliable statements about what you may and may not photograph. Those uncertainties make life as difficult for law enforcement officers as they do for photographers. That kind of uncertainty, combined with a healthy dose of post-9/11 apprehension, has led to an environment where the attitude of police and other officials is often, "better safe than sorry." That, in turn, has led to a tendency to stop people, and arrest them, even though it turns out that the action was unnecessary and/or improper.

Traditionally, our (the authors') general attitude about making photographs from public places has been that it is better to ask for forgiveness than permission. However, in today's climate, it may make more sense to try to get clearance, first, and then decide whether the photograph is worth the problems that you are likely to face if permission is not granted. We know of photographers who have recently been arrested for making photographs of bridges, of police officers performing routine operations, and of other seemingly innocuous subjects. Even if you are released and get your film back, the time and emotional costs, and often the legal fees, of dealing with that kind of situation can be extremely high. You need to make a risk-reward analysis when making photographs that you expect might raise issues like these or when approached by an official. You need to be aware that your initial reaction to enforce your constitutionally protected right of expression may be legally justified, but it may also be quite costly.

For these reasons, when you are going to photograph some property or person that is controlled or owned by an organization that has a public information office or similar liaison with the media, you may want to approach that office for permission before photographing. If you do, you should bring with you as many credentials as possible to demonstrate both your status as a professional and your non-threatening purposes. Association and press credentials, student ID cards, and proof of enrollment in photography courses, wish lists from stock houses, letters and other documents from clients outlining assignments, etc., all may help.

If you are photographing on public property without permission and are approached by an official, you are probably better off stopping and discussing the situation than trying to squeeze out a few final frames before starting to talk. That one more shot after being told to stop can make the difference between a casual conversation and a trip to the local detention center. Remember that even if you are released shortly after being arrested, once you are booked, you will probably have an arrest record, and the only way to get rid of it may be by hiring a lawyer and having the record expunged. And that will take both time and money.

Another aspect of heightened security, and sometimes of revenue raising, has been a trend towards requiring permits for photography. Lands owned or managed by the federal government had been subject to a collection of widely varying requirements (and even more widely varying interpretation and enforcement of those requirements) for permits to photograph. Within the past few years, fortunately, there has been something of a move towards uniformity, so that it has become slightly less important whether the National Park Service, the Bureau of Land Management, or one of the other government agencies charged with managing public resources controls a particular facility.

The general approach that has become more prevalent is that photography permits are required only if: (1) the photographer is using models or props, or (2) the photographer requires access to parts of the facility that are generally not available to the public, or (3) the photography places unusual demands or burdens on the facility or its staff. These rules are intended to correct the unfairness of requiring professional photographers to apply and pay for permits when they were only doing exactly what amateurs and tourists were doing. Nevertheless, if you are going to be photographing in public parks owned or managed by the federal government, you should find out exactly which agency is in charge and what their requirements are for permits, preferably well in advance of the time that you want to start photographing. If you

do need a permit, you should be aware that the place where you obtain it may be quite a distance from the place where you plan to photograph, and the process may take longer than you think. The Internet is a good place to start looking for that kind of information; even if the ranger or other official on site is friendly and helpful, he or she can often have inaccurate information or an incorrect interpretation regarding the requirements.

Unfortunately, the trend towards treating professional photographers better on federal parklands seems to be more the exception than the rule. The New York City subway system recently proposed a permit requirement for virtually all photography in or on its facilities. Following the outcry by professional and other photographers, their trade associations, and publishers, as of this writing, the requirement has been withdrawn, at least for the time being. The National Arboretum in Washington, D.C., also recently tried to impose burdensome and expensive permit requirements for photographers. A number of people and organizations filed comments in protest during the public comment period, and, as of this writing, it is uncertain whether those requirements will be imposed. In any event, though, the trend is clear: there are ever more restrictions on where, what, whether, and under what conditions you can make photographs, and the safer course may be to do some research before heading out into the field. Even if you decide to proceed without getting permits or other permissions, you will at least know what to expect and how to approach any discussions that may come up while you are out shooting.

## RIGHTS OF PRIVACY

Remember our cardiologist/bad boy biker in the photo that led to so much trouble at the beginning of this chapter? His lawsuit was based on the violation of his right of privacy. Most states have a common law (judge-made) right of privacy, although more and more states are putting those rights into statutes (and many of the states are also creating related statutory rights of publicity, which we will discuss later). Since privacy rights are state rights, not federal ones, there are widely varied approaches to them, depending on exactly which states' laws are involved. This is one of those cases where we can only speak in generalities that may be completely incorrect when applied to any individual situation.

The general rule is that you must have a person's permission in order to use a recognizable likeness of him for purposes of trade or advertising.

Let's look more closely at that general rule. The basic elements of the rule, and thus the potential issues, are: (1) permission, (2) recognizable likeness, and (3) trade or advertising.

First, there is the question of permission. Permission (or right) to make a photograph of someone does not automatically mean or even imply that you have the permission or right to use that photograph. Generally, as we mentioned earlier, if the subject is in a place where people who are in a place that is available to the public can see him without using extraordinary means, you do not need permission to make a photograph of him. Alternatively, let's assume that you do have the subject's permission to make the photograph. Neither of those situations gives you an automatic right to *use* the photos. The fact that the subject gave you permission to make the photos in the first place will not be interpreted to mean that he automatically gave you permission to do anything with those pictures.

The only way to use the photos legally for certain purposes is to have the subject's permission. In most states, that permission can be verbal. However, the problem with verbal permissions is that they can be impossible to prove. For that reason, model releases are usually used as the primary way of getting (and later proving) permission. You will see sample forms of different kinds of model releases at the end of this chapter.

The second issue is whether the photograph shows a recognizable likeness of the subject. At one time, photographs almost always showed recognizable likenesses of the people whose images were captured on film. The nature of photography is that it starts out by capturing and reproducing reality. Someone at whom a camera was pointed generally had her likeness captured, and in most cases it was recognizable. The courts have traditionally been more likely to find that a photographic image of someone was recognizable as such than not.

Things may be changing in the digital world. The ability to alter images quickly, easily, inexpensively, and without showing signs of alteration is one of the hallmarks of digital photography. The ability to "Photoshop®" anything that you might want to change in a photograph is taken for granted these days. That means that it is relatively easy to start with a photograph of your next-door neighbor and fairly quickly end up with a picture that her own parents wouldn't recognize as her. While this might seem to simplify the need for a model release, it complicates things a bit when you do use a model release. More about that later.

The third issue is probably the most complicated one: whether the use of the photograph is for purposes of trade or advertising. Determining

exactly what constitutes trade or advertising can become somewhat difficult when you start to look at real-world usages. The general rule has always been that you can use someone's recognizable likeness without his permission for non-fiction editorial purposes. The First Amendment (or at least court interpretations of the First Amendment) gives uses of that nature the highest level of protection. That's well and good, and it's pretty obvious that newspapers, news magazines, non-fiction books, fine art prints, and the like are generally covered by that rule. However, what about some specific uses, such as the covers of those books and magazines? Are they editorial usages or are they a form of advertising? What exactly are those hybrids, such as advertorials and magalogs, and do they require releases?

The uncertainty of how specific courts might answer those questions suggests strongly that you should err on the side of caution and obtain model releases. Another reason for caution, even where the intended usage is 100 percent certain to be non-fiction editorial, is that your editorial client might like your photograph so much that he decides to use it in an advertisement for the publication. Suddenly, and probably through no fault of your own, the photo that did not need a release has an absolute need for one, at a time when you may find it difficult or impossible to obtain one. The lesson is clear: always get model releases when you can.

If determining what constitutes an editorial use can be difficult, deciding what constitutes purposes of trade or advertising can be even more complicated. Generally, the fact that the photographers, writers, editors, and publishers are getting paid does not mean the publication of a photograph automatically constitutes trade (although some courts have erroneously thought so). If that were true, the only usages that could qualify as editorial for purposes of not needing releases would be those pamphlets produced on photocopying machines and desktop printers in people's basements that are handed out on street corners. Not even *Time* magazine or the *New York Times* would qualify, since the publishers, editors, staff, and freelance contributors are getting paid.

The complicated part is often figuring out what constitutes "trade," since advertising is in most cases easier to recognize. Trade can consist of product packaging and an almost unlimited variety of products (other than publications, prints, and "art" posters without commercial text). Those products include everything you see for sale at gift shops and kiosks anywhere there are tourists: key fobs, calendars, coffee mugs, T-shirts, snow globes, note cards, postcards, stationery—and the list goes on and on.

In order to simplify all of this, we prepared a brief summary and checklist for ASMP members, which we reproduce here with ASMP's permission:

A model release is needed from each person whose likeness appears in a photograph that is used for advertising or trade (business) purposes when the person is identifiable. Look at the photograph and the person(s) in it and ask these questions:

❶ Could the person in the photograph be recognized by anyone?
   A. If the answer to question #1 is "no," then you do not need a release.
   B. If the answer to question #1 is "yes," then answer questions #2 and 3.
❷ Is the photograph going to be used for an advertisement?
❸ Is the photograph going to be used for commercial business purposes, like a brochure, calendar, poster, Web site, or other use that is intended to enhance a business interest?
   A. If the answer to #2 and #3 is "no," then you do not need a release.
   B. If the answer to #2 and/or #3 is "yes," then you do need a release.

Related to rights of privacy is the subject of property releases. As with model releases, the following is based on information that we prepared for ASMP members. Unlike the subject of model releases, the whole subject of property releases is filled with more urban legend, assumption, and myth than hard law. Unlike people, property has no right of privacy. So why is a release needed and why does such a thing even exist? It's a good question, but one that requires a complicated answer. First, we need to point out that we have never seen a statute or legal case that actually requires a release for property. The recommendation that you get one is based upon two legal theories as to possible sources of liability.

Here, we will use a house as the property in question, but remember that the theory applies to property of any kind, including pets, cars, and other personal property. The first theory is that a person's identity might be connected to the property. That is, the property could be so recognizable as being related to the owner that a photograph of the property is the equivalent of a photograph of the owner. Let's say that you take a picture of a house and license it for use in an article about drugs users. The owner

might get very angry; in fact, he might get angry enough to sue because everyone on the block knows whose house it is. Since the house is not actually connected with drugs, the image was used in a misleading context and paints the owner in a bad light. If the owner sees the use of the image as an invasion of his right of privacy, or even as a defamation of his character, a lawsuit might be the response. Obviously, whether he wins or loses, a properly worded property release would probably have prevented the lawsuit from ever being filed or defended against.

The second possible theory is that there is an offense called conversion, which essentially means that you use (convert) another's property to your own personal gain without the owner's permission. It is a bit like copyright infringement, which covers intangible property, except that conversion covers tangible property. For example, if we rent out your house while you are away without your permission, we have converted it to our personal gain. That is conversion.

The question is this: is it conversion if we rent out, not your house, but a picture of your house, say for an advertisement, without your permission?; i.e., is the photo of the house the same as the house, at least for purposes of this issue? We know of no case that has ever settled this question. Many lawyers and photographers' trade associations advise that property releases should be acquired whenever possible just to be safe, because they do not want to see you become the test case.

If you do get a release to use a photo of a house, there is a follow-up question: If and when ownership of the house changes hands, is the release still binding? We would say probably yes, as you got it from the proper owner at the time. If ownership changes, that property owner is probably technically obligated to tell the prospective owner of the permission he gave you before the sale is made, so the prospective buyer can decide if he wants to purchase under that condition. Does this mean that a new owner won't sue you? By no means does it mean that. What it means is that you have a defense, and probably an effective one, if you are sued. Unfortunately, only the courts can definitively sort it out. The problem is that there is little or no case law on these situations, so the courts will have to make it up as they go along. That is the most expensive kind of litigation that there is— making new law.

If you want to make sure that your release will protect you in spite of changes in ownership, you have to do whatever is required by the law of the state in which the property is located to have the release "run with the land." We will have some specific suggestions for how to do this when we get to release forms, later in this chapter.

As was the case with model releases, we prepared a summary and checklist on how to know when you might need a property release for ASMP, and here it is:

> The answer to this question can be reached by asking a series of questions about the subject and use of the photograph. A property release is advisable and may be needed from each property owner whose property appears in a photograph that is used for advertising or trade (business) purposes if and when the property owner is clearly identifiable by the property. Look at the photograph and the property in it, and ask these questions:
>
> ❶ Could the owner of the property in the photograph be identified by anyone just by looking at the photograph of the property?
>   A. If the answer to question #1 is "no," then you do not need a release.
>   B. If the answer to question #1 is "yes," then answer questions #2 and 3.
> ❷ Is the photograph to be used for an advertisement?
> ❸ Is the photograph going to be used for commercial business purposes, like a brochure, calendar, poster, Web site, or other use that is intended to enhance a business interest?
>   A. If the answer to #2 and #3 is "no," then you do not need a release.
>   B. If the answer to #2 and/or #3 is "yes," then a release would be advisable.

## RIGHTS OF PUBLICITY

Increasing numbers of states have started creating a category of rights related to rights of privacy, called "rights of publicity." This trend more or less started when Elvis Presley died, and the state of Tennessee wanted to make sure that the flow of licensing revenues did not die with him. The reason for this is that privacy rights are personal rights—they belong exclusively to that person. Because they are completely personal, rights like those typically die when the person dies. One of the differences between rights of privacy and rights of publicity is that rights of publicity do not die with the person. Instead, they can keep going for generations.

One of the other key differences between rights of privacy and publicity is that rights of publicity usually exist only for people who have invested in creating and capitalizing on their likenesses (which includes their faces, names, voices, etc.). That is, rights of publicity usually belong only to people who are considered to be some sort of celebrity.

Another important difference is that right of publicity statutes are often extremely detailed and specific as to what uses can be made of someone's likeness without permission. These rights usually exist only by state statute, and some of those statutes can be quite long and complex. If you are going to be photographing people who may be considered celebrities, and if you want to be able to use those photographs safely for anything other than news reporting, you would be well advised to talk to a local lawyer who is familiar with this area or, at a minimum, to do some legal research yourself. At the very least, you need to know what the right of publicity laws are in the states where those celebrities live, in the states where you work and live, and in the states where your clients are based. Remember, in an era of Internet publication, your photos are likely to be considered as being published virtually (no pun intended) everywhere in the world.

Let's get back to our cardiologist/biker. Just to make matters worse, it turns out that he appears weekly in a cable television show about health on The Learning Channel. Because of this, his claims against you are not just for violation of his rights of privacy, but of his rights of publicity, as well.

## DEFAMATION, FALSE LIGHT, AND OBSCENITY

All three of these areas of the law can cause problems for you from the licensing and publication of your photographs, but their underlying legal theories are quite different. Defamation is essentially making a false statement about some person (or other entity) that damages him in some way, usually by hurting his reputation or causing him to be ridiculed. You may know the word "defamation" by its constituent terms, "libel" (for written defamation) and/or "slander" (for spoken defamation). The "statement" does not have to be in the form of words; it can also be in the form of visual information (pictures).

Notice the first element: the statement has to be false. Since photographs at least start out as truthful, it is hard (if not impossible) to conceive of a photograph that can give rise to a valid defamation claim unless it has been (1) altered or (2) published in connection with text or other context.

Once alteration comes into the picture, it is easy to imagine a universe of possible changes to a photograph that would make it defamatory. Consider inserting a crack pipe into a person's hand, or distorting an attractive person's face. The possibilities are endless.

Alternatively, once the unaltered photograph appears in print, outside factors can make it defamatory. For example, imagine a photograph of a lawyer talking to his client, a well-known criminal. Published alone, there is no problem. Publish the same photo in a newspaper with an accurate caption, and again there is no problem. However, publish the same photo with a caption that says, "Crime Kingpins Conversing," and you have a probable lawsuit for defamation. Unless you can somehow prove that the lawyer is, in fact, a crime kingpin, you are likely to lose. As a general rule, since defamatory statements have to be untrue to be defamatory, the truth of the statement is almost always a complete defense.

The problem with defamation for photographers is that, even if the unaltered photo is completely accurate and truthful, and even if the photographer provided absolutely accurate caption information, and even if she had absolutely nothing to do with the story in connection with which the photograph is published, she will be one of the parties named in any lawsuit that might be filed. Once again, releases (along with the right kind and amount of liability insurance) can be worth their weight in gold. Remember, the costs of being involved in a lawsuit can be staggering, and the amount of time and emotional energy that they consume can be overwhelming.

In the world of defamation, you will run across discussions of issues such as whether the subject is a "public figure" and whether the publisher exercised the appropriate level of diligence or actual malice. Those issues really affect the publisher, not the photographer, as long as you have provided an accurate photograph and caption information.

An area that appears similar to defamation but that is actually a part of the right of privacy is known as "false light." Like defamatory publications, false light involves distributing information that is harmful to a person's reputation and/or that causes her humiliation. Unlike defamatory publications, however, publications that show someone in a false light are usually true, so truth is not an effective defense. For example, let's take our photo of the biker/cardiologist. Let's say that after the Honda ad appears, a local newspaper sees your credit line and calls you to license the photo for use on the front page of its next issue. When the paper hits the streets, you see that

the headline and article in which the photo appears is all about the terrible outlaw biker gang problem that the community is facing. Although the article doesn't specifically identify the biker in the photo or state that he is part of an outlaw biker gang, the implication that he is one is pretty clear. Both the photo and the article are literally true. However, by placing the two together, the subject of the photo has been shown in a false light. Another lawsuit is about to be served on you!

The third related area is obscenity. Here, the real legal problems are more likely to come from a government agency, rather than from the subject. Defining exactly what constitutes obscenity has troubled legal scholars ever since the concept first arose. The near-impossibility of trying to define it has reduced even brilliant legal minds like United States' Supreme Court Justice Potter Stewarts to saying, "I know it when I see it." The basic concept is that regulating obscenity is a form of censorship, pure and simple. It is an area where the government has decided that its citizens need to be protected from being exposed to certain kinds of images or combinations of words.

Unfortunately, nobody is sure exactly what those images and words are or exactly what the test should be. In fact, the series of U.S. Supreme Court decisions and the various statutes that try to define obscenity are all over the map and are often contradictory. Even the closest thing to a clear definition is filled with terms that are not defined, ". . . (a) Whether 'the average person applying contemporary community standards' would find that the work, taken as a whole, appeals to the prurient interest, (b) whether the work depicts or describes, in a patently offensive way, sexual conduct specifically defined by the applicable state law, and (c) whether the work, taken as a whole, lacks serious literary, artistic, political or scientific values." (Miller v. California, U.S. Supreme Court, 1974).

Trying to figure out what that means when applied to any particular photograph is virtually impossible, and trying to guess what a specific judge and jury will think it means is an exercise in futility. The best practical approach is to assume that, if you have sexually explicit photographs that you want to license, you would be well advised to consult with a competent attorney who is experienced in and familiar with the laws governing obscenity. If you do not, you are putting yourself, your career, your reputation, and your economic survival in great jeopardy.

If you have photographs of minors that are in any way sexually oriented, or if you have completely non-sexual photographs of minors who happen to be nude, you are walking through a minefield. If you send the images to

a lab for any reason, the lab owner may be legally required to report you to the authorities. These days, even the classic (or perhaps clichéd) photo of the naked baby on a bearskin rug can create a major legal problem for you. You have to make your own risk-reward analysis, but a word to the wise is sufficient.

## COPYRIGHTED WORKS AND OBJECTS

Photographs often include objects that may be protected by copyright. For example, many (if not most) photographs of street scenes include billboards, posters, signs, murals, automobiles, clothing, jewelry, and other objects on people and in shop windows, most of which are likely to be protected by their own copyrights. Photographs of parks may include copyrighted sculptures. Indoor photographs may include copyrighted paintings, sculptures, and other photographs. The list is endless. Does this mean that these photographs cannot be legally published, or even made in the first place, without permission from the copyright owners? As with every other legal question, the answer is, "It depends."

Technically, the mere making of a photograph that incorporates other copyrighted works is a violation of the exclusive rights of the copyright owners to reproduce the work and/or to make derivative works. Uses of such a photograph can also violate those rights, as well as other rights of the copyright owner, such as the right of public display. This means that the real question is whether there is any defense available.

The two main defenses that may be available are those of fair use and de minimis use. Both of those have been discussed in the preceding chapter on copyrights. While fair use is harder to find in a commercial context than an editorial one, it is not impossible. De minimis uses will depend on the sizes and prominence or focus of the copyrighted works included in the photograph. However, before you decide to rely on these defenses, you need to be aware of a couple of facts. First, there are cases, for example, where a copyrighted poster appeared on a wall on the set of one episode of a television show. It only appeared in the background and was on screen only a few times for a total time that was only a small portion of the episode's running time. Most of the time, it wasn't even in sharp focus. That usage was held to be a copyright violation.

Second, the movie studios, which are in the business of creating and capitalizing on copyrighted works on the largest scale in the world, are

generally scrupulous about clearing rights to virtually everything that will appear on screen. While they obviously have the budgets (and clout) to get all of those clearances, those same assets would allow them to defend against claims, if they thought that was a financially better course to follow. The fact that they spend a lot of money on maintaining staffs to obtain clearances, as well as paying the necessary licensing fees, says that the big-time pros believe that getting permission is better in the long run than taking risks—even calculated ones.

## TRADEMARKS AND LOGOS

Just as photographs can often include copyrighted materials as part of their subject matter, they can also frequently include trademarks and logos. Most city photographs will include automobiles and other products that have trademark protection and/or include logos. Even photos of kids playing in the park will probably show the manufacturers' trademarks and logos on the clothes and shoes that they are wearing. Does this mean that you need to get permission from Wrangler, the Gap, and Nike before you can license these photos?

Once again, the answer is, "It depends." The important thing to remember is that not every use of a trademark is a trademark use. Let's repeat that: not every use of a trademark is a trademark use. The trademark laws came about not to protect the manufacturers' property rights, but as a form of consumer protection. They were created so that consumers would know the sources of the products they were buying. While things have changed in the marketplace and trademarks and logos have in effect become products, themselves, the law has not strayed too far from its roots. For that reason, for a photograph showing a trademark or logo to be a violation of the trademark owners' rights, it has to be used in a way that would either (1) confuse a consumer as to the source of origin of the usage in some way or (2) dilute the value of the trademark in the marketplace.

Let's see what that means. Let's say that you make a photo of the hood and grille of a Rolls Royce. It shows the trademarked hood ornament and the RR logo on the front of the grille. Is making the photo without permission legal? Yes. Now let's say that you want to produce and sell a limited edition of fine arts prints. Is that legal without permission? Again, yes. The same is true of a poster that doesn't have any kind of commercial message on it. Similarly, you can include it in a coffee-table book about fine cars, or

even about Rolls Royce cars, even though you do not have permission. You are not using these photos in a trademark sense.

However, what happens if you want to license the same photo to prospective clients? Let's say a local auto mechanic named Bentley owns a garage that he operates under the name of "Bentley Motors." Can he use the photo in an advertisement without permission from Rolls Royce? Probably not, because anyone looking at the ad might think that there was some affiliation between the garage and Rolls Royce or that there might be some implied endorsement of the garage by Rolls Royce.

On the other hand, a close-up photograph of a distinguished-looking man holding a Coach briefcase and showing the Coach logo could probably be used in a law firm brochure or financial services company advertisement. The reason is that the average person would not be likely to believe that there was some connection between the firm and Coach or that Coach in some way endorsed the firm.

Now let's take that same Coach briefcase and put it in an ad for a chain of stores known for selling lower quality merchandise for extremely low prices. At that point, Coach probably has claims on at least two trademark-related grounds. First, there would probably be an assumption by someone viewing the ad that the bag could be bought at that store; i.e., that the store is a distributor of Coach products, which would be factually untrue. Second, because of the prestige of the Coach brand, the use in connection with a discount chain store specializing in lower quality products would probably allow a valid claim that the value of Coach's trademark had been diluted.

## BUILDINGS, SKYLINES, AND TREES

In recent years, a number of property owners have tried to assert proprietary rights of one form or another to prevent photographers from making and licensing photographs showing their properties. Typically, the most common claims have been based on alleged violations of trademark rights. Fortunately, those claims have almost never turned into actual lawsuits. Equally fortunately, on those rare occasions when they have, the property owners have generally lost.

The landmark case in this area was a suit by the Rock and Roll Hall of Fame against Cleveland photographer Chuck Gentile. Chuck stood on a public sidewalk across from the Rock and Roll Hall of Fame building in Cleveland and made a gorgeous photograph of it at sunset. He turned the

photograph into a poster that showed the building and bore a caption that identified the building, the city and state, and the photographer's name. The Hall of Fame sued him for trademark violations, having registered a logo showing a highly stylized depiction of the outline of the building. The Federal courts ended up ruling against the Hall of Fame, since the poster was not a trademark use and wasn't even a use of the Hall of Fame's actual trademark.

That decision has gone a long way towards deterring the owners of property such as the Lone Cypress, Pebble Beach Golf Course, and the Chrysler Building from filing legal actions against photographers. However, you need to be careful how you license photos showing landmarks and other pieces of property that are likely to be the basis for property interest claims such as trademarks. For example, the decision in the Rock and Roll Hall of Fame case could have turned out differently if the design(s) that they had registered had been different and/or if Gentile's photograph had been on a coffee mug or in an advertisement for his studio. You need to keep in mind the discussion of trademarks in the previous section and be sure that the uses that you license do not appear likely to turn into legal claims.

Another source of potential problems when you are licensing photos made outside the studio is copyrighted works. Earlier in this chapter we discussed the possible problems of showing things like sculptures in your photographs, and you need to be aware of those issues when you make, and particularly when you license, your photos. For example, the owners of the Eiffel Tower came up with a creative solution to the fact that the Tower itself was no longer protected under French copyright law: They installed a lighting design on the Tower that is protected as a newly copyrighted work. At least under French law, photographs of the Tower are now a copyright infringement. While nobody is enforcing that copyright against amateurs, professionals are another story, and any non-editorial uses of photos of the new and improved Tower are fair game.

## REPRESENTATIONS, WARRANTIES, AND INDEMNIFICATIONS

Because of all of these possible third-party issues, you have to be very careful when you create the paperwork that gives the details of your licenses. If you are using your own forms, you need to be sure that they have been

written correctly in the first place. If you are using documents that were written by a client or agent, you need to read the fine print very carefully. If you cannot get the other side to agree to the changes that you want, you need to make a serious risk-reward analysis and decide whether the amount of money that you will get from the deal is worth the potential legal liabilities to which you are exposing yourself.

Specifically, most licenses, whether created by you or your clients, will contain certain provisions that bear on these third-party issues. First, they are likely to have a place where you will state whether the image is "released"; i.e., whether you have all model and/or property releases that may be needed to make the licensed usages without risk of legal liability. You need to make sure that you provide clear and accurate information on that question.

Second, there is likely to be language that states a default assumption as to whether you have such releases, if you have not specifically provided that information for the particular photographs being licensed. Generally, forms written by photographers and their organizations will make the default provision say that, unless specifically stated otherwise, there is no release for any of the images.

Unfortunately, most agreements provided by clients will go in exactly the opposite direction: they will say that, unless specified otherwise, you are representing that there is a release for every person from whom a release might be needed. Sometimes, that isn't even an assumption—it's a requirement and a statement of absolute fact for which there is no place where you can state that there is no release. In short, many clients are willing to accept only released images and to hold you accountable if you provide any that are not released.

Further complicating the situation for photographers is the fact that many clients are now requiring, or at least trying to require, that you must use the client's specific form of release, not yours. Aside from the fact that this means you may have to go back and get another set of releases for each image submitted to one of those clients (which may be impossible to do), it also means that the release will work only for the client's benefit, not the photographer's. In those cases, you have to get two releases, one for the benefit of the client on the client's form and one for your benefit, if you want to be able to use the photographs for any purpose other than that particular client's.

The statement that you have a release is generally considered to be (and is usually labeled as) a "representation." That is, you are representing to the

client as an absolute fact that you have a release. In documents prepared by clients, those representations are in effect turned into guarantees under a section generally referred to as "warranties." That means that you are guaranteeing the truth of anything that you have represented, and you will be required by law to back up that warranty.

Making the situation even worse is a related set of provisions called "indemnifications." Clients will generally try to get you to accept documents that say that you will in effect act as their insurance company. That is, if there are any claims made against the client because of, or even just claiming, anything that would violate your representations (such as a claim for a violation of a right of privacy), you will pay for all legal fees and costs of defending the claim, even if you win, and even if the claim was completely bogus! And if you do lose, you will also pay any judgments or settlements! In short, the client is trying to shift all of the risks of doing business from the client to the photographer.

Obviously, you should try to delete or change the warranty, representation, and indemnification provisions, if it is at all possible. In fact, in a just world, it is actually the client who should be indemnifying the photographer, instead of the other way around. It is rare that making a photograph violates any third-party rights. If there are any violations, they are generally caused by the usages made by the clients. The photographers control only the making of the photographs—the clients control the uses. Unfortunately, we do not live in a just world, and market forces are such that the clients more and more frequently get to set the terms of the deal.

## RELEASE FORMS

The first thing that you need to keep in mind is that a release is a legal document. To be binding, it has to be signed by someone who has legal standing to enter into valid agreements. In the United States, that means that he or she has to be eighteen years old or older and cannot have a disability that would keep him from being considered legally competent. If you are photographing someone under eighteen, you should get a release from his or her parent, at a minimum, and preferably from both parents. If there is a legal guardian who has been appointed by a court, you should get that person's signature, rather than the parents'.

In addition, if the minor is a teenager, it is probably a good idea to get his or her signature, as well. In many states, it is possible for a minor to rescind the permission granted by a model release after he or she reaches majority, and having the release signed by the teenager might conceivably help if that becomes an issue. In any event, like chicken soup, it can't hurt.

When you read the forms that follow, you will notice references to something called "consideration." For an agreement to be legally enforceable, it generally has to contain three elements: an offer, an acceptance of that offer, and consideration. Consideration is generally something that has value. In many forms, you will see references to "one dollar and other good and valuable consideration," or some language along those lines. It is important to recite the fact that consideration is being provided, along with an acknowledgment by the other person that the consideration has been received. It is also helpful to state exactly what is at least one form of that consideration (e.g., "one dollar," "one photographic print," etc.). However, whenever you specify what the consideration is, you need to be certain that you actually provide it. For example, if it says that consideration is, or includes, one dollar, be sure to hand over that greenback, preferably in front of a witness who is also signing the release. In the days before digital cameras, many pros carried a Polaroid camera or a Polaroid camera back, and one of the ways that they convinced people to sign releases was to give them a Polaroid print on the spot. In those cases, that print was the consideration.

Addresses should be obtained whenever possible, both for identification purposes (to show that you have the release from the right Sam Jones) and in case you need to contact the subject for any reason. In addition, whenever possible, a witness should sign, as well, especially if the witness is someone who has no affiliation with either you or the subject and, therefore, is likely to be a credible witness if you ever need one. Here again, an address would be very helpful.

Another practical tip comes from the fact that permission is not worth anything if you cannot prove that you have it. For that reason, good record keeping as to the existence of releases is crucial, and the ability to retrieve a release and identify it as applying to a specific photograph can make the difference between avoiding a lawsuit and losing one. Whether you do it by way of an elaborate digital database or a simple set of paper files with copies of prints and releases doesn't matter, as long as you have a system and it works. Stapling a copy of

a release to a photo of the subject is a good way to figure out whose release you need when you are looking at a stack of photos months or years after you took them.

## Adult Model Release

There are several variations on the forms for model releases, so let's begin with the most inclusive and comprehensive one, the Adult Model Release. (See page 61 for an example.) You should use this version whenever possible, as long as there are no minors involved. It gives you the greatest level of protection. Because of that, it is also the longest and the most potentially intimidating to people who are not familiar with documents like these and/or who are hesitant to sign one.

## Twenty-first-Century Concerns

Two issues have recently surfaced that need to be considered in obtaining and drafting model releases. The first is digital alteration. In the old days (before Photoshop), composites and major changes in photographs were difficult, often expensive, comparatively infrequent, and generally easy to detect (and those facts were probably related). Today, alterations of even the most astonishing proportions are relatively easy, inexpensive, and virtually undetectable. Because of this, you can photograph someone shaking hands with the President of the United States, play with your computer for a few minutes, and end up with a completely genuine-looking photograph of that same person shaking hands with a third-world dictator.

Someone giving you permission to use a photograph of him shaking hands with the President may not be willing to give you the same permission when the photograph shows him shaking hands with a genocidal villain, especially when that photograph depicts an event that never happened. Similarly, there is real question as to whether the permission that he gave you to use the photograph of him with the president actually gives you permission to show him with General XYZ. The only way around that is to make sure that your release specifically allows digital compositing. You will find that sort of language in the forms, below.

The second issue relates to what are referred to as "sensitive" uses or issues or subjects. Many people have concerns about being associated with certain subjects. Typically, they are subjects related to sex, religion,

politics, and health. In some cases, appearing in the "wrong" ad campaign can spell ruin for a model's career. For those reasons, if you are going to use a photograph for any purpose that some people may find offensive or even distasteful, you should make sure that your release specifically authorizes that use. Since the nature of that kind of permission is specific, having a general authorization to use images for "sensitive uses" would probably not be effective. Instead, when needed, you should insert language similar to the following on an as-needed basis, changing words like "suffer" to fit your particular situation:

*I understand that the pictures of me will be used in public service advertisements to promote* _____. *Knowing that such advertisements may intentionally or unintentionally give rise to the impression that I suffer from this disease, I nevertheless consent to this use.*

### Simplified Adult Model Release

Because of the length, complexity, and occasionally intimidating legal language in the regular Adult Model Release, some photographers prefer to use a simplified version. (See page 63 for example.) They trade off some protection for a simpler document and one that people who are not professional models may be more willing to sign.

### Pocket Release

For those times when you need to have something quick and easy that you can carry with you and that is likely to be signed with minimal resistance, there is the Pocket Release. This document does not provide nearly the level of assurance that the more intricate releases do, but it should provide at least a reasonable level of protection. See page 66 for a sample Pocket Release.

### Property Release

The sample Property Release on page 67 has a section at the end that, if signed before a notary public and notarized ("acknowledged"), will allow it to be recorded in most states as if it were a deed or similar document. Recording it would essentially put the world on notice that you have permission to make and use photographs of this property, and any future owner of it will take title subject to that permission.

# ADULT MODEL RELEASE

In consideration of my engagement as a model, and for other good and valuable consideration herein acknowledged as received, I hereby grant to _____ ("Photographer"), his/her heirs, legal representatives, and assigns, those for whom Photographer is acting, and those acting with his/her authority and permission, the irrevocable and unrestricted right and permission to take, use, re-use, publish, and republish photographic portraits or pictures of me or in which I may be included, in whole or in part, or composite or distorted in character or form, without restriction as to changes or alterations, in conjunction with my own or a fictitious name, or reproductions thereof in color or otherwise, made through any medium at his/her studios or elsewhere, and in any and all media now or hereafter known, specifically including but not limited to print media and distribution over the Internet for illustration, promotion, art, editorial, advertising, trade, or any other purpose whatsoever. I specifically consent to the digital compositing or distortion of the portraits or pictures, including without restriction any changes or alterations as to color, size, shape, perspective, context, foreground, or background. I also consent to the use of any published matter in conjunction therewith. I hereby waive any right that I may have to inspect or approve the finished product or products and the advertising copy or other matter that may be used in connection therewith or the use to which it may be applied. I hereby release, discharge, and agree to save harmless Photographer, his/her heirs, legal representatives, and assigns, and all persons acting under his/her permission or authority or those for whom he/she is acting, from any liability by virtue of any blurring, distortion, alteration, optical illusion, or use in composite form, whether intentional or otherwise, that may occur or be produced in the taking of said picture or in any subsequent processing

thereof, as well as any publication thereof, including without limitation any claims for libel or violation of any right of publicity or privacy. I hereby warrant that I am of full age and have the right to contract in my own name. I have read the above authorization, release, and agreement, prior to its execution, and I am fully familiar with the contents thereof. This release shall be binding upon me and my heirs, legal representatives, and assigns.

X _____ *(Seal)*
SIGNATURE

_____
NAME

_____
ADDRESS   *(Line 1)*

_____
ADDRESS   *(Line 2)*

_____
DATE

X _____
WITNESS

_____
ADDRESS   *(Line 1)*

_____
ADDRESS   *(Line 2)*

# SIMPLIFIED ADULT RELEASE

For valuable consideration received, I grant to _____ ("Photographer") the absolute and irrevocable right and unrestricted permission concerning any photographs that he/she has taken or may take of me or in which I may be included with others, to use, re-use, publish, and republish the photographs in whole or in part, individually or in connection with other material, in any and all media now or hereafter known, including the Internet, and for any purpose whatsoever, specifically including illustration, promotion, art, editorial, advertising, and trade, without restriction as to alteration; and to use my name in connection with any use if he/she so chooses. I release and discharge Photographer from any and all claims and demands that may arise out of or in connection with the use of the photographs, including without limitation any and all claims for libel or violation of any right of publicity or privacy. This authorization and release shall also inure to the benefit of the heirs, legal representatives, licensees, and assigns of Photographer, as well as the person(s) for whom he/she took the photographs. I am a legally competent adult and have the right to contract in my own name. I have read this document and fully understand its contents. This release shall be binding upon me and my heirs, legal representatives, and assigns.

X _____ *(Seal)*
SIGNATURE

_____
NAME

_____
DATE

_____
ADDRESS  *(Line 1)*

_____
ADDRESS  *(Line 2)*

X _____
WITNESS

_____
ADDRESS  *(Line 1)*

_____
ADDRESS  *(Line 2)*

# MINOR RELEASE

In consideration of the engagement as a model of the minor named below, and for other good and valuable consideration that I acknowledge as having received, I hereby grant to _____ ("Photographer"), his/her legal representatives and assigns, those for whom Photographer is acting, and those acting with his/her authority and permission, the absolute right and permission to take, use, re-use, publish, and republish photographic portraits or pictures of the minor or in which the minor may be included, in whole or in part, or composite or distorted in character or form, without restriction as to changes or alterations from time to time, in conjunction with the minor's own or a fictitious name, or reproductions of such photographs in color or otherwise, made through any medium at Photographer's studios or elsewhere, and in any and all media now or hereafter known, including the Internet, for art, advertising, trade, or any other purpose whatsoever. I also consent to the use of any published matter in conjunction therewith. I specifically consent to the digital compositing or distortion of the portraits or pictures, including without restriction any changes or alterations as to color, size, shape, perspective, context, foreground, or background. I waive any right that the minor or I may have to inspect or approve any finished product or products or the advertising copy or printed matter that may be used in connection such photographs or the use to which it may be applied. I release, discharge, and agree to save harmless and defend Photographer, his/her legal representatives or assigns, and all persons acting under his/her permission or authority or those for whom he/she is acting, from any liability by virtue of any reason in connection with the making and use of such photographs, including blurring, distortion, alteration, optical illusion, or use in composite form, whether intentional or otherwise, that may occur or be produced in the taking of said picture or in any subsequent processing thereof, as well as any publication

thereof, including without limitation any claims for libel or violation of any right of publicity or privacy. I hereby warrant that I am a legal competent adult and a parent or legally appointed guardian of the minor, and that I have every right to contract for the minor in the above regard. I state further that I have read the above authorization, release, and agreement, prior to its execution, and that I am fully familiar with the contents of it. This release shall be binding upon the minor and me, and our respective heirs, legal representatives, and assigns.

X _____ *(Seal)*
FATHER, MOTHER, OR LEGAL GUARDIAN

X _____
FATHER, MOTHER, OR LEGAL GUARDIAN

X _____
MINOR'S SIGNATURE (if 14 or older)

_____
MINOR'S NAME

_____
ADDRESS *(Line 1)*

_____
ADDRESS *(Line 2)*

X _____
WITNESS

_____
ADDRESS *(Line 1)*

_____
ADDRESS *(Line 2)*

# POCKET RELEASE

For valuable consideration received, I grant to _____ ("Photographer") and his/her legal representatives and assigns the irrevocable and unrestricted right to use and publish photographs of me, or in which I may be included, for editorial, trade, advertising, and any other purpose and in any manner and medium; and to alter the same without restriction and without my inspection or approval. I hereby release Photographer and his/her legal representatives and assigns from all claims and liability relating to said photographs.

X _____ (Seal)
SIGNATURE

_____
NAME (PRINT)

_____
DATE

_____
PHONE

_____
STREET ADDRESS

_____
CITY/STATE/ZIP

X _____ (Seal)
IF MINOR, SIGNATURE OF
PARENT/GUARDIAN

X _____
WITNESS

# PROPERTY RELEASE

For good and valuable consideration herein acknowledged as received, the undersigned, being the legal owner of, or having the right to permit the taking and use of photographs of, certain property designated as _____, does grant to _____ ("Photographer"), his/her heirs, legal representatives, agents, and assigns the full rights to take and use such photographs in advertising, trade, or for any purpose. The undersigned also consents to the use of any printed matter in conjunction therewith. The undersigned hereby waives any right that he/she/it may have to inspect or approve the finished product or products, or the advertising copy or published matter that may be used in connection therewith, or the use to which it may be applied. The undersigned hereby releases, discharges, and agrees to save harmless and defend Photographer, his/her heirs, legal representatives, and assigns, and all persons acting under his/her permission or authority, or those for whom he/she is acting, from any liability by virtue of any blurring, distortion, alteration, optical illusion, or use in composite form, whether intentional or otherwise, that may occur or be produced in the taking of said picture or in any subsequent processing thereof, as well as any publication thereof, even though it may subject the undersigned, his/her heirs, representatives, successors, and assigns, to ridicule, scandal, reproach, scorn, and indignity. The undersigned hereby warrants that he/she is a legally competent adult and has every right to contract in his/her own name in the above regard. The undersigned states further that he/she has read the above authorization, release, and agreement, prior to its execution, and that he/she is fully familiar with the contents thereof. If the undersigned is signing as an agent or employee of a firm or corporation, the undersigned warrants that he/she is fully authorized to do so. This release shall be binding upon the undersigned and his/her/its heirs, legal representatives, successors, and assigns.

X _____ *(Seal)*
S I G N A T U R E

_____
N A M E

_____
D A T E

_____
W I T N E S S

_____
A D D R E S S   *(Line 1)*

_____
A D D R E S S   *(Line 2)*

S T A T E   O F :

                                    : S S

C O U N T Y   O F              :

On this _____ day of _____, 20_____, before me, a Notary Public for the State of _____, the undersigned officer, personally appeared _____, known or satisfactorily proven to me to be the person whose name is subscribed to the foregoing instrument, and acknowledged that he executed the same for the purposes therein contained.

In Witness Whereof, I have hereunto set my hand and notarial seal.

_____

N O T A R Y   P U B L I C

# C H A P T E R  4

# *Effective Licensing Agreements*

*E*very business day, photographers have a need to communicate transactional information to their prospects and clients. It might be the information or proposal in an estimate, the agreement expressed in a confirmation, or the verification of a delivery of photographs. Regardless of the nature of the communication, records of your communications are of critical importance, especially when they set the terms, conditions, price, and license to use your work. This is the advice that we have given to ASMP's members for years, and it is reproduced here with ASMP's persmission.

## GET IT IN WRITING

There are two types of communication: oral and written. Many of our communications are oral. No one could take the time in business to write everything down. However, some things are important enough to require a written record. Certainly, any communication defining the fees for, and licensing of, your work should be in writing. Even in the best of circumstances, memory is unreliable at the outset and deteriorates over time, communication is far from perfect, and personnel change. You have to assume that if it isn't in writing, it doesn't exist. If you cannot prove with clarity and certainty what the deal was, you will be at the mercy of your client. You may be there, anyway, but with proper documentation, you at least have the option of enforcing the terms of your agreement. Without written proof, your options are likely to be somewhere between slim and none.

Photographers need written records of their agreements concerning services, licenses, compensation, delivery, and value. Estimates, confirmations, invoices, delivery memos, and copyright licenses should be simple and straightforward and should embody the terms under which you conduct your business and to which both sides have agreed. Estimates and

confirmations are more likely to be used in assignment than in stock photography deals, while delivery memos and invoices are common to both.

These agreements are often expressed through the use of forms, an easy means of communication that requires less time and effort to use than other written means. Some photographers prefer to use friendlier formats like letters, some like to use e-mail, while still others turn to more formally drawn contracts. Most use some combination of them. Regardless of which you choose, the important point is to use, and to keep a copy of, some form of written communication whenever you carry out your transactional dealings.

Timely communication is very important. You should begin to communicate the transactional details of an assignment, whether merely proposed or actually awarded, immediately after your first contact with the prospective client. Too many photographers rely on their invoices to set the terms of their agreements. The danger of expressing your terms for the first time on the invoice is that it arrives after the work is done. If it contains any surprises in its content, such as details that were not discussed prior to the work being done, it will be contestable and could be considered an attempt by you to impose new conditions after the fact. In such a case, some or all of the invoice's terms would probably not be binding on the client. If a client has ever handed you an agreement that significantly changes any of the terms of what you thought was the deal—after you have shot the assignment—you know how distressing that feels and how damaging that is to the relationship. Follow the Golden Rule and don't do things to your client that you would not want your client to do to you.

Keep in mind that you always want to present your terms, fees, etc., before the work is started. If a client has full access to your terms and other details before you start working, and allows you to start and complete the work, it will be difficult for the client to protest later. When a client is fully informed and allows you to proceed with the work, it implies that a contract was in force, and that the conduct of the client (in allowing the work to proceed) probably amounts to the client's acceptance of your previously presented stipulations, terms, conditions, fees, and so on.

## WHEN DO CONTRACTS EXIST?

A contract is formed between parties when certain conditions exist. There must be an offer, an acceptance, and that thing called "consideration" that we discussed earlier. Your estimate is essentially an offer to

perform work with certain stipulations. An acceptance of your offer could take the form of a purchase order matching the estimate, a letter awarding you the work, a client-signed confirmation, or an oral OK over the telephone.

It is this oral acceptance that can present a problem, if denied later. This is where consent by conduct, allowing you to do the work, can be a factor. Remember: Unless your stipulations were in the client's hands before the consent by conduct, you might not be able to enforce your stipulations. Do your paperwork in a timely fashion. Even if time is extremely short, which it often is, at a minimum you can send off some kind of written document that confirms at least the basics of your understanding of the deal that you have just struck.

You should be aware that having the correct forms and releases is no guarantee that you will not be involved in a legal dispute. The purpose of correct paperwork is to avoid misunderstandings, to lessen the possibility of disputes, and to protect you and strengthen your position if they do happen.

## LETTER AGREEMENTS

Form letters, easily prepared and stored in your computer, are a softer way to present your paperwork than more formal documents. They have the advantage of appearing more personal and less aggressive. The same stipulations made on form agreements can be made in form letters. However, one should exercise care not to soften the language of the letter to the degree that the enforceability of the document comes into question. To avoid this, a transactional form letter should be specific and to the point, and not use any camouflage, or ambiguous wording. Arbitrators and judges alike—not to mention everyday business people who want to be up front about the details of their deals—frown on hidden terms and ambiguity. Remember that if a document ever has to be scrutinized by a judge, the law will usually interpret any ambiguities against the party who wrote the document and in favor of the other party.

One drawback of letter agreements is that they never contain the kind of detailed "boilerplate" that appears in formal agreements. Because of this, there will be language missing that, in retrospect, you may wish you had included or that may have helped you to resolve whatever problem that may have arisen. If you decide to create a form letter, you should write it up in your own style. You should then have the end result reviewed by your attorney.

A sample form letter agreement appears at the end of this chapter on page 136, along with the other forms. As you will see, our preferred form uses an informal letter but incorporates the detailed terms and conditions by reference to an enclosure. Our feeling is that, if you want to use a letter, your best bet is to make it essentially a cover letter for a detailed agreement.

## FORMS

For many years, photographers have relied on forms to present their estimates, confirmations, invoices, delivery agreements, and other business communications. Forms have the benefit of being quick and simple to complete. Generally, however, they have some inherent disadvantages. They are seemingly set in stone, often appear imposing, carry some terms and conditions that are completely inapplicable to any given deal, and often call for more information than one needs to present to the client. However, with the advent of the computer, it is possible to create form agreements that have only those specific elements that you need to convey for any specific situation.

Let's take a look at some of the forms a photographer might use in his business and what purpose they serve.

### The Estimate

An estimate is used to communicate the projected cost of the work to a prospective client. Additionally, it should embody other important details that you want a client to know about and understand before the two of you decide to do business together. An estimate is a description of the work to be done, the media usage allowed for the stated fee, and the terms and conditions that govern the transaction, performance, payment, etc. In legal terms, it is your offer.

The estimate should be sent to the client prior to starting any work. Even in cases where an estimate is provided on the telephone, you should alert your client that you are sending a written version of what you have just been discussing over the telephone. Send the estimate so it arrives in a timely fashion—in time for your client to review it before the work starts—and you should obtain proof of delivery. E-mail via a fast, broadband connection is crucial in today's high-speed, high-tech world. If you do not have an e-mail address today, you are not even in the game. A modem is also a helpful device for fast delivery of documents. Fax machines can also serve this

purpose, but in the twenty-first century, they are well on their way on the path to obsolescence. They have been replaced by computer-generated or scanned documents and e-mail or FTP downloads. For fast delivery combined with confirmation of that delivery, express delivery services such as Federal Express, UPS, DHL, etc., are good choices. They also communicate a subliminal message to your client that you are a professional businessperson, that his project is important to you, and that you appreciate the need for speed and the value of time. See sample estimate on page 98.

## The Confirmation

After your estimate is received, negotiated, and approved, including an oral acceptance over the telephone, you should confirm the final details of the transaction. This may be done by having the client sign a copy of the estimate and return the signed copy to you. Or, it may be accomplished by sending a separate confirmation to the client that embodies the details of the transaction. The confirmation may be exactly the same form as your estimate but with a different heading, or it may be a simple letter referring to the estimate and stating that the work will proceed under the details specified in the estimate, and with a copy attached. See page 100 for a sample assignment confirmation.

Again, the confirmation should be sent to the client before you start to work on the assignment, if it is to have maximum force and value in any dispute that might arise. Work that is properly estimated and confirmed prior to the start of work is the least likely to be contested later. The properly executed confirmation, more than any other document, is an "ounce of prevention."

## The Invoice

Everyone wants to get paid, and the invoice is the classic means of presenting your request for payment for services rendered. Invoices usually end up in accounts receivable departments of companies, and, therefore, are not usually in files pertaining to assignments. This is another reason why the invoice is not the best place to present your terms and conditions or licensing of rights. There is no point in having them reside only in the accounting department's files—generally, the people with whom you negotiated the assignment have no idea what's in accounts receivable, and the people in accounts receivable have no idea as to what you negotiated. You need these terms in the project work file in the office of the assigning party. Nevertheless, you should restate on the invoice any stipulations that appeared on your estimate or confirmation, or include a copy of the prior document. This emphasizes the details, and it reinforces your position.

## The Delivery Memo

Never deliver your photography without a proof of delivery and a memo presenting the terms of that delivery. Your photographs, whether assignment or stock photography or just a portfolio that is being dropped off in hope of getting some work, have value. That value should be protected for both your clients' and your interest. The delivery memo is similar in effect to a contract for a rental. It confirms that a prospective client has received something of value, and it asserts the obligations of the recipient either to return it in the same condition in which it was received or pay for it. What could be simpler and more reasonable? People sign such agreements all the time.

When you ship assignment work, you should include an assignment delivery memo. It is like a packing slip, detailing the contents of the shipment and providing the information needed by the client to match the shipment of work to its specific project. When you ship stock photography, the delivery memo serves to quantify and value the work and the terms under which it is delivered to and may be retained by the recipient.

Some courts have held that the delivery memo, when preceded by a telephone conversation in which the terms and conditions of delivery could have been discussed, is a contract after the fact. Indeed, many a recipient is astonished to find out that the transparencies that they have received are worth a small fortune. However, the enforceability of a stock photography delivery memo is not guaranteed. Specific facts of a given situation will determine if the document has a binding effect on the recipient. Nonetheless, one should never fail to send a delivery memo. It is far better than sending nothing at all.

The following is a checklist of items that should be included on assignment, portfolio, and stock delivery memos.

## Assignment Delivery Memo Checklist

- ☐ Heading: Date, Job #, P.O. #, A.D., Client, and so on
- ☐ Description of contents enclosed: Number, format, color or B&W, digital media, prints, or transparencies
- ☐ Terms and conditions of use: (same language as Estimate, Assignment Agreement/Confirmation)
- ☐ Requirements (suggested language): Return unselected media by (date) Return published media by (date)

☐ (*If contents are proofs*):
☐ For review only
    Make selection based on composition and expression
    Final image will be full frame unless specific crop or proportion are
    indicated

☐ Notes:
Please review the attached schedule of images.
Count will be considered accurate and quality deemed satisfactory for reproduction if exceptions have not been reported within 24 hours.
    Your acceptance of this delivery constitutes your acceptance of all terms on both sides of this delivery memo, whether signed by you or not.
    Acceptance signature and date

## Portfolio Delivery Memo Checklist
☐ Headings
☐ Description of contents enclosed
☐ Dollar value of contents and case
☐ Requirements (Suggested language)
☐ For review only
    No reproduction rights granted
    Images may/may not be scanned or copied for file reference only
    Portfolio to be returned by (date)

☐ Notes:
Your acceptance of this delivery constitutes your acceptance of all terms on both sides of this delivery memo, whether signed by you or not.
    Acceptance signature and date

## Stock Photography Delivery Memo Checklist
☐ Headings
☐ Terms and conditions of use: (either for review or specific license.)
☐ Description of images:    Quantity, original, duplicate, format, ID number, value
☐ Total:    Count, dollar value

☐ Notes:
Your acceptance of this delivery constitutes your acceptance of all terms on both sides of this delivery memo, whether signed by you or not.
    Acceptance signature and date

## The Pre-Delivery Confirmation

Some stock photographers, in an effort to protect their work, have begun to use something called a "pre-delivery confirmation." This form presents the stipulations that must be agreed to before you will send the work. Generally, it is e-mailed or faxed to the prospect, who must sign or electronically agree to it and return it before the photographer releases the shipment of photographs for delivery. When signed or electronically accepted by a duly authorized party, it should have a binding effect. When your work has recognized value, it would seem quite advisable to use one of these forms.

## The Form's Face

It is generally accepted that the face of a form has more weight than the reverse side, as does large print over small print. It is important, therefore, to have the most important and basic information on the face of the form. This information includes the job description, grant of media usage, price (fees and expenses), and the essential payment terms and conditions. Remember that the estimate and confirmation are the most important paperwork you can have to protect your interest, and this information should be clearly stated on them.

Because the language dealing with usage rights and payments—the most important parts of any agreement—varies so greatly from case to case, we cannot provide you with any boilerplate language dealing with those items. One issue that you need to consider in crafting that language is whether to break down your fee into several components or to leave it as a single line item. There has been a lot of debate on this subject over the years. Some photographers like to break down their fees between some aspect dealing with the creation of the photographs ("creative fee," "production fee," or something similar) and a fee for the usage of the photographs ("usage fee," "license fee," etc.). There are pros and cons to both approaches. Our feeling is that the more detail you give a prospective client to work with, the more you are handing him opportunities for negotiation. For example, if you provide a separate license or usage fee and the client decides not to use the photos, after all, a specific usage fee might give him a good basis to request a refund of that portion of the fee. For that kind of reason, we are inclined to use a single fee line, without any breakdown between creation, license, or any other component.

Another fee area that many photographers break out separately is the fee for post-capture digital services. With the advent of digital

photography, most photographers are finding themselves spending a lot of time and money in providing the kinds of services that used to be done by labs and other pre-press operations. Because clients no longer see these outside providers being involved or submitting bills when digital photography is involved, there is a tendency on their part to assume that the need for that work has simply disappeared and that there is no need to pay for it. In fact, all that has happened is that the photographer is now providing most of those services in-house—they have not disappeared at all.

The photographers should be compensated for that work, as well as the equipment, staff, and training needed to do that work and do it well. The answer is that the clients need to be educated as to the services that they are receiving. Some photographers prefer to do at least part of that education, in effect, by creating new categories of digital services that appear as line items making up the fee. Others prefer simply to keep the fee to a single line and to educate their clients verbally as to all of the services that are included in that fee. For the same reason that we prefer not to break out creative and licensing fees, we tend to recommend not breaking out photography and post-capture digital fees. However, you know your clients better than we do, and you have to choose the approach that works best for you.

One very good element to employ on your paperwork is a "condition precedent" regarding payment. A condition precedent is a stipulation that conditions the sale in such a way as to have a binding effect if the purchaser accepts your proposal. It is a condition that must be accepted before the rest of the deal can go into effect.

Here is an example: On the front of the estimate, confirmation, and invoice, near the statement of price, your paperwork might carry this legend:

*Media Usage RIGHTS GRANTED, as defined herein, are granted conditioned upon receipt of full payment of price indicated herein. Failure to make full and timely payment voids any media usage granted and constitutes copyright infringement.*

## Licensing Considerations

When writing a license or defining use, you should be as specific as possible. Otherwise, your license may turn out to have given your client more rights than you intended—for no additional money. Various licensing considerations are presented below to assist you.

## Copyright Rights—(Your Authority to License Rights)

Copyright owners have the right to control the following uses of their visual works:

❶ Reproduction—making copies by any means
❷ Derivation—making new work(s) based on yours
❸ Distribution—publication of your work (distribution to the public)
❹ Performance—showing your work (by mechanical means; applies to photographs only if they are incorporated into audiovisual works)
❺ Public Display—exhibition of your work

## Examples of Copyright Rights

| Reproduction | Derivation | Distribution | Performance |
|---|---|---|---|
| Display | Photocopying | Art reference | Electronic |
| Slide show | Exhibit | Scanning | Art rendering |
| Print | Compositing | | |

## Types of Media and Application

| Print | Electronic | Film | Posters |
|---|---|---|---|
| Television | Motion pictures | Brochures | Videotape |
| Film strip | Billboards | Laser disk | Audiovisual show |
| Bound pages | CD-ROM | Slide show | CD-Interactive |
| Magazines★ | Books★ | Product packaging | |

★ Note: Books and magazines could be print (bound pages), electronic (CD-ROM or CD-Interactive), or via electronic delivery services.

## Factors a License Should Include

❶ Copyright rights involved
❷ Media use (with digital and internet uses specifically addressed)
❸ Specific application
❹ Geographic limits
❺ Quantity limits (press run/circulation)
❻ Time limits on rights
❼ Size and placement of work.

For a list of additional considerations, see next page.

Example: Images to be reproduced and distributed in print version of *Hoopla Magazine*, one time only, between January and March 2008.

Circulation not to exceed 1 million copies in North America only. Images to be used inside magazine and up to 1/4 of a page per image.

## Considerations for Licensing Use of Images

I. Grant of Rights
  A. term
    1. period of years
    2. life of product
    3. copyright life of product
  B. extension
    1. versions
    2. additional pressings
    3. revisions
  C. exclusivity
    1. non-exclusive
    2. limited exclusivity
    3. full exclusivity
  D. territory
    1. limited
    2. unlimited
  E. restrictions
    1. mechanical (to press disks)
    2. on-screen only
    3. print with the product
    4. advertising/promotion of product
    5. public display
    6. broadcast
    7. derivative
    8. alteration
    9. file storage–size per image
    10. transmission
    11. printout from disk or screen

II. Define Application
  A. type (disk, online, cable TV, etc.)
  B. title(s)
  C. quantity
  D. labeling
  E. encryption
  F. protection of images

III. Compensation
    A. flat fee
    B. fee stepped to quantity
    C. advance plus royalty
    D. advance against royalty
    E. royalty
IV. Conditions
    A. warrantees
    B. obligations
    C. remedies
    D. status of provider digital files
V. Miscellaneous
    A. designation of agent
    B. settling disputes
    C. audit rights
    D. definitions

## SPECIFYING USAGE

The following are examples of common usage situations for which you would construct a license to grant rights. Always keep in mind, however, that each situation is unique. In book usage, for example, such factors as chapter openers, frontispiece, hard- or soft-cover, and book club editions could be part of a license.

A license of rights for such uses as audio-visual, wall murals, postcards, posters, greeting cards, and art decor should specify the limitations on size, number, time, location, and any other factor relating to the particular use to avoid questions or disputes that might otherwise arise later.

Any businessperson working in the twenty-first century has to think about potential digital uses, and that includes you. Try to predict what uses your client will want to make and address them. Either grant them specifically, if that is part of the deal, or clearly state that any rights, and particularly any electronic rights, that are not specifically granted are reserved to you. New uses for photography arise daily, but the following samples should help you in constructing licenses for your own business. Do it well so that both the seller's and the buyer's rights are understood.

## Advertising Rights Granted

*One-time, non-exclusive usage by (client) as (1/4, 1/2, full-page, or spread) image for (consumer or trade) ad, limited to (number) insertions for (national or regional) circulation in (color or B&W), as (define media and application types) for (number of months, years, or unlimited). Subject photograph is of (description) and is copyrighted by (photographer). All rights are reserved except those noted on this invoice.*

## Annual Report or Brochure Rights Granted

*One-time, non-exclusive usage by (client) in (title of annual report or brochure), limited to a print run of (number) as (cover or inside), used no larger than (page, spread, or wraparound) in (color or B&W). Subject photograph is of (description) and is copyrighted by (photographer). All rights are reserved except those noted on this invoice.*

## Magazine Rights Granted

*One-time, non-exclusive (e.g., English, French) language rights for editorial usage in (name of magazine), with a printed circulation of (number), for (month or edition and year) for distribution in (country or region), to be published only as (cover or inside, portion of page, number of pages). Subject photograph is of (description) and is copyrighted by (photographer). No rights granted for advertising or promotion of cover or inside pages. All rights are reserved except those noted on this invoice.*

(Note: Define whether the media is print, electronic, or both.)

## A NOTE ABOUT DIGITAL MEDIA

When you give a publisher or other client the right to use your photograph in a print publication of a collective work, such as a magazine, does the publisher automatically get the right to publish an exact digital version of that magazine without your permission and without paying you any additional royalties? Although the question has not yet been answered with absolute certainty in the courts, you have to assume that the answer will be Yes, unless you specifically provide to the contrary. For that reason, whenever you are intending that usage rights be limited to print usage only, you need to say so, clearly and specifically. We have included a provision like the following as part of our recommended terms and conditions, but you might

want to emphasize the point by including something along these lines, right on the front of the document:

*All usage rights are limited to print media, and no digital usages of any kind are permitted. This prohibition includes any rights that may be claimed under §201(c) of the Copyright Act of 1976 or any similar provision of any applicable law.*

## TERMS AND CONDITIONS

Another important part of your form agreements, after the specific details of the work, price, and rights, will be the terms and conditions that you use to govern the transaction. There are many possible combinations of these elements, depending on the nature of the work. This text has been prepared so that you can customize your terms and conditions depending on your own needs, either in general or for specific situations. That is, you can use this information to customize standard forms or to construct forms made to order for each use.

### Conditions on the Front Side of Your Assignment Form

The front of your form agreements should contain the most important conditions that you are imposing as a part of your offer to perform work or your acceptance of work. We have listed seven conditions that we see as extremely important.

These seven conditions are placed prominently to avoid any claim that the client did not see or was not aware of them. The conditions operate as follows:

❶ Allows a variance in estimated expenses.
❷ Makes the transfer of usage rights conditional upon payment in full.
❸ Makes the use specified the only use allowed, and requires written additions.
❹ Sets payment terms, and imposes a rebilling fee for unpaid invoices. (You might prefer to charge interest for unpaid invoices.)
❺ Requires that advance payments be received before you begin assignment.
❻ Refers the client to the other terms and conditions on the reverse side (see next page).
❼ Forms an agreement by the client's conduct if you are allowed to do the work.

Over the years, many photographers have asked us to develop a set of terms and conditions that are "softer and more client friendly." After much consideration, we have repeatedly decided not to do this. Our responsibility is to provide the best protection, in our judgment, for photographers like you. Softer, friendlier terms are generally weaker terms. While individual photographers may choose to take this path, we think that it is better to give you the best tools that we can and then let you make whatever changes you want. Straightforward, factual, and fair terms are nothing to shy away from. When was the last time that you rented an apartment, car, or camera equipment and signed a warm and fuzzy rental agreement?

## Signed or Unsigned

There are two approaches taken with these forms. On one, we provided a sample of language to be used if you are going to get your paperwork signed. We recommend that you get signed paperwork, as it is the most likely to be enforceable.

However, we understand that some clients will refuse to sign anything. So we have attempted to make the acceptance language on the bottom of the forms as enforceable as possible, whether signed or not. Still, a signature is best if you can get it.

## Terms and Conditions on the Reverse Side of Your Forms

The terms and conditions on the reverse side of the forms serve very useful business and legal purposes. You need to understand these terms, when to apply them, and what options are available. One way to make the documents seem friendlier to clients is to remove those provisions that can have no possible application to your situation. Before you can do that, you first have to understand what each of the provisions means. The following section is intended to provide the photographer with insight into the protective language used on the reverse side of the forms, and when to apply it.

The best way to prepare your forms is to customize the basic forms to meet the needs of your specific practices and policies, and then tailor each one for each specific job. To do this, you should have a firm understanding of what each term establishes by its presence, and when each applies. This is not a place for guesswork. If you are not sure, get competent advice. If you are still in doubt as to whether a term applies, it is almost always better to include it than to exclude it. Printed here are the terms and conditions that are normally found on the reverse side of a form. These specific terms are

meant to be used with the specific terms and conditions that appear on the front of the form. These terms are discussed in the preceding section.

## Term #1

**Question: Are you supplying images in some form? If yes, use term #1.**

*[1] Definition: "Image(s)" means all visual representations furnished to client by Photographer, whether captured, delivered, or stored in photographic, magnetic, optical, electronic, or any other media. Unless otherwise specified on the front of this document, Photographer may deliver, and Client agrees to accept, Images encoded in an industry-standard data format that Photographer may select, at a resolution that Photographer determines will be suitable to the subject matter of each Image and the reproduction technology and uses for which the Image is licensed. In addition, each Image will contain or be accompanied by a color profile published by the International Color Consortium or other generally recognized industry group; or if no profile is provided, Client shall assume that a color profile equivalent to Adobe RGB-1998 is intended. It is Client's responsibility to verify that the digital data (including color profile, if provided) are suitable for image reproduction of the expected quality and color accuracy, and that all necessary steps are taken to ensure correct reproduction. If the data are not deemed suitable, Photographer's sole obligation will be to replace or repair the data, but in no event will Photographer be liable for poor reproduction quality, delays, or consequential damages.*

This term defines "Images" in a manner to include all visuals furnished by you, regardless of medium. The word "Images" appears throughout the terms and conditions, and use of this definition is critically important to protect your interest. The use of "Images" with a capital "I" in the rest of the document means that you are using that word to mean "images" in the way that you have defined it.

With the world turning to the digital capture and delivery of images, it is becoming necessary also to define precisely what you are promising to deliver, as well as to make it clear that you are not responsible for the performance of those people who will be converting your digital images in different media. You may wish to alter the language to select whatever color standard you prefer.

## Term #2

**Question: Do you intend to own the processed film, prints, digital files, etc., and the copyright to the work? If yes, then use term #2.**

*[2] Rights: All Images and rights relating to them, including copyright and ownership rights in the media in which the Images are stored, remain the*

*sole and exclusive property of Photographer. Unless otherwise specifically provided elsewhere in this document, any grant of rights is limited to a term of one (1) year from the date hereof and to usage in print (conventional non-electronic and non-digital) media in the territory of the United States. Unless otherwise specifically provided elsewhere in this document, no image licensed for use on a cover of a publication may be used for promotional or advertising purposes without the express permission of Photographer and the payment of additional fees. No rights are transferred to Client unless and until Photographer has received payment in full. The parties agree that any usage of any Image without the prior permission of Photographer will be invoiced at three times Photographer's customary fee for such usage. Client agrees to provide Photographer with three copies of each published use of each Image not later than fifteen (15) days after the date of first publication of each use. If any Image is being published only in an electronic medium, Client agrees to provide Photographer with an electronic tear sheet, such as a PDF facsimile of the published use of each such photograph, within fifteen (15) days after the date of first publication of each use. Unless specifically provided elsewhere in this document, all usage rights are limited to print media, and no digital usages of any kind are permitted. This prohibition includes any rights that may be claimed under §201(c) of the Copyright Act of 1976 or any similar provision of any applicable law. Digital files may contain copyright and other information imbedded in the header of the image file or elsewhere; removing and/or altering such information is strictly prohibited and constitutes violation of the Copyright Act.*

This term establishes that you retain ownership to: (1) the tangible images (prints, disks, transparencies, etc.) and (2) the copyright to the images.

The term also sets defaults on the use of the images, if you do not specify other limits in the usage specifications, to: (1) a maximum of one year, to conventional print usage, and (2) to the United States only. It also excludes uses for promotional and advertising purposes unless you are paid additional fees. Note that it grants a license only upon your receipt of payment in full. Further, it prohibits digital uses, unless you specify (presumably on the front) that digital uses are being licensed.

You should also be aware that the provision specifying a three times multiple for unauthorized use may not be enforceable in court. However, it may help in negotiations, and its presence in documents like these is a common practice.

## A Note about Massachusetts

There is a 2004 Massachusetts law that you need to be aware of if you are ever going to work in Massachusetts, for clients in Massachusetts, or hire residents of Massachusetts. Essentially, it changes the rules for determining who is considered an independent contractor and who is an employee. Without going into detail that is beyond the scope of this kind of book, it basically presumes that everyone who works for someone else is an employee, not an independent contractor, unless three specific tests are met. Because of this, there appears to be at least a theoretical possibility that any photographer working in Massachusetts or even for a client in Massachusetts may be considered an employee. If that happens, there is another theoretical possibility: that the job will be considered work-made-for-hire, which means that the client would be considered both the author and the copyright owner.

We consider this result to be just a theoretical possibility at this point. However, to be certain, you may want to add the following at the end of Term #2 of the Terms and Conditions of all paperwork relating to assignments. "If Photographer is deemed under any law to be an employee of Client, and if the photographs created pursuant to this assignment are considered works made for hire under the U.S. Copyright Act, Client hereby agrees to transfer the copyright to all such photographs to Photographer. Client agrees to execute any documents reasonably requested by Photographer to confirm, expedite, or otherwise assist in such transfer."

Note: If you choose to use this language, the document in which it appears *must* be signed by both the Photographer and the Client, or by a duly authorized agent of either. Otherwise, it is likely not to be effective.

## Term #3

**Question: Do you want to hold your client responsible to return your images in good condition and to delete all digital files, and to do so in a reasonable period of time? If yes, then use term #3.**

*[3] Return and Removal of Images: Client assumes insurer's liability (a) to indemnify Photographer for loss, damage, or misuse of any Images, and (b) to return all Images prepaid and fully insured, safe and undamaged, by bonded messenger, air freight, or registered mail. Unless the right to archive Images has been specifically granted by Photographer on the front of this document, Client agrees to remove and destroy all digital copies of all Images. All Images shall be returned, and all digital files containing any Images shall be deleted or destroyed, within thirty (30) days after the later of: (1) the final licensed use as provided in this*

*document and, (2) if not used, within thirty (30) days after the date of the expiration of the license. Client assumes full liability for its principals, employees, agents, affiliates, successors, and assigns (including without limitation independent contractors, messengers, and freelance researchers) for any loss, damage, delay in returning or deleting, or misuse of the Images.*

This term places responsibility on the client for:

❶ protecting your interest for any loss, damage, or misuse of the images

❷ returning the images by specified means, including the destruction of digital files

❸ returning the images or destroying digital files by specified deadlines

❹ any losses, misuse, etc., by any party receiving the images from the client

## Term #4

**Question: Do you want to set a default for the value of your work in case it is lost or damaged? If yes, then use term #4. However, be sure to attach the required schedule(s) if they apply.**

*[4] Loss or Damage: Reimbursement by Client for loss or damage of each original photographic transparency or film negative ("Original[s]") shall be in the amount of One Thousand Five Hundred Dollars ($1,500) or such other amount if a different amount is set forth next to the lost or damaged item on the reverse side or attached schedule. Reimbursement by Client for loss or damage of each item other than an Original, including digital files, shall be in the amount set forth next to the item on the reverse side or attached schedule. Photographer and Client agree that said amount represents the fair and reasonable value of each item, and that Photographer would not sell all rights to such item for less than said amount. Client understands that each original photographic transparency and film negative is unique and does not have an exact duplicate, and may be impossible to replace or re-create. Client also understands that its acceptance of the stipulated value of the Images is a material consideration in Photographer's acceptance of the terms and prices in this agreement.*

This term sets the traditional $1,500 value per item for your original photographic images, unless you specify otherwise on the front or on a separate list. The values of non-original items are to be specified on the front or an attached schedule.

Note: If you are routinely supplying dupes, scans on disk or tape, etc., you should include the value of such items in the clause. Keep in mind that any

declared value must be reasonable and provable if it is to be accepted by a court. Also note that any value that you set is likely to be challenged if you try to enforce this provision and that courts generally do not like provisions like these.

## Term #5

**Question: Are you requesting a copyright credit line with your images? If yes, then use term #5 and be sure to specify the placement**.

*[5] Photo Credit: All published usages of Images will be accompanied by written credit to Photographer or copyright notice as specified on the reverse side unless no placement of a credit or copyright notice is specified. If a credit is required but not actually provided, Client agrees that the amount of the invoiced fee will be subject to a three times multiple as reasonable compensation to Photographer for the lost value of the credit line.*

This term requires that a credit line be given as stated on the front of the form and in the place specified (note that you have to specify those requirements). No credit is required if no placement is specified. It also provides that, if a credit is required but is not actually provided, the invoice will be subject to a three-times multiple. As with the multiplier mentioned earlier, you need to understand that this provision may not prove to be legally enforceable, but there is at least one case in which it was, and at a minimum it is valuable as a negotiating chip.

Note: If you are doing work in applications where credit lines are not normally given, you can leave the placement blank or remove the term from your form. Copyright credit is not required to retain your copyright, but it is desired and has specific advantages if used. As a rule of thumb, in practice, credits are typically given for the types of uses that generally do not require model releases, and vice versa; however, there are probably almost as many exceptions as there are examples that follow the rule, so you should always try to negotiate for a photo credit.

## Term #6

**Question: Does the work you are doing require alteration of the image you supply to the client? If yes, use option #6C. If no, use option #6A or 6B**.

*[6] Option A: Alterations: Client will not make or permit any alterations, including but not limited to, additions, subtractions, or adaptations in respect of the Images, alone or with any other material, including making digital scans, unless specifically permitted on the reverse side.*

*[6] Option B: Alterations: Client may not make or permit any alterations, including but not limited to, additions, subtractions, or adaptations in respect of the Images, alone or with any other material, including making digital scans unless specifically permitted on the reverse side, except that cropping and alterations of contrast, brightness, and color balance, consistent with reproduction needs may be made.*

Terms 6A or B should be inserted when you will not allow the client to alter the image in any way (6A) or in only minor ways to adjust for reproduction (6B).

*[6] Option C: Alterations: Client may make or permit any alterations, including but not limited to, additions, subtractions, or adaptations in respect of the Images alone or with any other material, including making digital scans, subject to the provisions as stated in [7] below.*

Term 6C permits the client to make alterations but makes them responsible for any consequences to those alterations, in accord with term [7].

Note: Some applications for images, like advertising, require that images be altered. It would seem necessary to give the client permission to make such alterations, provided that you are protected from any consequences of the alteration under term [7]. In any event, if you choose Option C, be certain that you have signed model releases that specifically allow such alterations.

## Term #7

**Question: There is no question here at all. Use this term on all your paperwork. It's the safest way.**

*[7] Indemnification: Client will indemnify and defend Photographer against all claims, liability, damages, costs, and expenses, including reasonable legal fees and expenses, arising out of any use of any Images or arising out of use of or relating to any materials furnished by Client. Unless delivered to Client by Photographer, no model or property release exists. Photographer's liability for all claims shall not exceed in any event the total amount paid under this invoice.*

This protects you if the images are used in an application requiring a release or license, and you have not supplied any, and for images altered by the client. It also establishes that there is no release or other permission unless you have supplied it.

Note: Some releases protect better than others. If you want to transfer the responsibility for assessing the force of the release to the client, you might consider adding this optional clause to the term's language:

*Copies of any available model and property releases and third party licenses are attached hereto. Determining the suitability of same for any application is the sole responsibility of the client.*

If you add this language, you must attach copies of the actual release(s) and/or licenses for the work.

## Term #8

**Question: Is your client supplying props or other items for the shoot? If yes, use term #8.**

*[8] Assumption of Risk: Client assumes full risk of loss or damage to or arising from the use of all materials furnished by client and warrants that said materials and their uses are adequately insured against such loss, damage, or liability. Client shall indemnify and defend Photographer against all claims, liability, damages, and expenses incurred by Photographer in connection with any claim arising out of use of said materials.*

This term is intended to transfer responsibility for any client-supplied materials, props, etc., on the assignment. The principle is meant to transfer the bailee responsibility you have for another's property while it is in your care, as well as to protect you from any unforeseeable problems that may arise out of the use of such property. It is not a substitute for insurance (which you should always carry), but it is an added safeguard to protect your interest.

## Term #9

**Question: There is no question here. Use this term on all your paperwork for maximum protection.**

*[9] Transfer and Assignment: Client may not assign or transfer this agreement or any rights granted under it. This agreement binds client and inures to the benefit of Photographer, as well as their respective principals, employees, agents and affiliates, heirs, legal representatives, successors, and assigns. Client and its principals, employees, agents, and affiliates are jointly and severally liable for the performance of all payments and other obligations hereunder. No amendment or waiver of any terms is binding unless set forth in writing and signed by the parties. However, the invoice may reflect, and Client is bound by client's oral authorizations for fees or expenses that could not be confirmed in writing because of*

insufficient time. This agreement incorporates by reference the Copyright Act of 1976, as amended. It also incorporates by reference those provisions of Article 2 of the Uniform Commercial Code that do not conflict with any specific provisions of this agreement; to the extent that any provision of this agreement may be in direct, indirect, or partial conflict with any provision of the Uniform Commercial Code, the terms of this agreement shall prevail. To the maximum extent permitted by law, the parties intend that this agreement shall not be governed by or subject to the UCITA of any state.

This term prevents the client from assigning responsibility for the agreement to another party. It also limits changes to the agreement to those made in writing and signed by both parties, unless the client makes them during the assignment. Finally, it specifies the application of certain laws to the agreement, as a means of reinforcing the agreement's strength and of interpreting the agreement in your best interest.

## Term #10

**Question: There is no question here. Use this term on all your paperwork for maximum protection**.

*[10] Disputes: Except as provided in [11] below, any dispute regarding this agreement shall, at Photographer's sole discretion, either: (1) be arbitrated in [PHOTOGRAPHER'S CITY AND STATE] under rules of the American Arbitration Association and the laws of [STATE OF ARBITRATION]; provided, however, that the parties are not required to use the services of arbitrators participating in the American Arbitration Association or to pay the arbitrators in accordance with the fee schedules specified in those rules, irrespective of any provision of those rules. Judgment on the arbitration award may be entered in any court having jurisdiction. Any dispute involving $____[LIMIT OF LOCAL SMALL CLAIMS COURT] or less may be submitted without arbitration to any court having jurisdiction thereof, to which jurisdiction Client hereby submits. OR (2) be adjudicated in [PHOTOGRAPHER'S CITY AND STATE] under the laws of the United States and/or of [STATE]. (3) In the event of a dispute, Client shall pay all court costs, Photographer's reasonable legal fees, and expenses, and legal interest on any award or judgment in favor of Photographer.*

This provision gives you the option of deciding whether to have disputes resolved through arbitration or litigation. Use this term in all your paperwork, and be sure to insert the required geographic information. You will probably have to check with your local small claims court to find out the maximum amount of its jurisdiction.

## Term #11

**Question: There is no question here, use this on all your paperwork. It is the law.**

*[11] Federal Jurisdiction: Client hereby expressly consents to the jurisdiction of the federal courts with respect to claims by Photographer under the Copyright Act of 1976, as amended, including subsidiary and related claims.*

This clause makes the federal courts the forum for a copyright infringement case. This is in keeping with the federal copyright law itself, which defines the federal courts as the courts of proper jurisdiction for such action, and it eliminates a point of possible argument.

## Term #12

**Question: Do you pay freelance and staff overtime? If yes, consider using term #12.**

*[12] Overtime: In the event a shoot extends beyond eight (8) consecutive hours, Photographer may charge for such excess time of assistants and freelance staff at the rate of one-and-one half times their hourly rates.*

This term sets eight consecutive hours as a standard day and reserves the right for you to charge overtime fees for your staff and assistants.

## Term #13

**Question: Do you want to be paid for a reshoot demanded by a client? If yes, use term #13.**

*[13] Reshoots: Client will be charged 100 percent fee and expenses for any reshoot required by Client, unless due to the negligence of Photographer. For any reshoot required because of any reason outside the control of Client, specifically including but not limited to acts of God, nature, war, terrorism, civil disturbance or the fault of a third party, Photographer will charge no additional fee, and Client will pay all expenses. If Photographer charges for special contingency insurance and is paid in full for the shoot, Client will not be charged for any expenses covered by insurance. A list of exclusions from such insurance will be provided on request.*

The charges for a reshoot are established in this term. If the client requires the reshoot, it sets 100 percent of the original fee and expenses as the payment. It requires payment of expenses only when a reshoot is required because of the act of a third party or an act of God. It also provides that no expenses covered by insurance will be charged to the client if it has paid a fee for the coverage.

Note: This clause does not absolve you from having to reshoot at your own expense if your negligence is the cause of a reshoot. You should consider deleting the statements about insurance if you do not make such contingency insurance available to your clients.

## Term #14

**Question: Do you want to establish a cancellation policy? If yes, use term #14**.

*[14] Cancellations and postponements. Cancellations: Client is responsible for payment of all expenses incurred up to the time of cancellation, plus 50 percent of Photographer's fee; however, if notice of cancellation is given less than two (2) business days before the shoot date, Client will be charged 100 percent fee. Postponements: Unless otherwise agreed in writing, Client will be charged a 100 percent fee if postponement occurs after photographer has departed for location, and 50 percent fee if postponement occurs before departure to location. Fees for cancellations and postponements will apply irrespective of the reasons for them, specifically including but not limited to weather conditions, acts of war, terrorism, and civil disturbance.*

This term sets up a cancellation policy and speaks clearly for itself.

Note: You might want to consider the use and language of this term in light of your own policy before you accept this specific language as a default.

## INDEPENDENT CONTRACTOR'S AGREEMENT

All too often, we see photographers caught up in cases in which their freelance assistants, and often models, claim to have been employees. They do this when they run out of work and seek unemployment benefits, or when they are injured on a job and are not covered by insurance.

The problem is that government agencies seem to go out of their way when reviewing these cases to make the claimant an employee. We expect it is because they don't like to deny citizens claims when there is someone there to pay for them. You, the photographer, could be held responsible if you do not have the proper insurance, or have not treated the claimant's payments as wages.

We also see problems where state and federal tax examiners hold freelance assistants, models, and other service providers to be employees of photographers, and then tax and penalize the photographers for failure to

report and withhold the proper taxes. This is good for the government treasury and bad for the photographers, and you can't insure against it.

While there is no guaranteed way to protect yourself from this danger, we suggest that you have independent contractors execute an agreement acknowledging their status with you (the only alternative is to treat everybody that works with you—models, stylists, assistants, etc.—as employees for purposes of tax and other payments and reports). A sample form to this effect is included in the packet of sample forms. Again, a legal review is recommended, as state laws will have a major bearing on the enforceability of such an agreement.

We have added a condition precedent to the agreement, which is intended to fend off the cases of the kind we have described above. Still, there are no guarantees in business, and especially not in this area.

## INDEMNIFICATION AGREEMENT

There are times in your work when a party you contract with has to take a risk. It might be a model being asked to sit on the edge of a roof of a tall building, or being asked to pose with a lion. In each of these situations, the photographer is at special risk. If the lion, trained as it might be, gets spooked and bites the model, or a gust of wind causes the model to lose balance and fall off the roof, you might be held liable for the damages.

Obviously, the best way to deal with risk is to insure for it. In addition, however, it is prudent to secure an indemnification agreement from those parties who might be at risk while rendering services to you, on your shoot. We have included a sample indemnification agreement in our grouping of sample forms. This, like all agreements, will be influenced by state law and court decisions. Having this form reviewed by your attorney for its enforceability under your state laws is a good idea.

Keep in mind that you are responsible for injury to your employees, and they cannot indemnify you under law. You are supposed to carry workers compensation insurance for this purpose. It would not be uncommon for an injured freelance assistant or model to claim that she was your employee if she signed such an indemnification agreement. If the authorities found her to be an employee, you would be liable, in spite of the agreement. Here is one case in which an independent contractor's agreement is in order. However, you need to be aware that the independent contractor's agreement will not guarantee that the person will not be considered your employee under the law; it will be one of the factors that will determine that person's status.

# INDEMNIFICATION AGREEMENT

(MODEL) hereby agrees to protect, defend, indemnify, and hold harmless (PHOTOGRAPHER) from and against any and all claims, losses, liabilities, settlements, expenses, and damages, including legal fees and costs (all referred to collectively as "Claims"), which (PHOTOGRAPHER) may suffer or to which (he/she/it) may be subjected for any reason, even if attributable to negligence on the part of (PHOTOGRAPHER) or any other entity, arising out of or related to any act, omission, or occurrence in connection with the creation, production, or use of any image or the performance of any service relating to this Agreement or its subject matter. This provision shall apply to Claims of every sort and nature, whether based on tort, strict liability, personal injury, property damage, contract, defamation, privacy rights, publicity rights, copyrights, or otherwise. (MODEL) assumes all risks, and (his/her/its) obligations under this provision shall survive the performance, termination, or cancellation of this Agreement.

_____          _____
DATE                             NAME

_____          _____
WITNESS                          ADDRESS

# INDEPENDENT CONTRACTOR AGREEMENT

AGREEMENT entered into as of the _____ day of _____, 20____, between _____ located at _____ (hereinafter referred to as the "Photographer") and _____, located at _____ (hereinafter referred to as the "Contractor").

The Parties hereto agree as follows:

1. Services to be Rendered. The Contractor agrees to perform the following services for the Photographer: _____
   _____
   _____

2. Schedule. The Contractor shall complete the services pursuant to the following schedule: _____
   _____
   _____
   _____

3. Fee and Expenses. The Contractor shall be paid as follows: The Photographer shall reimburse the Contractor only for the listed expenses: _____
   _____

4. Payment. Payment shall be made as follows: _____
   _____

5. Condition precedent to Agreement. Contractor does not consider himself eligible for nor has any intention to, and will not, apply for, unemployment or workers' compensation benefits in a claim against the Photographer.

6. Relationship of Parties. Both parties agree that the Contractor is an independent contractor. This Agreement is not an employment agreement, nor does it constitute a joint venture or partnership between the Photographer and Contractor. Nothing contained herein shall be construed to be inconsistent with this independent contractor relationship.

7. Proprietary Rights. The proprietary rights in any work produced in conjunction with this Agreement shall be vested solely and exclusively in the Photographer.

8. Miscellany. This Agreement constitutes the entire agreement between the parties. Its terms can be modified only by an instrument in writing signed by both parties, except that oral authorizations of additional fees and expenses shall be permitted if necessary to speed the progress of work. This Agreement shall be binding on the parties, their heirs, successors, assigns, and personal representatives. A waiver of a breach of any of the provisions of this Agreement shall not be construed as a continuing waiver of other breaches of the same or other provisions hereof. This Agreement shall be governed by the laws of the State of _____.

    IN WITNESS WHEREOF, the parties hereto have signed this as of the date first set forth above.

_____     _____

PHOTOGRAPHER       CONTRACTOR

# ESTIMATE

Straight Shooter Studio, Inc.
123 Anystreet
Hometown, ZX 12345
Telephone: 123-555-1212
Fax: 123-555-2121

## ESTIMATE

THIS ESTIMATE IS VALID FOR NINETY DAYS FROM
THIS DATE OF ISSUE: _____
REFERENCE # _____
CLIENT: _____

## ASSIGNMENT DESCRIPTION

Description: _____
_____
_____

Usage Specifications: _____
_____

Estimated Price: FEES _____ EXPENSES _____
TOTAL _____
Note: For details of fee structure and expenses, refer to
attached schedule.

Advance Payments: FEES _____ EXPENSES _____
TOTAL _____

## CONDITIONS OF TRANSACTION:

1. The copyright to all images created or supplied pursuant to this
   agreement remains the sole and exclusive property of the photog-
   rapher. There is no assignment of copyright, agreement to do work

for hire, or intention of joint copyright expressed or implied hereunder. Conditioned upon payment in full, the client is licensed the above usage specifications in accord with the conditions stated herein. Proper copyright notice, which reads: © 20____ Straight Shooter, must be displayed with the following placement: _____. Notice is not required if placement is not specified. Omission of required notice results in loss to the photographer and will be billed at triple the invoiced fee.

2. All expense estimates are subject to normal trade variance of 10 percent.

3. Usage specifications above convert to copyright license only upon receipt of full payment.

4. Usage beyond that defined above requires additional written license from the licensor.

5. Invoices are payable on receipt. Unpaid invoices are subject to a rebilling fee of _____.

6. Advance payments must be received at least twenty-four hours prior to assignment commencement.

7. The assignment is subject to all terms and conditions on the reverse side hereof.

8. *If you order the performance of any services required to complete the above described assignment, that act constitutes your acceptance by conduct of the terms on both sides of this estimate in their entirety, whether signed by you or not.*

SUBMITTED BY: _____ Date: _____, 20_____

ACCEPTED BY: _____ Date: _____, 20_____

# ASSIGNMENT CONFIRMATION

Straight Shooter Studio, Inc.
123 Anystreet,
Hometown, ZX 12345
Telephone: 123-555-1212
Fax: 123-555-2121

## ASSIGNMENT CONFIRMATION

Date assignment to begin: _____ Reference # _____
Date of Confirmation _____
Client: _____

Assignment Description: _____

Usage Specifications: _____

Estimated Price: FEES: _____ EXPENSES: _____
TOTAL: _____
Note: For details of fee structure and expenses, refer to attached schedule.

Estimated Price: FEES: _____ EXPENSES: _____
TOTAL: _____

## CONDITIONS OF TRANSACTION:

1. The copyright to all images created or supplied pursuant to this agreement remain the sole and exclusive property of the photographer. There is no assignment of copyright, agreement to do work for hire, or intention of joint copyright expressed or implied hereunder. Conditioned on payment in full, the client is licensed the above usage specifications in accord with the conditions stated herein. Proper copyright notice, which reads: © 20_____ Straight Shooter, must be displayed with the

following placement: _____. Notice is not required if placement is not specified. Omission of required notice results in loss to the photographer and will be billed at triple the invoiced fee.

2. All expense estimates are subject to normal trade variance of 10 percent.

3. Usage specifications above convert to copyright license only upon receipt of full payment.

4. Usage beyond that defined above requires additional written license from the licensor.

5. Invoices are payable on receipt. Unpaid invoices are subject to a rebilling fee of _____.

6. Advance payments must be received at least 24 hours prior to assignment commencement.

7. The sale is subject to all terms and conditions on the reverse side hereof.

8. *If you order the performance of any services required to complete the above-described assignment, that act constitutes your acceptance by conduct of the terms on both sides of this confirmation in their entirety.*

This confirms the details of the assignment that you have awarded to Straight Shooter Studio, Inc.

Thank you for selecting us to fulfill this important need.

# INVOICE

Straight Shooter Studio, Inc.
123 Anystreet
Hometown, ZX 12345
Telephone: 123-555-1212
Fax: 123-555-2121

## INVOICE

Date of Invoice: _____ Reference # _____

Your P.O.# & Date: _____  _____, 20_____

Client: _____

Assignment Description: _____

_____

Usage Specifications: _____

_____

Price

FEES _____     TOTAL PRICE _____

EXPENSES _____     LESS ADVANCES _____

SALES TAX _____     BALANCE DUE _____

PLEASE REMIT $ _____

## CONDITIONS OF TRANSACTION:

1. The copyright to all images created or supplied pursuant to
   this agreement remain the sole and exclusive property of the
   photographer. There is no assignment of copyright, agree-
   ment to do work for hire, or intention of joint copyright
   expressed or implied hereunder. Conditioned on payment in
   full, the client is licensed the above usage specifications in
   accord with the conditions stated herein. Proper copyright

notice, which reads: © 20__ Straight Shooter, must be displayed with the following placement: _____.
Notice is not required if placement is not specified. Omission of required notice results in loss to the licensor and will be billed at triple the invoiced fee.

2. All expense estimates are subject to normal trade variance of 10 percent.

3. Usage specifications above convert to copyright license only upon receipt of full payment.

4. Usage beyond that defined above requires additional written license from the licensor.

5. Invoices are payable on receipt. Unpaid invoices are subject to a rebilling fee of _____.

6. The sale is subject to all terms and conditions on the reverse side hereof.

7. Your having ordered the performance of any services required to complete the above-described assignment, and/or accepted delivery of any Image created in connection with that assignment, constituted your acceptance by conduct of the terms on both sides of this invoice, in their entirety.

Provider E.I.N. or S.S. # _____

Work Delivered Via _____

Date Work Delivered _____ , 20 ____

Work Delivered To _____

# TERMS AND CONDITIONS FOR REVERSE SIDE OF ASSIGNMENT ESTIMATE, CONFIRMATION, INVOICE

[1] Definition: "Image(s)" means all visual representations furnished to Client by Photographer, whether captured, delivered, or stored in photographic, magnetic, optical, electronic, or any other media. Unless otherwise specified on the front of this document, Photographer may deliver, and Client agrees to accept, Images encoded in an industry-standard data format that Photographer may select, at a resolution that Photographer determines will be suitable to the subject matter of each Image and the reproduction technology and uses for which the Image is licensed. In addition, each Image will contain or be accompanied by a color profile published by the International Color Consortium or other generally recognized industry group; or if no profile is provided, Client shall assume that a color profile equivalent to Adobe RGB-1998 is intended. It is Client's responsibility to verify that the digital data (including color profile, if provided) are suitable for image reproduction of the expected quality and color accuracy, and that all necessary steps are taken to ensure correct reproduction. If the data are not deemed suitable, Photographer's sole obligation will be to replace or repair the data, but in no event will Photographer be liable for poor reproduction quality, delays, or consequential damages.

[2] Rights: All Images and rights relating to them, including copyright and ownership rights in the media in which the Images are stored, remain the sole and exclusive property of Photographer. Unless otherwise specifically provided elsewhere in this document, any grant of rights is limited to a term of one (1) year from the date hereof and to usage in print (conventional non-electronic and non-digital) media in the territory of the United States. Unless otherwise specifically provided elsewhere in this document, no image licensed for use on a cover of a publication may be used for promotional or advertising purposes without the express permission of Photographer and the payment of additional fees. No rights are transferred to Client unless and until Photographer has received payment in full. The parties agree that any usage of any Image without the prior permission of Photographer will be invoiced at three times Photographer's customary fee for such usage. Client agrees to provide Photographer with three copies of each published use of each Image not later than fifteen (15) days after the date of first publication of each use. If any Image is being published only in

an electronic medium, Client agrees to provide Photographer with an electronic tear sheet, such as a PDF facsimile of the published use of each such photograph, within fifteen (15) days after the date of first publication of each use. Unless otherwise specifically provided elsewhere in this document, all usage rights are limited to print media, and no digital usages of any kind are permitted. This prohibition includes any rights that may be claimed under §201(c) of the Copyright Act of 1976 or any similar provision of any applicable law. Digital files may contain copyright and other information imbedded in the header of the image file or elsewhere; removing and/or altering such information is strictly prohibited and constitutes violation of the Copyright Act.

[3] Return and Removal of Images: Client assumes insurer's liability (a) to indemnify Photographer for loss, damage, or misuse of any Images, and (b) to return all Images prepaid and fully insured, safe and undamaged, by bonded messenger, air freight, or registered mail. Unless the right to archive Images has been specifically granted by Photographer on the front of this document, Client agrees to remove and destroy all digital copies of all Images. All Images shall be returned, and all digital files containing any Images shall be deleted or destroyed, within thirty (30) days after the later of: (1) the final licensed use as provided in this document and, (2) if not used, within thirty (30) days after the date of the expiration of the license. Client assumes full liability for its principals, employees, agents, affiliates, successors, and assigns (including without limitation independent contractors, messengers, and freelance researchers) for any loss, damage, delay in returning or deleting, or misuse of the Images.

[4] Loss or Damage: Reimbursement by Client for loss or damage of each original photographic transparency or film negative ("Original[s]") shall be in the amount of One Thousand Five Hundred Dollars ($1,500), or such other amount if a different amount is set forth next to the lost or damaged item on the reverse side or attached schedule. Reimbursement by Client for loss or damage of each item other than an Original, including digital files, shall be in the amount set forth next to the item on the reverse side or attached schedule. Photographer and Client agree that said amount represents the fair and reasonable value of each item, and that Photographer would not sell all rights to such item for less than said amount. Client understands that each Original is unique and does not have an exact duplicate, and may be impossible to replace or re-create. Client also understands that its acceptance of the stipulated value of the

Images is a material consideration in Photographer's acceptance of the terms and prices in this agreement.

[5] Photo Credit: All published usages of Images will be accompanied by written credit to Photographer or copyright notice as specified on the reverse side unless no placement of a credit or copyright notice is specified. If a credit is required but not actually provided, Client agrees that the amount of the invoiced fee will be subject to a three times multiple as reasonable compensation to Photographer for the lost value of the credit line.

OPTION: [6A] Alterations: Client will not make or permit any alterations, including but not limited to additions, subtractions, or adaptations in respect of the Images, alone or with any other material, including making digital scans unless specifically permitted on the reverse side. OR

[6B] Alterations: Client may not make or permit any alterations, including but not limited to additions, subtractions, or adaptations in respect of the Images, alone or with any other material, including making digital scans unless specifically permitted on the reverse side, except that cropping and alterations of contrast, brightness, and color balance, consistent with reproduction needs may be made. OR

[6C] Alterations: Client may make or permit any alterations, including but not limited to additions, subtractions, or adaptations in respect of the Images alone or with any other material, including making digital scans, subject to the provisions as stated in [7] below.

[7] Indemnification: Client will indemnify and defend Photographer against all claims, liability, damages, costs, and expenses, including reasonable legal fees and expenses, arising out of the creation or any use of any Images or arising out of use of or relating to any materials furnished by Client. Unless delivered to Client by Photographer, no model or property release exists. Photographer's liability for all claims shall not exceed in any event the total amount paid under this invoice.

[8] Assumption of Risk: Client assumes full risk of loss or damage to or arising from the use of all materials furnished by Client and warrants that said materials are adequately insured against such loss, damage, or liability. Client shall indemnify and defend Photographer against all claims, liability, damages, and expenses incurred by Photographer in connection with any claim arising out of use of said material.

[9] Transfer and Assignment: Client may not assign or transfer this agreement or any rights granted under it. This agreement binds Client and

inures to the benefit of Photographer, as well as their respective principals, employees, agents, and affiliates, heirs, legal representatives, successors, and assigns. Client and its principals, employees, agents, and affiliates are jointly and severally liable for the performance of all payments and other obligations hereunder. No amendment or waiver of any terms is binding unless set forth in writing and signed by the parties. However, the invoice may reflect, and Client is bound by, Client's oral authorizations for fees or expenses that could not be confirmed in writing because of insufficient time. This agreement incorporates by reference the Copyright Act of 1976, as amended. It also incorporates by reference those provisions of Article 2 of the Uniform Commercial Code that do not conflict with any specific provisions of this agreement; to the extent that any provision of this agreement may be in direct, indirect, or partial conflict with any provision of the Uniform Commercial Code, the terms of this agreement shall prevail. To the maximum extent permitted by law, the parties intend that this agreement shall not be governed by or subject to the UCITA of any state.

[10] Disputes: Except as provided in [11] below, any dispute regarding this agreement shall, at Photographer's sole discretion, either:

(1) be arbitrated in [PHOTOGRAPHER'S CITY AND STATE] under rules of the American Arbitration Association and the laws of [STATE OF ARBITRATION]; provided, however, that the parties are not required to use the services of arbitrators participating in the American Arbitration Association or to pay the arbitrators in accordance with the fee schedules specified in those rules irrespective of any provision of those rules. Judgment on the arbitration award may be entered in any court having jurisdiction. Any dispute involving $_____ [LIMIT OF LOCAL SMALL CLAIMS COURT] or less may be submitted without arbitration to any court having jurisdiction thereof. OR

(2) be adjudicated in [PHOTOGRAPHER'S CITY AND STATE] under the laws of the United States and/or of [STATE].

(3) In the event of a dispute, Client shall pay all court costs, Photographer's reasonable legal fees, and expenses, and legal interest on any award or judgment in favor of Photographer.

[11] Federal Jurisdiction: Client hereby expressly consents to the jurisdiction of the federal courts with respect to claims by Photographer under the Copyright Act of 1976, as amended, including subsidiary and related claims.

[12] Overtime: In the event a shoot extends beyond eight (8) consecutive hours, Photographer may charge for such excess time of assistants and freelance staff at the rate of 1-1/2 times their hourly rates.

[13] Reshoots: Client will be charged 100 percent fee and expenses for any reshoot required by Client. For any reshoot required because of any reason outside the control of Client, specifically including but not limited to acts of God, nature, war, terrorism, civil disturbance or the fault of a third party, Photographer will charge no additional fee, and Client will pay all expenses. If Photographer charges for special contingency insurance and is paid in full for the shoot, Client will not be charged for any expenses covered by insurance. A list of exclusions from such insurance will be provided on request.

[14] Cancellations and postponements. Cancellations: Client is responsible for payment of all expenses incurred up to the time of cancellation, plus 50 percent of Photographer's fee; however, if notice of cancellation is given less than two (2) business days before the shoot date, Client will be charged 100 percent fee. Postponements: Unless otherwise agreed in writing, Client will be charged a 100 percent fee if postponement occurs after photographer has departed for location, and 50 percent fee if postponement occurs before departure to location. Fees for cancellations and postponements will apply irrespective of the reasons for them, specifically including but not limited to weather conditions, acts of war, terrorism, and civil disturbance.

# SCHEDULE OF FEES AND EXPENSES

Client: _____ DATE: _____

Reference # _____

Photography: _____ $___

Preproduction: _____ $___

Travel: _____ $___

Weather delays: _____ $___

Other: _____ $___

Casting:      Fee

             Film                _____

             Casting from files  _____

             _____  _____ $___

Crew:        Assistants          _____

             Home economist    _____

             Prod. coordinator   _____

Stylists:     hair                 _____

             props              _____

             wardrobe         _____

             Trainer/animals    _____

             Welfare/teacher    _____

             _____  _____ $___

Film, Digital
and Lab
Charges:    Editing            _____

             Polaroid          _____

             Prints            _____

             Roll film         _____

             Sheet film       _____

              Digital fees      _____

             Digital media     _____

             _____  _____ $___

Insurance:  Liability          _____

             Photo pac        _____

             Riders/binders    _____

             _____  _____ $___

| Location: | Scout | _____ |
| | Film | _____ |
| | Research | _____ |
| | Location fee | _____ |
| | Permits | _____ |
| | Travel | _____ |
| | _____ | _____ $___ |

| Messenger/ | | |
| Shipping: | Messenger | _____ |
| | Out-of-town | _____ |
| | Trucking | _____ |
| | _____ | _____ $___ |

| Props: | Purchase | _____ |
| | Rental | _____ |
| | Food | _____ |
| | _____ | _____ $___ |

| Rental: | Camera | _____ |
| | Grip truck | _____ |
| | Lenses | _____ |
| | Lighting | _____ |
| | Special effects | _____ |
| | Special equipment | _____ |
| | _____ | _____ $___ |

| Sets: | Carpenter/painter | _____ |
| | Hardware/lumber | _____ |
| | Paint/wallpaper | _____ |
| | Set design/research | _____ |
| | Backgrounds/backdrops | _____ |
| | Studio materials | _____ |
| | Surfaces | _____ |
| | _____ | _____ $___ |

| Studio: | Build days | _____ |
| | Shoot days | _____ |
| | Overtime | _____ |
| | Strike set | _____ |
| | _____ | _____ $___ |

| Travel: | Air fares | _____ | |
| | Excess baggage | _____ | |
| | Cabs | _____ | |
| | Car rental/mileage | _____ | |
| | Truck/car rental | _____ | |
| | Motor home/ | | |
| | dressing room | _____ | |
| | Parking tolls/gas | _____ | |
| | Lodging, per diems (est) | _____ | |
| | Hotel | _____ | |
| | Meals | _____ | |
| | _____ | _____ | $_____ |

| Wardrobe: | Costume design | _____ | |
| | Seamstress | _____ | |
| | Purchase | _____ | |
| | Rental | _____ | |
| | Special make-up/wigs | _____ | |
| | _____ | _____ | $_____ |

| Miscellaneous: | Gratuities | _____ | |
| | Long distance/phone | _____ | |
| | Nonprofessional talent | _____ | |
| | Working meals | _____ | |
| | _____ | _____ | $_____ |

| Model details: | NUMBER | HOURS | TOTAL TIME |
|---|---|---|---|
| Adults | _____ | _____ | _____ |
| Children | _____ | _____ | _____ |
| Extras | _____ | _____ | _____ |

# PRE-DELIVERY CONFIRMATION FACSIMILE

Straight Shooter Studio, Inc.
123 Anystreet
Hometown, ZX 12345
Telephone: 123-555-1212
Fax: 123-555-2121

## PRE-DELIVERY CONFIRMATION FACSIMILE

RETURN VIA FAX TO: 123-555-2121

To: _____     Fax No: _____
_____     Transmission Date: _____
_____     Transmission Time: _____

Thank you for requesting a submission of stock imaging of the following subject(s): _____
_____

    We will prepare and release our submission for your consideration upon receipt of a signed copy of this confirmation of certain terms and conditions precedent to delivery. Your review and acknowledgment will help to avoid misunderstandings. Should you require an explanation of any of these terms and conditions, please call us at the above phone number. After reviewing, please sign the form in the space provided below and fax the signed copy to the return fax number listed above.

[1] "Image(s)" means all viewable renditions furnished by Photographer hereunder, whether captured or stored in photographic, magnetic, optical, or any other medium whatsoever.

[2] After fourteen days, the following holding fees are charged until return: Five Dollars ($5.00) per week per color transparency and One Dollar ($1.00) per week per print.

[3] Submission is for examination only. Images may not be reproduced, copied, scanned, projected, or used in any way or

medium without (a) express written permission on Photographer's invoice stating the rights granted and the terms thereof and (b) full payment of said invoice. The reasonable and stipulated fee for any other use shall be three times Photographer's normal fee for such usage.

[4] Reimbursement by Client for loss or damage of each original photographic transparency or film negative shall be in the amount of One Thousand Five Hundred Dollars ($1,500), or in such other amount as may be set forth next to said item on the attached schedule. Photographer and Client agree that said amount represents the fair and reasonable value of each item, and that Photographer would not sell all rights to such item for less than said amount. Client understands that each original photographic transparency and film negative is unique and does not have an exact duplicate, and may be impossible to replace or re-create.

[5] Additional terms and conditions regarding the use, return, and responsibilities of the parties accompany the images when delivered.

I have reviewed the above terms and conditions and acknowledge my acceptance of them with the understanding that my responsibility for the shipment will begin at the time they are received by me or my company. I also acknowledge that I am authorized to make such a commitment for my company. *I also acknowledge that my acceptance of delivery of any Image created in connection with the above-described request constitutes my acceptance by conduct of the terms and conditions on both sides of the delivery memo that accompanies delivery of the Image, in their entirety, with or without my signature.*

_____  _____  _____, 20 _____
SIGNED          TITLE           DATE

# PRE-DELIVERY CONFIRMATION E-MAIL

To: _____

Subject: Pre-Delivery Confirmation

Thank you for requesting a submission of stock imaging of the following subject(s): _____

   We will prepare and release our submission for your consideration upon receipt of a reply from you in confirmation of certain terms and conditions precedent to delivery. Your review and acknowledgment will help to avoid misunderstandings. Should you require an explanation of any of these terms and conditions, please call us at the phone number below or send us an e-mail reply with your questions. After reviewing the following, please complete the form in the space provided and send it to us as a reply e-mail.

[1] "Image(s)" means all viewable renditions furnished to you by Photographer, whether captured or stored in photographic, magnetic, optical, or any other medium whatsoever.

[2] After fourteen days, the following holding fees are charged until return: Five Dollars ($5.00) per week per transparency, negative and digital file, and One Dollar ($1.00) per week per print.

[3] Submission is for examination only. Images may not be reproduced, copied, scanned, projected, or used in any way or medium without (a) express written permission on Photographer's invoice stating the rights granted and the terms thereof and (b) full payment of said invoice. The reasonable and stipulated fee for any other use shall be three times Photographer's normal fee for such usage.

[4] Reimbursement by you for loss or damage of each original photographic transparency or film negative shall be in the amount of One Thousand Five Hundred Dollars ($1,500), or in

such other amount as may be set forth next to said item on the attached schedule. You agree that said amount represents the fair and reasonable value of each item, and that Photographer would not sell all rights to such item for less than said amount. You understand that each original photographic transparency and film negative is unique and does not have an exact duplicate, and may be impossible to replace or re-create.

[5] Additional terms and conditions regarding the use, return, and responsibilities of the parties accompany the images when delivered.

By placing an X or other mark below next to "I AGREE" below and replying to this message, you acknowledge that you have reviewed the above terms and conditions, and you acknowledge your acceptance of them with the understanding that your responsibility for the shipment will begin at the time they are received by you or your company. You also acknowledge that you are authorized to make such a commitment for your company. *You also acknowledge that your acceptance of delivery of any image created in connection with the above-described request constitutes your acceptance by conduct of the terms and conditions on both sides of the delivery memo that accompanies delivery of the image, in their entirety, with or without your signature.*

Straight Shooter Studio, Inc.
123 Anystreet
Hometown, ZX 12345
Telephone: 123-555-1212
Fax: 123-555-2121
E-mail: owner@straightshooterstudio.com
url: www.straightshooterstudio.com

_____

[ ] I AGREE

Name: _____

Title: _____

# ASSIGNMENT PHOTOGRAPHY DELIVERY MEMO

Straight Shooter Studio, Inc.
123 Anystreet,
Hometown, ZX 12345
Telephone: 123-555-1212
Fax: 123-555-2121

## ASSIGNMENT PHOTOGRAPHY DELIVERY MEMO

Date Assignment to Begin: _____ Reference # _____
Date of Confirmation _____
Client: _____

Assignment Description: _____
_____

Usage Specifications: _____
_____

Estimated Price: FEES _____ EXPENSES _____
TOTAL _____
Note: For details of fee structure and expenses, refer to attached schedule.

Advance Payments: FEES _____ EXPENSES _____
TOTAL _____

## CONDITIONS OF TRANSACTION:

1. The copyright to all Images created or supplied pursuant to this agreement remains the sole and exclusive property of the photographer. There is no assignment of copyright, agreement to do work for hire, or intention of joint copyright expressed or implied hereunder. Conditioned on payment in full, the client is licensed the above usage specifications in accord with the conditions stated

herein. Proper copyright notice, which reads: © 20__ Straight Shooter, must be displayed with the following placement: _____. Notice is not required if placement is not specified. Omission of required notice results in loss to the licensor and will be billed at triple the invoiced fee.

2. Usage specifications above convert to copyright license only upon receipt of full payment.

3. Usage beyond that defined above requires additional written license from the licensor.

4. The license is subject to all terms and conditions on the reverse side hereof.

5. The client's having ordered the performance of any services required to complete the above-described assignment constitutes an acceptance by conduct of the original estimate in its entirety.

---

*Please review the attached schedule of images. Count shall be considered accurate and quality deemed satisfactory for reproduction unless a copy of the schedule with all exceptions duly noted is immediately received by return mail. Your acceptance of this delivery constitutes your acceptance of all terms and conditions on both sides of this memo, whether signed by you or not.*

_____       _____, 20____

Acknowledged and Accepted           Date

# TERMS AND CONDITIONS FOR ASSIGNMENT
# PHOTOGRAPHY DELIVERY MEMO

[1] Definition: "Image(s)" means all visual representations furnished to Client by Photographer, whether captured, delivered, or stored in photographic, magnetic, optical, electronic, or any other media. Unless otherwise specified on the front of this document, Photographer may deliver, and Client agrees to accept, Images encoded in an industry-standard data format that Photographer may select, at a resolution that Photographer determines will be suitable to the subject matter of each Image and the reproduction technology and uses for which the Image is licensed. In addition, each Image will contain or be accompanied by a color profile published by the International Color Consortium or other generally recognized industry group; or if no profile is provided, Client shall assume that a color profile equivalent to Adobe RGB-1998 is intended. It is Client's responsibility to verify that the digital data (including color profile, if provided) are suitable for image reproduction of the expected quality and color accuracy, and that all necessary steps are taken to ensure correct reproduction. If the data are not deemed suitable, Photographer's sole obligation will be to replace or repair the data, but in no event will Photographer be liable for poor reproduction quality, delays, or consequential damages.

[2] Rights: All Images and rights relating to them, including copyright and ownership rights in the media in which the Images are stored, remain the sole and exclusive property of Photographer. Unless otherwise specifically provided elsewhere in this document, any grant of rights is limited to a term of one (1) year from the date hereof and to usage in print (conventional non-electronic and non-digital) media in the territory of the United States. Unless otherwise specifically provided elsewhere in this document, no image licensed for use on a cover of a publication may be used for promotional or advertising purposes without the express permission of Photographer and the payment of additional fees. No rights are transferred to Client unless and until Photographer has received payment in full. The parties agree that any usage of any Image without the prior permission of Photographer will be invoiced at three times Photographer's customary fee for such usage. Client agrees to provide Photographer with three copies of each published use of each Image not later than fifteen (15) days after the date of first publication of each use. If any Image is being published only in

an electronic medium, Client agrees to provide Photographer with an electronic tear sheet, such as a PDF facsimile of the published use of each such photograph, within fifteen (15) days after the date of first publication of each use. Unless otherwise specifically provided elsewhere in this document, all usage rights are limited to print media, and no digital usages of any kind are permitted. This prohibition includes any rights that may be claimed under §201(c) of the Copyright Act of 1976 or any similar provision of any applicable law. Digital files may contain copyright and other information imbedded in the header of the image file or elsewhere; removing and/or altering such information is strictly prohibited and constitutes violation of the Copyright Act.

[3] Return and Removal of Images: Client assumes insurer's liability (a) to indemnify Photographer for loss, damage, or misuse of any Images, and (b) to return all Images prepaid and fully insured, safe and undamaged, by bonded messenger, air freight, or registered mail. Unless the right to archive Images has been specifically granted by Photographer on the front of this document, Client agrees to remove and destroy all digital copies of all Images. All Images shall be returned, and all digital files containing any Images shall be deleted or destroyed, within thirty (30) days after the later of: (1) the final licensed use as provided in this document and, (2) if not used, within thirty (30) days after the date of the expiration of the license. Client assumes full liability for its principals, employees, agents, affiliates, successors, and assigns (including without limitation independent contractors, messengers, and freelance researchers) for any loss, damage, delay in returning or deleting, or misuse of the Images.

[4] Loss or Damage: Reimbursement by Client for loss or damage of each original photographic transparency or film negative ("Original[s]") shall be in the amount of One Thousand Five Hundred Dollars ($1,500), or such other amount if a different amount is set forth next to the lost or damaged item on the reverse side or attached schedule. Reimbursement by Client for loss or damage of each item other than an Original, including digital files, shall be in the amount set forth next to the item on the reverse side or attached schedule. Photographer and Client agree that said amount represents the fair and reasonable value of each item, and that Photographer would not sell all rights to such item for less than said amount. Client understands that each Original is unique and does not have an exact duplicate, and may be impossible to replace or re-create.

Client also understands that its acceptance of the stipulated value of the Images is a material consideration in Photographer's acceptance of the terms and prices in this agreement.

[5] Photo Credit: All published usages of Images will be accompanied by written credit to Photographer or copyright notice as specified on the reverse side unless no placement of a credit or copyright notice is specified. If a credit is required but not actually provided, Client agrees that the amount of the invoiced fee will be subject to a three times multiple as reasonable compensation to Photographer for the lost value of the credit line.

OPTION: [6A] Alterations: Client will not make or permit any alterations, including but not limited to additions, subtractions, or adaptations in respect of the Images, alone or with any other material, including making digital scans unless specifically permitted on the reverse side. OR

[6B] Alterations: Client may not make or permit any alterations, including but not limited to additions, subtractions, or adaptations in respect of the Images, alone or with any other material, including making digital scans unless specifically permitted on the reverse side, except that cropping and alterations of contrast, brightness, and color balance, consistent with reproduction needs may be made. OR

[6C] Alterations: Client may make or permit any alterations, including but not limited to additions, subtractions, or adaptations in respect of the Images alone or with any other material, including making digital scans, subject to the provisions as stated in [7] below.

[7] Indemnification: Client will indemnify and defend Photographer against all claims, liability, damages, costs, and expenses, including reasonable legal fees and expenses, arising out of the creation or any use of any Images or arising out of use of or relating to any materials furnished by Client. Unless delivered to Client by Photographer, no model or property release exists. Photographer's liability for all claims shall not exceed in any event the total amount paid under this invoice.

[8] Assumption of Risk: Client assumes full risk of loss or damage to or arising from the use of all materials furnished by Client and warrants that said materials are adequately insured against such loss, damage, or liability. Client shall indemnify Photographer against all claims, liability, damages, and expenses incurred by Photographer in connection with any claim arising out of use of said material.

[9] Transfer and Assignment: Client may not assign or transfer this agreement or any rights granted under it. This agreement binds Client and inures to the benefit of Photographer, as well as their respective principals, employees, agents, and affiliates, heirs, legal representatives, successors, and assigns. Client and its principals, employees, agents, and affiliates are jointly and severally liable for the performance of all payments and other obligations hereunder. No amendment or waiver of any terms is binding unless set forth in writing and signed by the parties. However, the invoice may reflect, and Client is bound by, Client's oral authorizations for fees or expenses, which could not be confirmed in writing because of insufficient time. This agreement incorporates by reference the Copyright Act of 1976, as amended. It also incorporates by reference those provisions of Article 2 of the Uniform Commercial Code that do not conflict with any specific provisions of this agreement; to the extent that any provision of this agreement may be in direct, indirect, or partial conflict with any provision of the Uniform Commercial Code, the terms of this agreement shall prevail. To the maximum extent permitted by law, the parties intend that this agreement shall not be governed by or subject to the UCITA of any state.

[10] Disputes: Except as provided in [11] below, any dispute regarding this agreement shall, at Photographer's sole discretion, either: (1) be arbitrated in [PHOTOGRAPHER'S CITY AND STATE] under rules of the American Arbitration Association and the laws of [STATE OF ARBITRATION]; provided, however, that the parties are not required to use the services of arbitrators participating in the American Arbitration Association or to pay the arbitrators in accordance with the fee schedules specified in those rules irrespective of any provision of these rules. Judgment on the arbitration award may be entered in any court having jurisdiction. Any dispute involving $____[LIMIT OF LOCAL SMALL CLAIMS COURT] or less may be submitted without arbitration to any court having jurisdiction thereof. OR (2) be adjudicated in [PHOTOGRAPHER'S CITY AND STATE] under the laws of the United States an/or of [STATE]. (3) In the event of a dispute, Client shall pay all court costs, Photographer's reasonable legal fees, and expenses, and legal interest on any award or judgment in favor of Photographer.

[11] Federal Jurisdiction: Client hereby expressly consents to the jurisdiction of the federal courts with respect to claims by Photographer under the Copyright Act of 1976, as amended, including subsidiary and related claims.

# E-MAIL COVER

To:

CC:

Re:

_____

Attached to this cover please find the following:

___ Assignment Estimate
___ Assignment Invoice
___ Stock Estimate
___ Stock Invoice
___ Pre-Delivery Memo
___ Delivery Memo
___ Other

In order for us to proceed with your project in a timely manner and in order to meet your scheduling requirements, we need to request that you review the attached document(s) as quickly as possible. You can indicate your acceptance of the prices quoted, the terms under which we will proceed, and the schedule we anticipate by simply replying to this e-mail with an X or other mark placed next to the "I AGREE" box below. Once we receive your e-mailed agreement, we will begin production.

BY MARKING THE "I AGREE" BOX BELOW AND REPLYING TO THIS E-MAIL, YOU ARE INDICATING YOUR ACCEPTANCE OF ALL TERMS AND CONDITIONS, PRICES, AND SCHEDULES ASSOCIATED WITH THIS PROJECT AND THE ATTACHED PAPERWORK UNDER THE ELECTRONIC SIGNATURES IN GLOBAL COMMERCE ACT OF 2001.

Thank you in advance for your timely reply and please contact us immediately via telephone if you have any questions.

Straight Shooter Studio, Inc.
123 Anystreet
Hometown, ZX 12345
Telephone: 123-555-1212
Fax: 123-555-2121
E-mail: owner@straightshooterstudio.com
url: *www.straightshooterstudio.com*

[ ] I AGREE

Name: _____

Title: _____

# STOCK PHOTOGRAPHY DELIVERY MEMO

Straight Shooter Studio, Inc.
123 Anystreet
Hometown, ZX 12345
Telephone: 123-555-1212
Fax: 123-555-2121

## STOCK PHOTOGRAPHY DELIVERY MEMO

Date shipped: _____ Reference # _____

Return Images by _____

Client: _____

Description of Images: _____

_____

| Orig.(O) Qty. | Dupl.(D) | Media | Photograph Subject/ ID No. | Value (if not $1,500/item) |
|---|---|---|---|---|
| _____ | _____ | _____ | _____ | _____ |

Total Count: _____

_____

Title in the copyright to all Images supplied pursuant to this agreement will remain the sole and exclusive property of the Photographer. There is no assignment of copyright title, agreement to do work for hire, or intention of joint copyright expressed or implied hereunder. No permission to use any of the Images supplied are granted. The client is licensed only by subsequent written license on an invoice and payment in full. Proper copyright notice, which reads: © 20____ Straight Shooter, must be displayed with the following placement: _____. Notice is not required if placement is

not specified. Omission of required notice results in loss to the licensor and will be billed at triple the invoiced fee.

Check count and acknowledge receipt by signing and returning one copy. Count shall be considered accurate and quality deemed satisfactory for reproduction if said copy is not immediately received by return mail with all exceptions duly noted. Photographs must be returned by registered mail, air courier, or other bonded messenger that provides proof of return.

## SUBJECT TO ALL TERMS AND CONDITIONS ABOVE AND ON REVERSE SIDE

_____     _____, 20 _____
Acknowledged and Accepted            Date

(Please sign here)

*Your acceptance of this delivery constitutes your acceptance of all terms and conditions on both sides of this memo, whether signed by you or not.*

# TERMS AND CONDITIONS FOR STOCK PHOTOGRAPHY DELIVERY MEMO

[1] Definition: "Image(s)" means all visual representations furnished to Client by Photographer, whether captured, delivered, or stored in photographic, magnetic, optical, electronic, or any other media. Unless otherwise specified on the front of this document, Photographer may deliver, and Client agrees to accept, Images encoded in an industry-standard data format that Photographer may select, at a resolution that Photographer determines will be suitable to the subject matter of each Image and the reproduction technology and uses for which the Image is licensed. In addition, each Image will contain or be accompanied by a color profile published by the International Color Consortium or other generally recognized industry group; or if no profile is provided, Client shall assume that a color profile equivalent to Adobe RGB-1998 is intended. It is Client's responsibility to verify that the digital data (including color profile, if provided) are suitable for image reproduction of the expected quality and color accuracy, and that all necessary steps are taken to ensure correct reproduction. If the data is not deemed suitable, Photographer's sole obligation will be to replace or repair the data, but in no event will Photographer be liable for poor reproduction quality, delays, or consequential damages.

[2] Rights: Submission is for examination only. All Images and rights relating to them, including copyright and ownership rights in the media in which the Images are stored, remain the sole and exclusive property of Photographer. Unless otherwise specifically provided elsewhere in this document, any grant of rights is limited to a term of one (1) year from the date hereof and to usage in print (conventional non-electronic and non-digital) media in the territory of the United States. Unless otherwise specifically provided elsewhere in this document, no Image licensed for use on a cover of a publication may be used for promotional or advertising purposes without the express permission of Photographer and the payment of additional fees. No rights are transferred to Client unless and until Photographer has received payment in full. The parties agree that any usage of any Image without the prior permission of Photographer will be invoiced at three times Photographer's customary fee for such usage. Client agrees to provide Photographer with three copies of each published use of each Image not later than fifteen (15) days after the date of first publication of each use. If any Image is being published only in an electronic medium, Client agrees

to provide Photographer with an electronic tear sheet, such as a PDF facsimile of the published use of each such photograph, within fifteen (15) days after the date of first publication of each use. Unless otherwise specifically provided in this document, all usage rights are limited to print media, and no digital usages of any kind are permitted. This prohibition includes any rights that may be claimed under §201(c) of the Copyright Act of 1976 or any similar provision of any applicable law. Digital files may contain copyright and other information imbedded in the header of the image file or elsewhere; removing and/or altering such information is strictly prohibited and constitutes violation of the Copyright Act.

[3] Return and Removal of Images: Client assumes insurer's liability (a) to indemnify Photographer for loss, damage, or misuse of any Images, and (b) to return all Images prepaid and fully insured, safe and undamaged, by bonded messenger, air freight, or registered mail. Unless the right to archive Images has been specifically granted by Photographer on the front of this document, Client agrees to remove and destroy all digital copies of all Images. All Images shall be returned, and all digital files containing any Images shall be deleted or destroyed, within thirty (30) days after the later of: (1) the final licensed use as provided in this document and, (2) if not used, within thirty (30) days after the date of the expiration of the license. Client assumes full liability for its principals, employees, agents, affiliates, successors, and assigns (including without limitation independent contractors, messengers, and freelance researchers) for any loss, damage, delay in returning or deleting, or misuse of the Images.

[4] Loss or Damage: Reimbursement by Client for loss or damage of each original photographic transparency or film negative ("Original[s]") shall be in the amount of One Thousand Five Hundred Dollars ($1,500), or such other amount if a different amount is set forth next to the lost or damaged item on the reverse side or attached schedule. Reimbursement by Client for loss or damage of each item other than an Original, including digital files, shall be in the amount set forth next to the item on the reverse side or attached schedule. Photographer and Client agree that said amount represents the fair and reasonable value of each item, and that Photographer would not sell all rights to such item for less than said amount. Client understands that each Original is unique and does not have an exact duplicate, and may be impossible to replace or re-create. Client also understands that its acceptance of the stipulated value of the Images is a material consideration in Photographer's acceptance of the terms and prices in this agreement.

[5] Photo Credit: All published usages of Images will be accompanied by written credit to Photographer or copyright notice as specified on the reverse side unless no placement of a credit or copyright notice is specified. If a credit is required but not actually provided, Client agrees that the amount of the invoiced fee will be subject to a three times multiple as reasonable compensation to Photographer for the lost value of the credit line.

OPTION: [6A] Alterations: Client will not make or permit any alterations, including but not limited to additions, subtractions, or adaptations in respect of the Images, alone or with any other material, including making digital scans unless specifically permitted on the reverse side. OR

[6B] Alterations: Client may not make or permit any alterations, including but not limited to additions, subtractions, or adaptations in respect of the Images, alone or with any other material, including making digital scans unless specifically permitted on the reverse side, except that cropping and alterations of contrast, brightness, and color balance, consistent with reproduction needs may be made. OR

[6C] Alterations: Client may make or permit any alterations, including but not limited to additions, subtractions, or adaptations in respect of the Images alone or with any other material, including making digital scans, subject to the provisions as stated in [7] below.

[7] Indemnification: Client will indemnify and defend Photographer against all claims, liability, damages, costs, and expenses, including reasonable legal fees and expenses, arising out of any use of any Images or arising out of use of or relating to any materials furnished by Client. Unless delivered to Client by Photographer, no model or property release exists. Photographer's liability for all claims shall not exceed in any event the total amount paid under this invoice.

[8] Assumption of Risk: Client assumes full risk of loss or damage to or arising from materials furnished by Client and warrants that said materials are adequately insured against such loss, damage, or liability. Client shall indemnify and defend Photographer against all claims, liability, damages, and expenses incurred by Photographer in connection with any claim arising out of use of said material.

[9] Transfer and Assignment: Client may not assign or transfer this agreement or any rights granted under it. This agreement binds Client and inures to the benefit of Photographer, as well as their respective principals, employees, agents and affiliates, heirs, legal representatives, successors, and assigns. Client and its principals, employees, agents, and affiliates are

jointly and severally liable for the performance of all payments and other obligations hereunder. No amendment or waiver of any terms is binding unless set forth in writing and signed by the parties. However, the invoice may reflect, and Client is bound by, Client's oral authorizations for fees or expenses, which could not be confirmed in writing because of insufficient time. This agreement incorporates by reference the Copyright Act of 1976, as amended. It also incorporates by reference those provisions of Article 2 of the Uniform Commercial Code that do not conflict with any specific provisions of this agreement; to the extent that any provision of this agreement may be in direct, indirect, or partial conflict with any provision of the Uniform Commercial Code, the terms of this agreement shall prevail. To the maximum extent permitted by law, the parties intend that this agreement shall not be governed by or subject to the UCITA of any state.

[10] Disputes: Except as provided in [11] below, any dispute regarding this agreement shall, at Photographer's sole discretion, either: (1) be arbitrated in [PHOTOGRAPHER'S CITY AND STATE] under rules of the American Arbitration Association and the laws of [STATE OF ARBITRATION]; provided, however, that the parties are not required to use the services of arbitrators participating in the American Arbitration Association or to pay the arbitrators in accordance with the fee schedules specified in those rules irrespective of any provision of those rules. Judgment on the arbitration award may be entered in any court having jurisdiction. Any dispute involving $____[LIMIT OF LOCAL SMALL CLAIMS COURT] or less may be submitted without arbitration to any court having jurisdiction thereof. OR (2) be adjudicated in [PHOTOGRAPHER'S CITY AND STATE] under the laws of the United States and/or of [STATE]. (3) In the event of a dispute, Client shall pay all court costs, Photographer's reasonable legal fees, and expenses, and legal interest on any award or judgment in favor of Photographer.

[11] Federal Jurisdiction: Client hereby expressly consents to the jurisdiction of the federal courts with respect to claims by Photographer under the Copyright Act of 1976, as amended, including subsidiary and related claims.

# STOCK PHOTOGRAPHY INVOICE

Straight Shooter Studio, Inc.
123 Anystreet
Hometown, ZX 12345
Telephone: 123-555-1212
Fax: 123-555-2121

## STOCK PHOTOGRAPHY INVOICE

Date of Invoice: _____ Reference # _____

Your P.O.# and Date _____

Client: _____

Description of Images: _____

_____

Usage Specifications: _____

_____

Price:

USE FEES _____       TOTAL PRICE _____

RESEARCH FEE _____       SALES TAX _____

HOLDING FEES _____       TOTAL _____

SHIPPING _____

OTHER _____

PLEASE REMIT $ _____

_____

## CONDITIONS OF TRANSACTION:

1.  The copyright to all images created or supplied pursuant to this
    agreement remain the sole and exclusive property of the

photographer. There is no assignment of copyright, agreement to do work for hire, or intention of joint copyright expressed or implied hereunder. The client is licensed the above usage specifications in accord with the conditions stated herein. Proper copyright notice, which reads: © 20__ Straight Shooter, must be displayed with the following placement: _____.
Notice is not required if placement is not specified. Omission of required notice results in loss to the photographer and will be billed at triple the invoiced fee.

2. Usage specifications above convert to copyright license only upon receipt of full payment.

3. Usage beyond that defined above requires additional written license from the photographer.

4. Invoices are payable on receipt. Unpaid invoices are subject to a re-billing fee of _____.

5. The license is subject to all terms and conditions on the reverse side hereof.

6. *Your acceptance of delivery of any image described above constitutes your acceptance of all terms and conditions on both sides of the delivery memo that accompanied the delivery and of this invoice, in their entirety.*

# TERMS AND CONDITIONS FOR STOCK PHOTOGRAPHY INVOICE

[1] Definitions: "Image(s)" means all visual representations furnished to Client by Photographer, whether captured, delivered, or stored in photographic, magnetic, optical, electronic, or any other media. Unless otherwise specified on the front of this document, Photographer may deliver, and Client agrees to accept, Images encoded in an industry-standard data format that Photographer may select, at a resolution that Photographer determines will be suitable to the subject matter of each Image and the reproduction technology and uses for which the Image is licensed. In addition, each Image will contain or be accompanied by a color profile published by the International Color Consortium or other generally recognized industry group; or if no profile is provided, Client shall assume that a color profile equivalent to Adobe RGB-1998 is intended. It is Client's responsibility to verify that the digital data (including color profile, if provided) is suitable for image reproduction of the expected quality and color accuracy, and that all necessary steps are taken to ensure correct reproduction. If the data is not deemed suitable, Photographer's sole obligation will be to replace or repair the data, but in no event will Photographer be liable for poor reproduction quality, delays, or consequential damages.

[2] Rights: All Images and rights relating to them, including copyright and ownership rights in the media in which the Images are stored, remain the sole and exclusive property of Photographer. Unless otherwise specifically provided elsewhere in this document, any grant of rights is limited to a term of one (1) year from the date hereof and to usage in print (conventional non-electronic and non-digital) media in the territory of the United States. Unless otherwise specifically provided elsewhere in this document, no image licensed for use on a cover of a publication may be used for promotional or advertising purposes without the express permission of Photographer and the payment of additional fees. No rights are transferred to Client unless and until Photographer has received payment in full and has issued a separate license to Client. The parties agree that any usage of any Image without the prior permission of Photographer will be invoiced at three times Photographer's customary fee for such usage. Client agrees to provide Photographer with three copies of each published use of each Image not later than fifteen (15) days after the date of first

publication of each use. If any Image is being published only in an electronic medium, Client agrees to provide Photographer with an electronic tear sheet, such as a PDF facsimile of the published use of each such photograph, within fifteen (15) days after the date of first publication of each use. Unless otherwise specifically provided elsewhere in this agreement, all usage rights are limited to print media, and no digital usages of any kind are permitted. This prohibition includes any rights that may be claimed under §201(c) of the Copyright Act of 1976 or any similar provision of any applicable law. Digital files may contain copyright and other information imbedded in the header of the image file or elsewhere; removing and/or altering such information is strictly prohibited and constitutes violation of the Copyright Act.

[3] Return and Removal of Images: Client assumes insurer's liability (a) to indemnify Photographer for loss, damage, or misuse of any Images, and (b) to return all Images prepaid and fully insured, safe and undamaged, by bonded messenger, air freight, or registered mail. Unless the right to archive Images has been specifically granted by Photographer on the front of this document, Client agrees to remove and destroy all digital copies of all Images. All Images shall be returned, and all digital files containing any Images shall be deleted or destroyed, within thirty (30) days after the later of: (1) the final licensed use as provided in this document and, (2) if not used, within thirty (30) days after the date of the expiration of the license. Client assumes full liability for its principals, employees, agents, affiliates, successors, and assigns (including without limitation independent contractors, messengers, and freelance researchers) for any loss, damage, delay in returning or deleting, or misuse of the Images.

[4] Loss or Damage: Reimbursement by Client for loss or damage of each original photographic transparency or film negative ("Original[s]") shall be in the amount of One Thousand Five Hundred Dollars ($1,500), or such other amount if a different amount is set forth next to the lost or damaged item on the reverse side or attached schedule. Reimbursement by Client for loss or damage of each item other than an Original, including digital files, shall be in the amount set forth next to the item on the reverse side or attached schedule. Photographer and Client agree that said amount represents the fair and reasonable value of each item, and that Photographer would not sell all rights to such item for less than said amount. Client understands that each Original is unique and does not

have an exact duplicate, and may be impossible to replace or re-create. Client also understands that its acceptance of the stipulated value of the Images is a material consideration in Photographer's acceptance of the terms and prices in this agreement.

[5] Photo Credit: All published usages of Images will be accompanied by written credit to Photographer or copyright notice as specified on the reverse side unless no placement of a credit or copyright notice is specified. If a credit is required but not actually provided, Client agrees that the amount of the invoiced fee will be subject to a three times multiple as reasonable compensation to Photographer for the lost value of the credit line.

OPTION: [6A] Alterations: Client will not make or permit any alterations, including but not limited to additions, subtractions, or adaptations in respect of the Images, alone or with any other material, including making digital scans unless specifically permitted on the reverse side. OR

[6B] Alterations: Client may not make or permit any alterations, including but not limited to additions, subtractions, or adaptations in respect of the Images, alone or with any other material, including making digital scans unless specifically permitted on the reverse side, except that cropping, and alterations of contrast, brightness, and color balance, consistent with reproduction needs may be made. OR

[6C] Alterations: Client may make or permit any alterations, including but not limited to additions, subtractions, or adaptations in respect of the Images alone or with any other material, including making digital scans, subject to the provisions as stated in [7] below.

[7] Indemnification: Client will indemnify and defend Photographer against all claims, liability, damages, costs, and expenses, including reasonable legal fees and expenses, arising out of any use of any Images or arising out of use of or relating to any materials furnished by Client. Unless delivered to Client by Photographer, no model or property release exists. Photographer's liability for all claims shall not exceed in any event the total amount paid under this invoice.

[8] Transfer and Assignment: Client may not assign or transfer this agreement or any rights granted under this agreement. This agreement binds Client and inures to the benefit of Photographer as well as their respective principals, employees, agents, and affiliates, heirs, legal representatives,

successors, and assigns. Client and its principals, employees, agents, and affiliates are jointly and severally liable for the performance of all payments and other obligations hereunder. No amendment or waiver of any terms is binding unless set forth in writing and signed by the parties. However, the invoice may reflect, and Client is bound by, Client's oral authorizations for fees or expenses, which could not be confirmed in writing because of insufficient time. This agreement incorporates by reference the Copyright Act of 1976, as amended. It also incorporates by reference those provisions of Article 2 of the Uniform Commercial Code that do not conflict with any specific provisions of this agreement; to the extent that any provision of this agreement may be in direct, indirect, or partial conflict with any provision of the Uniform Commercial Code, the terms of this agreement shall prevail. To the maximum extent permitted by law, the parties intend that this agreement shall not be governed by or subject to the UCITA of any state.

[9] Disputes: Except as provided in [10] below, any dispute regarding this agreement shall, at Photographer's sole discretion, either: (1) be arbitrated in [PHOTOGRAPHER'S CITY AND STATE] under rules of the American Arbitration Association and the laws of [STATE OF ARBITRATION]; provided, however, that the parties are not required to use the services of arbitrators participating in the American Arbitration Association or to pay the arbitrators in accordance with the fee schedules specified in those rules irrespective of any provision of those rules. Judgment on the arbitration award may be entered in any court having jurisdiction. Any dispute involving $____[LIMIT OF LOCAL SMALL CLAIMS COURT] or less may be submitted without arbitration to any court having jurisdiction thereof. OR (2) be adjudicated in [PHOTOGRAPHER'S CITY AND STATE] under the laws of the United State and/or of [STATE]. (3) In the event of a dispute, Client shall pay all court costs, Photographer's reasonable legal fees and expenses, and legal interest on any award or judgment in favor of Photographer.

[10] Federal Jurisdiction: Client hereby expressly consents to the jurisdiction of the federal courts with respect to claims by Photographer under the Copyright Act of 1976, as amended, including subsidiary and related claims.

# LETTER AGREEMENT

Straight Shooter Studio, Inc.
123 Anystreet
Hometown, ZX 12345
Telephone: 123-555-1212
Fax: 123-555-2121

January 1, 20XX
Ms. Jane Smith, Art Buyer
Acme Advertising Agency
456 Your Avenue
Yourtown, WX, 56789
Re: Assignment Confirmation

Dear Jane:

I wanted to send you a brief note to thank you for giving me the assignment to shoot the principal photography in the ad campaign to launch the Delta Motor Company's new Zenith model and to confirm our understanding of the assignment. I cannot adequately express just how excited I am about this project or about the opportunity to work with you. This letter will lay out the basic terms of the job, and the detailed terms and conditions on the enclosed assignment confirmation form will fill in anything that I do not cover here. If you see anything in either document that does not conform to your understanding of our agreement, please let me know immediately.

You have hired me to (*describe the basic assignment—what, where, and when*). The usage of the photographs that I create during this assignment will be (*describe the usages being licensed, including time, extent, media, etc.*). Based on those needs, my fee will be \$XXXX, and I estimate expenses at \$XXXX, subject to the normal variances.

Because I will be incurring substantial transportation and location expenses before the photography can even begin, I will need advanced payment of 50% of my estimated expenses, or $XXX, from your agency before I can begin making arrangements to work on the project. Given your timetable, that means that I will need to receive that payment not later than January XX, 20XX, in order to stay on schedule. So that you can budget appropriately, my policy is to require payment of all fees and the balance of expenses within 15 days of your receipt of my invoice, which will be sent to you after the photography has been completed and delivered.

As I mentioned earlier, this letter outlines just the basics, and the enclosed form fills in the rest of the details. Please review both and let me know as soon as possible if you have any questions or see anything that does not match your understanding of our agreement. I would also appreciate your signing and returning a copy of the enclosed assignment confirmation at your earliest convenience. I will need that, along with the advance partial payment of expenses, before I can begin.

Jane, I know that the work that we do here will be truly great, and I cannot wait to get started! Thank you again for selecting me for this assignment. I am looking forward to what I believe will be just the start of a long and mutually rewarding relationship.

Best regards,

_____

# C H A P T E R  5

# Licensing in the Digital Age

At the advent of the digital age that we all now find ourselves immersed in there was a common belief that digital technology would call for a change in the way photography is licensed. Today we know that it caused little change in licensing practices and agreements except to distinguish between print and digital electronic uses in licensing agreements.

The major difference that digital technology provided was in the tools we have at our disposal to make and to license our photographs. Computer hardware, software programs, imaging technology, the Internet and Worldwide Web, the scanner, and the digital camera have developed to a point where they can contribute great benefit to the licensing process.

Digital technology has brought new ways to capture and process photographs. During those actions you can add information to your digital images. Digital database technology now allows you to store and retrieve that information along with photographs. The ability to link a photograph with technical and copyright information is the most important innovation in licensing since licensing began.

## COMPUTER TECHNOLOGY

Computers and the memory that enables them have become the functional brains of licensing systems. People still provide the creative brains. Whether the computer is sitting on your desktop or traveling in your briefcase, it is your—the licensor's—best friend. You can store copies of licenses and images that are associated with those licenses and connect the two together. You can license images from a hotel room as easily as

from your office. You can send and receive business correspondence, images, licenses, and invoices. You can even receive payments if you have a credit card agreement or are signed up with a credit card processing service.

Since licensing is so much a part of a photographer's life, you ought to have dual capability when it comes to computers. Desktop and laptop computers are only good when they are working properly. Having both not only allows you to take your licensing operation on the road, but it also provides you with a backup when one unit malfunctions. Not being able to license a photograph because your only computer is not working will not impress a client, nor will it help you pay for repairing the malfunctioning unit. We strongly suggest that you have both a desktop and a laptop computer, if you are in the business of licensing your photography and you don't have a staff to man your office when you are gone.

## PHOTOGRAPHY PROCESSING SOFTWARE

There are dozens of software programs that are touted as photographic processing and editing tools on the market today. But, if you are licensing your photography, many of those programs are inadequate for your needs. Whether you are working with scanned film or digital camera images, the software you use to process digital photographs should have the facility to add copyright data to the image file. Many programs allow you to include technical data, which is a good feature, but it has nothing to do with licensing. Whatever program you select, be sure it has the added facility to add IPTC data to the digital image.

IPTC is the acronym for International Press Telecommunications Council, a worldwide consortium of major news media companies. You can learn more about IPTC from its Web site (*www.iptc.org*). But you don't need to know about IPTC to benefit from the use of its standards. Major software manufacturers have incorporated IPTC data fields into their software. For example, Adobe has created a metadata framework called Extensible Metadata Platform—XMP. It is available in Photoshop and other Adobe products. XMP reads data recorded at the time of shooting of digital images. That data is attached to the digital image and stays attached unless you decide to remove it.

Photoshop also provides synchronization between IPTC and XMP data. The combined data elements offer a complete range of information about each image. Since Photoshop has become a standard professional imaging tool many other professional-level software manufacturers are incorporating the IPTC and XMP data features for either compatibility or competitive reasons. You want to be sure that any imaging software you use incorporates IPTC and XMP tables.

## XMP and IPTC Data Tables

The following list describes the categories of information that can be attached to a digital image in a program like Photoshop with XMP. These are only categories. In each category there are numerous fields of information that you can select or deselect.

- File Properties—Description of characteristics of the file, including the size, creation, and modification dates.
- IPTC—*The only editable category* allowing the addition of a caption for your files, as well as copyright information.
- Camera Data (EXIF)—Information including the camera settings that were used when the image was taken as assigned by the camera.
- GPS—Displays navigational information from Global Positioning System–enabled cameras.
- Camera Raw—Displays camera raw file format data.
- Edit History—A log of changes made to images

## Why IPTC?

IPTC data is the only editable data that you can change at will. The list in Figure 4 displays the complete range of information that you can record as IPTC data. Keep in mind that the data fields can be filled out selectively, so fields provided for information about text articles are simply skipped over by photographers.

The Caption field in an IPTC table offers the most space for recording data. With 2,000 characters, you can include a brief caption for the image and detailed license to use the image. In Figure 4, the Copyright and Special Instructions fields are used to alert the image recipient

| IPTC Field | Description | Example | # of Characters |
|---|---|---|---|
| Caption | Information | Sunrise over NYC ............ | 2000 |
| Keywords | Descriptors | NYC skyline | 64 |
| Credit | Photographer | - See Byline - | 32 |
| Copyright | Data | Permission #12587 as in caption | 128 |
| Object Name | Photo ID or name | DSN-235618 | 64 |
| Created Date | Date image taken | March 7, 2006 | 16 |
| City | Name | New York | 32 |
| Province/State | Name | New York | 32 |
| Country | Name | USA | 64 |
| Special Instructions | Directions | Licensed to *XYZ Magazine* Only | 256 |
| Byline | Your credit line | Pat Photographer/www.pp.com | 64 |
| Category | Groupings | Landscapes/Cities | 3 |
| Headline | Text | Not Applicable to Photographs | 256 |
| Source | Location of image | www.pp.com | 32 |

**FIGURE 4**

that the license is limited to a certain user and governed by a license in the caption field. The Caption field might contain information like this:

> Sunrise over New York City from the West bank of the Hudson River
>
> Use of this image is licensed only to *XYZ Magazine* and only for use in its May (year) issue on the magazine's cover. All rights other rights are reserved. Please see the accompanying invoice (insert invoice number) for complete licensing terms and conditions. Do not reproduce this image in any manner unless you are familiar with the complete license.

By using the IPTC tables you can attach information about your license to the photograph. This is no substitute for a separate written license. It is an adjunct to a written license. It lets anyone, other than your client, who might acquire a copy of the digital image know that they have no right to use it. Since most image users are using Photoshop or similar software to process images for publication, your licensing message will appear in the XMP/IPTC

file display when your image is on screen. That won't guarantee that they will look at it, but it will guarantee that you have made every effort to alert anyone who has a copy of the image as to the nature of the rights licensed and to whom. That can be a formidable weapon, if you ever have to take legal action because of an infringement.

## PRICING AND LICENSING SOFTWARE

There are a few companies that specialize in the photographic pricing and licensing software. Some of these programs are geared to stock photography only and others are geared to handle both assignment and stock photography. One advantage of these programs is that you don't have to do much thinking when working with them, but that is also their disadvantage. The approach they take to licensing is based upon the experience of the few people who advise the producers. Maybe those advisors are doing things right and maybe they are not when it comes to licensing terms and conditions. Personally, we believe that you are better off constructing your own very specific license language than using the one-size-fits-all language of mass-produced programs.

You have to ask what the price points for any specific usage are based upon. Is it the experience of the developer? Is it a survey of photographers, and how valid was that survey statistically? Our experience has been that pricing software usually provides fees that are higher than the norm of the trade. That can make them good indicators of starting points for a negotiation, but they are not necessarily going to be accepted by your prospective clients.

If you use such programs be sure to understand how the developer acquired the pricing information, and treat the information accordingly. You ought to compare the prices these programs recommend with other sources of pricing information, like the prices offered on Internet-based stock agencies.

## INTERNET-BASED INFORMATION

The Internet abounds with valuable information for the licensor of stock and assignment images. Photographers' forums, bulletin boards, and listserves offer the opportunity to exchange information with other professionals. You can learn about prospective clients' business habits, exchange price

information, access photography fee calculators, and even find how much the cost of living is escalating so you can adjust your pricing accordingly.

When accessing advice on the Internet you must take pains to be sure that the advice is sound. No one is editing most Internet-based information. Unlike the book publication business where the publisher normally evaluates the expertise of the writer before publishing that writer's work, on the Internet it is possible and not uncommon that the advice you are getting is from a person totally unqualified to give it. Always check the credentials of your sources. You can search them on the Internet to see what they do in the real world. One photographer did that in an effort to check the credentials of another photographer who gave corporate assignment licensing advice. An Internet search led the inquiring photographer to the Web site of the advising photographer. It turned out that the advisor was a very talented wedding photographer, but there was no sign of any corporate photography experience. Obviously, the corporate licensing advice received from the wedding photographer was not relied upon.

## STOCK AGENCIES ONLINE

Many stock agencies operate on the Internet. The larger ones have image search and pricing information online. Two of them, Corbis and Getty Images, are the largest agencies in the world. You can search through thousands of images in their archives. More important, you can price images for many different uses at their sites. Unlike pricing recommendations contained in pricing and licensing software, the online prices are the actual price lists of the companies that display them; that is, they are real prices. As such, these price lists can be more reliable guides than other sources of pricing information.

To access these price lists you will have to register with the site. It is an easy process that immediately allows you to see pricing information. Once you register, you don't have to do it again when accessing the site in the future. The only negative to registering online in order to access this information is that you will soon begin to receive e-mail promotions trying to sell you on the idea of buying image rights from the site's owner. That is not too heavy a price to pay for realistic pricing information.

Another value to stock agency Web sites is the access to the parameters of use that are used to determine the price. These parameters vary from application to application, but within any application the parameters help

define the scope of the license. For example, for use on the world wide Web as part of a corporate promotional Web site, the system will ask you to specify whether the placement of the image is a home page or secondary page. It will also ask for duration of use like one month, three months, etc. It will ask questions about the territory and language of use. Then it will return a price based on those criteria. Those criteria then become part of the license to use the image. A good stock agency Web site is a good place to take a lesson in licensing and pricing.

## FEAR OF DIGITAL

Digital technology creates fear in the hearts of some photographers. The fear is that digital images can be easily copied and used by others. That is true. So what? It was true when the only choice photographers had was film. Anyone with access to a film image could copy and use it just like anyone with access to a digital image can copy it. Nothing has changed except digital image copying is easier than film image copying. What has not changed is the ratio of honest people to dishonest ones. Regardless of what form your image is in, it is only going to be stolen by the dishonest person, and nothing you do will stop him, if he really wants it. The digital age is here. You have two choices: play in the digital game or don't play. So play and have fun.

## PREYING ON FEAR

Seeing a way to make a dollar, a number of technology companies prey on photographers' fears about piracy of their digital images. These companies offer a variety of services and products like image recognition software, watermarking, and Web spider services. We don't think any of them are worthwhile.

Image recognition services make copies of your images and then automatically search the Web for identical copies on Web sites. If the service finds a copy it notifies you so you can take action. The problem is that you have to pay the service per image you have on file with them. That can be quite expensive. Topping it off, we know of no case in which such a service resulted in the conviction of an infringer.

Adobe Photoshop and similar programs allow you to embed an invisible watermark in a digital file. It might be your name or copyright notice.

Using watermark reading technology, you can see the watermark. Without that reading technology no one knows the watermark is there. That means watermarks are not warnings. They are detection devices. The way detection works is this: Companies use things called "spiders" to crawl around the Web looking for watermarked images. Unlike the image-recognition approach, the watermark-seeking spider service does not require a fee per image. Instead, it usually is priced by annual fee. Like the image recognition approach, we know of no case in which such a service resulted in the conviction of an infringer.

Watermarks have a disadvantage. They are adding digital artifacts, often called "noise," into the digital image file. Noise deteriorates image quality. The more data in the watermark, the more noise in the digital image file. Finally, since a watermark is "noise" it can be reduced or eliminated in a program like Photoshop or other programs engineered specifically to eliminate noise.

It is our opinion that the best way to protect your digital images is by attaching the previously mentioned IPTC information. It won't stop a thief, but nothing else will either.

## PHOTOGRAPHY BUSINESS SOFTWARE

There are several companies that sell computer programs designed for the assignment and stock photographer. Some of these programs are modular so you can download nothing but the part of the program that you need, that is, if you only shoot and sell stock, you can just get that part, and likewise for assignments. Programs of this sort are known as vertical software because they are designed for a narrow niche market.

Vertical software can be very expensive for two reasons. One is that there is a small market so the costs of programming, revising, and supporting the software has to be spread out over a small customer base. Another reason is because they, unlike regular office software, are customized for the photography business. Customization always costs more.

There are three things you must be particularly aware of if you intend to purchase vertical software. First, be sure you can modify the terms and conditions of licensing agreement forms built into the system. You may want to modify them from license to license. Second, make sure that you can customize licensing language or write in your own. You don't

want the programmer to describe your licenses. Third, and very important, be sure that the data you put into and store in the program can be exported out of the program and imported into another program in a form that any database can read. You never want to be in a situation where the software provider goes out of business, then your program becomes obsolete, and you cannot use the data you have accumulated over years in a different program. Vertical markets are often fickle. They can reach sales saturation quickly. If that happens, it is possible that the company will have cash flow problems. Cash flow problems are the cause of most business failures.

## OFFICE SOFTWARE SUITES

A number of software companies offer suites of software suitable for the business office. These packages usually include word processing, spreadsheet, drawing, calendar, and contact components. The various components can be integrated to allow the user to add graphics, spreadsheets, and databases in text documents. They also allow the user to mail merge names into letters. In effect they are just like the vertical software that is marketed to photographers for office business management, but they do not have the industry-specific formatting of the vertical software applications.

If you are running a small photography business, you might not need a high-powered software application designed specifically for photographers. For example, if you are doing four assignments per month and ten stock licenses, do you need custom software? Only you can answer that. What we will demonstrate as we go on is how you can use an office software suite to meet your licensing needs. In our case, we are using Microsoft Office, an established product used by many businesses.

## WORD PROCESSOR

The keys to any licensing system are words and pictures. Licenses are expressed in words. A photographic picture is being licensed for use. You can put them together easily in a word processor. For our example we are using MS Word. Let's assume that you have finalized a transaction to license the image shown in Figure 5 to a magazine.

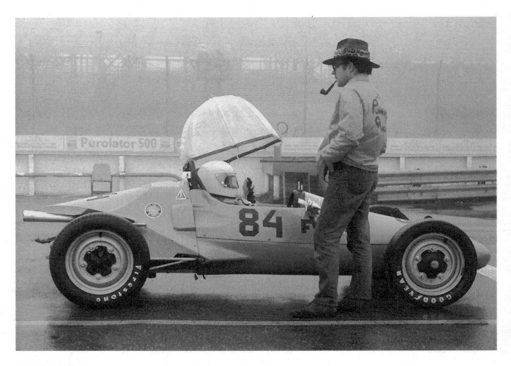

**FIGURE 5**

By including a reproduction of that specific image on the licensing document you eliminate the possibility of future uncertainty over exactly what image you have licensed. Since photographers often have similar images of the subjects they license, and since these similar images often end up in a client's hands, it is beneficial to specifically identify the photograph licensed for the client's use. If you rely on a text-only license for the image in Figure 5, it might describe the image as "Photograph of man holding an umbrella over race car driver." But, if you submitted a dozen shots taken from different angles, the license could be construed to mean any of the photographs or by the most liberal interpretation to mean all of the photographs. Technology allows you to add a copy of your image into the body of license. You ought to do it.

Figure 6 is an example of a license created in minutes in a word processor. The document was created by typing the appropriate information onto a sheet of letterhead and then by inserting a picture and a text block to describe the photograph. The entire process took only a few minutes since the digital image file was in the archive of images in my computer.

# Richard Weisgrau
*Photographer • Writer*

www.rwpwc.com
rw@rwpwc.com

P.O. Box 665, Narberth, PA 19072

## Permission To Use Photograph(s)

Sole ownership of the copyright(s) to the photograph(s) licensed for use by this permission rest with Richard Weisgrau. The copyright(s) have registered with the United States Copyright Office. Accordingly, no additional or other permission(s) to use the photograph(s) can be acquired without a written license from Richard Weisgrau only.

---------------------------------------------------------------------------------------------------------

Date: March 7, 2006                                    Permission #: 12587

Permission granted to: *Rainy Day Magazine*            Attention of: Eddie Editor
                     1234 Umbrella Street,
                     Raintown, Oregon

---------------------------------------------------------------------------------------------------------

Image number: RW675498

Title: Rain Delay

Provided to client as 30mb Tiff file on CD-Rom in Adobe Color Space

## License

Image number RW675498, as shown above, may be used only by *Rainy Day Magazine* for publication as follows: one time, inside use, in a single issue of *Rainy Day Magazine* to be distributed within one year of the date of this license. Publication is limited to the English language edition only and not to exceed a circulation of 55,000 copies. Byline must appear adjacent to photograph and must read: Photo by R. Weisgrau/rwpwc.com.

All other rights are reserved. No oral licenses to use this photograph have been or will be granted. The document expresses the full extent of the license granted. This license is not valid in the event of non-payment of the licensing fee stated on invoice #12587 accompanying this license.

**FIGURE 6**

It would be difficult for any licensor to misunderstand the terms of the license issued in Figure 6. Nor could they mistake which image the license applied to. Accuracy is an asset in licensing. The approach taken in Figure 6 accurately represents the license as issued. It is not arguable. It is impossible to mistake the image or the terms.

You can set up a file of such licenses in your computer by number, by client, by image number. Of course, if you are issuing dozens of such licenses each week, you might be better off with one of those vertical software packages made for photographers.

## SPREADSHEET/DATABASE

A spreadsheet is nothing more than a database that has been formatted for a certain purpose. The information we are offering here applies to either application. We are working with MS Excel to create our example. You could use any spreadsheet or flat database. You could also use any relational database, but those programs often are too difficult for the technologically challenged like us to cope with.

In chapter 1, "Licensing Concept and Reality," we provided a checklist in Figure 2. That list can be adapted for a spreadsheet or database and used in some very helpful ways. Figure 7 shows the list in spreadsheet form with entries in the pertinent fields based upon interviewing a licensee about the use to be made of a photograph.

With the checklist completed you can use it as a guide to write the usage terms in a license. Following the checklist from top to bottom you might construct the language of a license to look like this:

> For reproduction and distribution to commence between 3/7/2006 and 6/7/2006 within North America by Half-Baked Publications. The image may be used in printed and in electronic, digital versions of *Cookie Magazine* and its Web site, limited to the English language editions. The quantity of reproductions is unlimited but ends one year from the date of first distribution. The image may be used on up to one-half of an inside printed page or secondary Web page. The use will be exclusive for the one-year duration of the license with the exception that (your name) may use the image for promotional purposes.

| LICENSING CHECKLIST | | |
|---|---|---|
| Nature of Rights | Reproduction | Y |
| | Derivation | N |
| | Distribution | Y |
| | Performance | N |
| | Public Display | N |
| To be Used | When | within 3 mos. of 3/7/2005 |
| | Where | North America |
| | By Whom | Half-Baked Publications |
| Application | Print | Y |
| | Electronic | Y |
| | Digital | Y |
| | Analog | N |
| | Audio-Visual | N |
| | Copying | N |
| | Display | N |
| | Description | Cookie Magazine & WWW site |
| | Language(s) | English |
| | Geographic Limits | none |
| | Worldwide Rights | Y |
| | Quantity Limit | unlimited |
| | Time Limit | 1 year from date use begins |
| | Size of use | 1/2 page or less in print of Web page |
| | Placement | Inside Print – Secondary page Web site |
| | Exclusivity | One year |
| | Reserved Rights | My own promotion |

**FIGURE 7**

As you can see, each line of the checklist has become a sequential part of the licensing language making the construction of the license easier because of its order and accuracy.

Of course, you could develop such a checklist in a word processor, too, or as a photocopied form. We use the spreadsheet because it offers easily adjustable rows and columns. The completed form can be saved on your hard drive with a name that corresponds to the permission number like the one you can see in Figure 6.

# TRACKING LICENSES AND USES

There is not much reason to license your photography if you are not going to enforce the licenses. Fortunately, most licensees are faithful to the terms of a license. Some are not because they either forget or ignore the terms. Because of the latter group some police work is in order. You ought to check to see if images are still being used after the license to use them expires. For example, if you license a photograph to a Web site for one year, you ought to visit that Web site after the end of that period to see whether the image is still in use. Generally, print uses end with the distribution of a press run, but not always. Advertising uses end with the end of a campaign. Magazines and catalogs are dated. Sometimes brochures and similar materials are reprinted. Sometimes photographs used in one year's annual report are reused in the next year's report.

Getting your name on a client's mail list, subscribing to its publications, watching the trade press, and visiting Web sites are all ways you can police licenses. Most photographers develop an instinct for determining which clients need to be monitored. There are ample opportunities for licensees to make mistakes. You can help them to avoid them.

One way to reduce the amount of monitoring you need to do is to notify a licensee when its license is about to expire. To do that you have to track expiration dates. An easy way to do that is to set up a separate calendar in your office software. You enter the permission number in the calendar on the date that the license is set to expire. Each month you check the next month for expiration dates. Then you send a notice alerting the licensee to the approaching expiration date, and inviting them to obtain a new license, if they wish to use the photograph beyond the expiration date. If you used a license like that in Figure 6, the licensee will have no trouble either identifying the image or understanding the limits of the license. You can send the notification by e-mail with the license as an attachment. If you have created the license in MS Word, almost any business will be able to open it. You can also convert word processing documents to Adobe PDF files to attach to e-mail. Anyone can get a free copy of Adobe PDF Reader, and just about everyone who uses the Internet has done so.

A simple way to create a notification form is to modify the permission form that you use. Figure 8 is an example. If you compare it to Figure 6, the Permission form, you will see that the first part of the form has been modified to make it a reminder. It is so simple to do in a word processor that there is no excuse for not doing it.

# Richard Weisgrau

*Photographer • Writer*

www.rwpwc.com
rw@rwpwc.com

P.O. Box 665, Narberth, PA 19072

## Notice Of Expiring License

PLEASE NOTE: The license depicted below is approaching its expiration date at which time the use of the image for the licensed purpose must stop. If you have a need to continue the use of the image, you can obtain an extension to or renewal of the original license by contacting Richard Weisgrau. Please be sure to alert all parties responsible for copyright compliance about the approaching expiration date for this license.

---

Date: March 7, 2006                          Permission #: 12587

Permission granted to: *Rainy Day Magazine*          Attention of: Eddie Editor
                         1234 Umbrella Street,
                         Raintown, Oregon

---

Image number: RW675498

Title: Rain Delay

Provided to client as 30mb Tiff file on CD-Rom in Adobe Color Space

## License

Image number RW675498, as shown above, may be used only by *Rainy Day Magazine* for publication as follows: one time, inside use, in a single issue of *Rainy Day Magazine* to be distributed within one year of the date of this license. Publication is limited to the English language edition only and not to exceed a circulation of 55,000 copies. Byline must appear adjacent to photograph and must read: Photo by R.Weisgrau/rwpwc.com.

    All other rights are reserved. No oral licenses to use this photograph have been or will be granted. The document expresses the full extent of the license granted. This license is not valid in the event of non-payment of the licensing fee stated on invoice #12587 accompanying this license.

**FIGURE 8**

By notifying the licensee that its license is about to expire you guarantee to the fullest extent possible that any use beyond the license date will be provable as "willful." And willful infringements are eligible for the maximum statutory damages under the law, which, at the time of this writing, is $150,000 per infringement. To be eligible for statutory damages you will have to register your photographs with the copyright office. Chapter 2, "Understanding Copyright," discusses registration of photographs.

Good licensing combined with copyright registration provides photographers with the most effective enforcement tools available.

## EFFECTIVE ENFORCEMENT

Digital technology makes copyright enforcement easier. In addition to the tools previously cited as example of uses of digital technology, the registration of photographs with the copyright office is made much easier by it. Thousands of images can be registered with the Copyright Office on a single CD-Rom using a single registration form and paying a single registration fee, which at the time of this writing is $30.

Both unpublished and published images can be registered in groups. There are no time period limitations on the registration of groups of unpublished images. Groups of published images are limited to images published within any one calendar year. Each year requires a separate registration application and fee.

The issue for most photographers is whether to register unpublished or published images. For photographers shooting on film, the registration of vast numbers of unpublished images presents a challenge because a copy of each image must be filed with the registration application. Scanning takes time. Contact sheets are expensive. Making color photocopies of transparencies requires special gear and is also expensive. Film shooters are often better off just registering their published photographs. We'll explain that process a bit further on.

The digital photographer has a distinct advantage when it comes to registering unpublished images. All he has to do is set up his editing software to export small file-size jpegs of the images to a CD-Rom. Then that disk is sent to the Copyright Office with the registration application.

Since a photographer's published images are more likely to be infringed than his unpublished images, it makes sense to register published images as a group. The U.S. Copyright Office has published regulations governing

registration of photographs. Those regulations along with all copyright regulations can be found at the Copyright Office Web site (*www.copyright.gov*). Since registering published works is likely to be an acceptable means of registration for most photographers, we have included a copy of those regulations here. These regulations can be found in Copyright Office Circular FL124.

### Group Registration of Published Images

A group of published photographs may be registered on a single form with a single fee if all the following conditions are met:

❶ All the photographs are by the same photographer. If an employer for hire is named as author, only one photographer's work may be included.

❷ All the photographs are published within the same calendar year.

❸ All the photographs have the same copyright claimant(s).

To apply for registration, send the following material in the same envelope or package to the Library of Congress, Copyright Office, 101 Independence Avenue, S.E., Washington, D.C. 20559-6000:

❶ A correctly completed application Form VA or Short Form VA. Follow the instructions for completing Form VA as provided on the Form GR/PPh/ CON.

❷ A completed Form GR/PPh/ CON. You must normally use this form if the date of publication is not identified on each of the deposited images. However, use of this form is optional if the images you are registering were all published within the three-month period immediately prior to the date of receipt of your application, or if each of the deposited images published within a calendar year contains a specific date of publication. We strongly encourage its use, as doing so creates a more complete record. Photocopies of this form are acceptable, but both sides must be duplicated.

❸ A $30[*] nonrefundable filing fee for each VA application.

❹ A non-returnable deposit of the work to be registered.

---

* Copyright registration fees are subject to change. Be sure to periodically check the U.S. Copyright Office Web site for any changes.

You must deposit a copy of all photographs included in the group for which registration is sought. Only the photographs being registered as part of the group should be included. Submit the photos in one of the flexible formats listed on the instruction for Form GR/PPh/CON.

**Tips on Form GR/PPh/CON**
Form GR/PPh/CON is nothing more than an extension of Form VA that is normally used to register photographs. Because of the liberal quantities of photographs that can be registered in a group of published images, the Copyright Office created a new form to facilitate listing them. But this form contains some very helpful information that you ought to have as part of your understanding of the process. It is information that is not on Form VA and that is very specific to registering published photographs. The most pertinent information from the Form GR/PPh/Con follows:

**When does a group of photographs qualify for a single registration using Form GR/PPh/CON?** For published photographs, a single group copyright registration can be made if all the following conditions are met:

❶ All the photographs are by the same author, who may be an individual or an employer for hire

❷ All the photographs are published in the same calendar year

❸ All the photographs have the same copyright claimant(s)

**When to use this form**: You may use Form GR/PPh/CON to list title and publication date information to supplement Form VA for a group of published photographs that qualify for a single registration under Section 202.3 of the Copyright Office regulations. Use of Form GR/PPh/CON is optional.

**The advantage of group registration**: Any number of photographs published within a calendar year may be registered "on the basis of a single deposit, application, and registration fee."

**Cautions about group registration**: If infringement of a published work begins before the work has been registered, the copyright owner can obtain the ordinary remedies for copyright infringement (including injunctions, actual damages

and profits, and impounding and disposition of infringing articles). However, the owner cannot obtain special remedies (statutory damages and attorney's fees) unless registration was made before the infringement commenced or within three months after first publication of the work. To be certain that your application, deposit, and fee are received in the Copyright Office within three months of publication of the earliest published photograph within the group, you may wish to register fewer than three months of published photographs on a single application.

## This Form GR/PPh/CON:

- May only be submitted together with a Form VA.
- Must list a group of works that qualifies for a single copyright registration.

## Procedures for Group Registration of Photographs

❶ You must file a basic application on Form VA that contains information required for copyright registration.

❷ Use of Form GR/PPh/CON together with Form VA is optional, but encouraged. Form GR/PPh/CON provides separate identification for each photograph and gives information about the first publication of each as required by the regulation.

**What Copies Should Be Deposited for a Group Registration of Photographs?** You must deposit a copy of each photograph included in the group for which registration is sought. One copy of each photograph should be submitted in one of the following formats. The formats are listed in the Library of Congress's order of preference:

- Digital form on one or more CD-ROMs including CD-RWs and DVD-ROMs, in one of these formats: JPEG, GIF, TIFF, or PCD
- Unmounted prints at least 3" × 3" in size, but no larger than 20" × 24"
- Contact sheets
- Slides, each with a single image

- A format in which the photograph has been published; for example, clippings from newspapers or magazines
- A photocopy of each photograph, which must be either a photocopy of an unmounted print at least 3" × 3" in size, but no larger than 20" × 24", or a photocopy of the photograph in its published format. It must be a color photocopy if the photograph was published in color.
- Slides, each containing up to 36 images
- A videotape clearly depicting each photograph

**Note**: For a photograph published before March 1, 1989, the copy of the photograph must be one that shows the photograph as it was first published. The copy of the photograph must show the copyright notice, if any, that appeared on, or in connection with, the photographic work. This is necessary because the copyright law in effect from January 1, 1978, through February 28, 1989, required that a work be published with a copyright notice identifying the owner of the copyright and the year date of first publication of the work. (For more information on copyright notice, consult Circular 3) The deposit copy for a photograph published prior to March 1, 1989, may be any of the above listed formats as long as the format deposited faithfully reproduces the photograph in its exact, first-publication appearance.

As you can see, the opportunity to register your published work has never been better than it is now. While it may seem cumbersome, remember that prior to the enactment of this regulation, each published photograph had to be registered individually with a separate $30 fee. The deposit had to be two copies of the work as published, meaning copies of the images in the publication. The previous fee requirement, the difficulty of getting copies "as published," and the paperwork load filling out many, many forms kept photographers from registering. That meant that photographers had little access to the full range of protection under the law. We, the authors of this book, lobbied the Copyright Office and worked with it for almost a decade to get the regulation enacted. We urge you to gain its benefit by registering your photography periodically with the copyright office.

## DOUBLE EDGE

If you take the pains to issue accurate and thorough licenses, to attach copy-right information to your images, to alert licensees that licenses are near expiration, and to register your photographs in a timely fashion, you will have the upper hand if and when your copyright rights are infringed. You will most likely be able to prove that the infringement was willful. That will make you eligible to receive the maximum in statutory damages and to receive legal costs of enforcing your rights.

The digital age has heightened the level of threat to photographers' copyright rights, but it has also increased the ways in which you can protect and enforce your rights. Whenever you have to handle a double-edged sword, make sure the edge closest to the offender is the sharpest one. Effective licensing practices and copyright registration will provide you with that sharper edge.

# C H A P T E R    6

## *Pricing Licenses*

*T*he value of the use of a photograph ultimately is a decision of the buyer. The licensee might set a price, but the licensor sets the value. The value and the price are equal when the buyer agrees to purchase.

Arriving at the proper price for a license is both art and science. Assignment photography pricing includes some amount for the license of rights in addition to the cost of production. But how much of the assignment price is for the actual usage? There is no standard way to determine the price of usage for assignment photography. Therein lies the "art" of pricing. On the other hand, the stock photography business has a system for pricing licenses based upon established criteria. Therein lies the science. The photographer who licenses his work has to be both pricing artist and scientist.

In this chapter we are going to explore pricing licenses for both assignment and stock photography. Because stock photography is the most systematized of the two, we will examine it first. That knowledge will help you understand the factors that have to go into developing prices for assignment photography licenses.

## STOCK MEANS RESIDUALS

In the world of creative communications the word "residual" refers to payments for things like reruns of films for which the actors get payments, republication of article for which writers receive payments, and reuse of images for which photographers, illustrators, and other artists receive payment. If a photograph is used after its initial use, and not necessarily by the same user who used it previously, it is a reuse. Once a photograph has seen its first use, all subsequent uses are licensed from the residual rights remaining; that is, rights that are not restricted by the initial license. These

residual rights generate residual payments for photographers. But how does one determine what those payments should be? That information is in books, in computer programs, and online at stock agency Web sites. Those stock agency Web sites that display pricing information offer the best education about pricing licenses. They are an indicator of what kind of residuals you ought to be getting for licensing your residual rights. You want to visit those sites periodically to keep informed about current pricing trends and changes.

## STOCK PRICING COMPONENTS

In chapter 1, "Licensing Concept and Reality," you learned about the various control factors available to you when you license. You will remember the circumstantial questions and the checklists. Now let's look at how those factors are used at many stock photography agencies' Web sites.

Generally, agency Web sites allow you to select a photograph that you might want to license, and when you ask for the price you are asked a series of questions. Here's an example of some of the questions that might appear at a typical site.

- How will the image be used?
- What will be the specific application?
- What will be the size of the image relative to the whole page?
- Where will the image be reproduced?
- What will be the print run?
- What will be the circulation?
- What geographic territories will be covered?
- What will be the language of publication?
- What will be the starting date of use?
- What will be the duration of use?

The first few questions will determine what subsequent questions should be asked. The questions for a Web use are different than those for a magazine use. Here is an example of a Web use researched at an online stock agency Web site including answers.

- How will the image be used? Advertising—Print/Web
- What will be the specific application? Corporate or Promotional Web site
- Where will the image be reproduced? Home Page

- What geographic territories will be covered? United States
- What will be the starting date of use? March 22, 20XX
- What will be the duration of use? One month

Based upon the answers given, the system returns a licensing fee of $315. If you change the duration of use to six months, the fee changes to $680. If you change by specifying a secondary page location, the fee changes to $220 for one month. Each time you change the answers, the fee quotation changes based upon the criteria you entered.

If you price an application like an annual report, the system will ask appropriate questions adding things to the above list. Effectively, the system's owner has programmed a checklist into the system to create a semi-automatic pricing system. It is these kinds of systems that make pricing licenses for stock photography relatively easy.

## EXCEPTIONS TO THE RULE

Even the best systems have flaws. There are times when stock pricing systems fall short of the mark. You will have to be observant and contemplative to find them so you don't sell your stock at bargain prices or at prices that are unrealistic for the buyer. Two different stock usage scenarios are described below. As you read them you will see that, operating by the rules, one photograph is clearly worth more than the other. After you read subsequent paragraphs, you will understand how the system can lead you astray.

### Scenario One

The buyer represents an international credit card company. It wants to license a copy of an image of a typical businessman checking in at a hotel registration desk. The image will be used on the front panel of a tri-folded 8.5 × 11 paper brochure containing a credit card application. The image will cover most of the front panel. The press run will be five million copies to be distributed in five languages worldwide. Considering the stock pricing factors this sale should warrant high price. You quote a price of $5,000.

### Scenario Two

You get a call from a manufacturer of a particular-type valve used in submarines to control the submarine dive rate. You have photographed that part of a submarine's control panel for the Navy, and because it is an

unusual shot you placed it on your Web site. In this case the picture is going to be used in a five-color, slick, 8 × 8 brochure, as a full page on the cover. Then you learn that the press run will be 100 copies because there are only a half dozen companies worldwide that manufacture submarines because few navies have them or can afford them. They are printing 100 copies since they want a two-year supply that will be sent to all the higher-up engineers and designers in the six companies. With such a small press run the price appears to be miniscule compared to the credit card sale. You quote a price of $500, double the price recommended in pricing software because you have one of the few pictures of that valve, so you know you have little competition.

## The Surprise

The credit card company refuses your price and licenses from another very savvy photographer for $2,000. The valve company takes your offer without hesitation, making you think they perceive they got a bargain. What happened?

You did not consider the real value of the images to the buyers. The credit card company was creating a throwaway pamphlet, used in counter displays. People pick them up and throw them away a day later, or use them to write phone messages on. Maybe 1 percent of them get sent in as applications for a card. The application is not worth a lot of money. It never convinces anyone to apply for a card. While it contributes to brand recognition, it does not have the impact of other means of advertising. Why would they spend a lot of money for that kind of end use? There is no good reason to do it.

On the other hand, the valve company's brochure is the only way it can show its product to the engineers and designers. The valve is a most critical piece of hardware because if it malfunctions the sub might dive below the crush depth. Your photo is proof of the fact that the U.S. Navy uses it, and that visual endorsement is as good as a written one. Your picture is a main element in their sales effort. Without it, the valve company might not convince anyone to buy their product over another manufacturer's. On top of that, you forgot to research how much each valve costs. If you had, you would have realized that anyone selling a single valve with a price tag of $210,000 must have a very unique and important product.

If you had priced the credit card sale at $2,000 and the valve sale at $5,000, you would have made both sales. There are exceptions to every rule. You just have to look hard for them, and doing so can put extra money in your bank account.

# FIND THE EXCEPTIONS

Most stock sales are routine, but as the example above indicates, some can be exceptional because the pricing doesn't conform to the traditional rationale of stock photography pricing. You have to be on the lookout for these exceptions to the rule. When considering pricing stock you should take time to ask questions about the end user and use. Then you should reflect on the answers. If you have time or can postpone giving an immediate price, take time to look up the end user on the Internet. Get a feel for what they do and how big the company is. Try to get a fix on the size and nature of its customer base for the specific product line the stock photograph will be used to promote. There is a relationship between the size of a company and the size and nature of its customer base. There is no hard and fast rule for determining the pricing levels for the differences in the relationship between size of company and size of customer base. However when you reflect on the information, you might see a level of dependency on successful promotion of a single service or product. Just like the example of the valve manufacturer above, some small companies will pay dearly for the right image because part of their future is riding on the success of the promotion containing that image.

# VALUE VERSUS PRICE

Stock photography licensing systems are not intended to license the unusual or unique photograph. Those systems cannot consider what value-added features might be in a photograph. When you license photography, you can make that determination by understanding the licensee's needs and finding out why they are particularly attracted to your photograph. Here is a case in point.

The photograph in Figure 9 was licensed for a handsome figure to a consulting firm for use in a printed brochure and a version of that brochure that was downloadable from the licensee's Web site. When approached to license the image I asked all the routine questions on my licensing checklist. But I did not stop there. I also asked what concept they were trying to convey with the image. They replied that they were trying to express the idea of "light at the end of the tunnel." That answer told me I had an image that had added value to this prospective licensee. Think about it. Most pictures that show light at the end of a tunnel are nothing more than a lot of black surrounding a light shape of some sort. That's not very aesthetic. My image, on

© Richard Weisgrau 2005

**FIGURE 9**

the other hand, drew the eye into it until the viewer saw the light at the end of the passageway. It had an aesthetic quality that warranted a premium price. I also knew that they were unlikely to find an image that could compete with mine. I tripled my normal fee for openers. When the prospect protested that my price was much higher than those of stock agencies I replied that was because my photograph was much better at expressing their message than the photographs at the stock agencies.

The prospect licensed my photograph in spite of its higher price because it had added value for him. As I wrote in the opening paragraph of this chapter: "The value of the use of a photograph ultimately is a decision of the buyer. The licensee might set a price but the licensor sets the value. The value and the price are the same when the buyer agrees to purchase." Checklists are good tools for pricing, but never forget that the value of a photograph will vary depending upon the user, the user's needs, and the degree to which your image fulfills the user's creative concept.

## EXCLUSIVE OR NON-EXCLUSIVE

An important point to keep in mind about determining the price of a license to use a stock photograph is whether the licensee wants any exclusive rights. Generally, stock photography licenses are not exclusive in any way. That gives the licensor a greater opportunity to license the use of an image. But sometimes licensees want some level of exclusivity to assure that the images they are licensing will not appear in competitive applications. Sometimes licensees will want total exclusivity for a period of time so that the images licensed will appear to be solely theirs and not appear anywhere while they are using them to avoid confusion on the part of viewers.

There is a simple rule when it comes to licensing any level of exclusive rights. The value and the price go up as the level of exclusivity increases. Later in this chapter we will present a system for determining just how much the price ought to go up.

You must keep in mind that online stock photography pricing systems present prices for non-exclusive use of photographs. Anyone seeking exclusive use has to contact the agency and negotiate a price. You can be sure that the negotiated price for any level of exclusive rights will be higher than the price published on the Internet.

## STOCK PRICE LIST OR PRICING SYSTEM?

Some photographers work like stock agencies when it comes to pricing. They have a price list that covers all the basic rights that can be licensed. The list can be referred to upon any inquiry about a price for a specific use. Other photographers use stock photography pricing software. We discussed those types of programs in chapter 5, "Licensing in the Digital Age." You might want to reread that section because pricing software does not always reflect the real prices that are prevalent in the marketplace. If you purchase pricing software, you ought to compare its recommendations with the prices of your competitors, those stock agencies with online pricing apparatus. If you find the results to be dissimilar, you will know how to adjust your software's recommendation to meet the competition's prices.

Another way to quickly develop a pricing system, so you can calculate prices as the need arises and not spend the many hours needed to do it in advance, is by making your own price list. We assume you have a computer if you are in business or going into business today. We also

assume that you have a spreadsheet program in that computer. With those two tools, you can develop your own pricing system.

## DEVELOPING A PRICING SYSTEM

Developing a pricing system is simply a mathematical process based upon formulas that you can create or borrow from this book. Before we go into the process we want to urge you to do due diligence if you create your own pricing system. Test it before you use it. Compare its results with your online competitors. Adjust your results to be competitive. That kind of adjustment won't be difficult because your system should work by multiplying base prices by a variety of factors. You can change any calculated price category by changing its factor, or you can change all the prices by changing the base price.

Most photographers who license stock are aimed at supplying a particular segment of the market. Some supply content for editorial applications like newspapers and magazines. Others supply content for promotional content like brochures, advertisements, etc. Your price list ought to be limited to what you sell. There is no need to have ready pricing for something that you will rarely deal with. If you receive such an inquiry, you can always call the person back, using the interim time to look up similar pricing on the Internet. So, if you rarely get model releases from people in your photographs, you don't need to have promotional pricing at hand since your work is legally limited to editorial uses. Remember, it is always easier to gather information as you need it, rather than try to gather all the information you might ever need before you need it.

## DETERMINING A BASE PRICE AND FACTORS

The base price is the foundation of your system so it is important that it be carefully considered. It should also be a price for a low-level use. If you use a high-level use as a base you have to divide to get lower prices. (It always seems easy to multiply rather than divide.)

As an example, we will use editorial uses in print media. The chart in Figure 10 is a simple mathematical grid for establishing a pricing spreadsheet based upon a base figure. Undoubtedly, you will wonder how the factors were established. It was a simple but time-consuming operation. We researched the pricing of several online stock photography agencies. We found them to be similar, not identical. We averaged out the similarities and made a price sheet based upon those averages. Then we analyzed the

| Use: Editorial Magazine | | Inside | Weekly Publication | |
|---|---|---|---|---|
| Size of use → | _ page | _ page | full page | double page |
| Circulation ↓ | | | | |
| | Factor × Base ↓ | 1.1 × _ page ↓ | 1.5 × _ page ↓ | 2.0 × _ page ↓ |
| 10,000 | Base × 1 | | | |
| 25,000 | 1.03 | | | |
| 50,000 | 1.05 | | | |
| 100,000 | 1.15 | | | |
| 250,000 | 1.25 | | | |
| 500,000 | 1.35 | | | |
| 1,000,000 | 1.55 | | | |
| 2,000,000 | 1.65 | | | |
| 5,000,000 | 1.70 | | | |
| > 5,000,000 | 2.00 | | | |

**FIGURE 10**

percentage of difference between the rows and columns. Here's what we came up with for pricing a non-exclusive license to publish one photograph in one issue of a weekly magazine.

As you can see in Figure 10 the base price determines all other prices in the chart. But where do you get the base price? There are several ways you might do it, but we believe the best way is to look up several online stock agency price lists and come up with an average of their prices for their lowest categories to use as your base price.

We looked up the price for a one-quarter page or less use in a weekly magazine at several sites. The average came to $250. In Figure 11 we have inserted the $250 in the "Base × 1" cell and then applied the various factors to calculate up the prices in the grid. We rounded off all figures to the nearest dollar. You can set up a spreadsheet to do this for you, and the calculations will be instantaneous.

Once you have the grid set up in a spreadsheet with the appropriate formulas, you can insert any number into the "Base × 1" cell and it will automatically calculate the grid. Then you can look up the base price for a monthly or a quarterly magazine and get a new set of prices. You can also look up the price for newspaper use and insert that figure. This system works because the underlying pricing structure of each of those

| Use: Editorial Magazine | | Inside | Weekly Publication | |
| --- | --- | --- | --- | --- |
| Size of use → | _ page | _ page | full page | double page |
| Circulation ↓ | | | | |
| 10,000 | 250 | 275 | 375 | 500 |
| 25,000 | 258 | 283 | 387 | 515 |
| 50,000 | 264 | 290 | 396 | 527 |
| 100,000 | 288 | 317 | 432 | 575 |
| 250,000 | 313 | 344 | 470 | 625 |
| 500,000 | 338 | 372 | 507 | 675 |
| 1,000,000 | 388 | 427 | 582 | 775 |
| 2,000,000 | 413 | 454 | 620 | 825 |
| 5,000,000 | 425 | 468 | 638 | 850 |
| > 5,000,000 | 500 | 550 | 750 | 1,000 |

**FIGURE 11**

applications is similar enough to average. The price in dollars may vary from application to application, but the prices within applications have the same percentage relationships from application to application.

You can do this for editorial applications or promotional applications. Of course you have to research the relationship between the various price levels. The process takes time initially, but it saves countless hours later in addition to making you prepared to quote prices for the type of rights you license without delay. You can also skew your prices to be higher or lower than the average depending upon how your photographs stack up against other collections. If you get a call for some level of exclusive rights, you can multiply the base number by a factor to provide the extra compensation for the exclusive. In Figure 11 we use a "Base × 1" figure of $250. Suppose someone wanted the rights exclusively for six months. You might simply use a factor of two, changing the "Base × 1" cell to $500 and all the prices change accordingly.

If licensing stock is a big or growing part of your business, you ought to have an automated pricing system. If you don't, you will find yourself constantly checking Web sites, referring to pricing software or publications, or just guessing. Your business ought to be based upon your prices. You arrive at your prices by doing research and formulating your own prices based

upon that research. We gave you an example of how to do that, but the hard work is up to you. Remember, hard work pays off in the end.

## ASSIGNMENT LICENSING

As you read above, the stock photography licensing is formulaic, logical, and systematic. Assignment licensing is none of those things. Instead, it is an adventure in guesswork and speculation. There simply are no rules, no systems, and no formulas established as industry practice. The reason that assignment licensing is that way is simple. An assignment fee involves more than the cost of the rights to use the image. An assignment fee includes the production and creative costs of making the photographs to be licensed. A look back at history will help you understand how this state of affairs developed.

## THE 1909 COPYRIGHT LAW

Prior to January 1, 1978, the Copyright Law of 1909 governed all copyright transactions. Unlike today's law, under the prior law the party that commissioned an assignment owned the copyright to the photographs produced by the photographer. That meant that the photographer had no rights to license. Photographers sold services, not rights. The fees for those services were determined on a time and materials basis. The more talented photographers could get higher service fees than the less talented.

Most photographers charged by the day, the hour, or the shot. The time-based charges included all the photographer's indirect costs in addition to the cost of his labor. Expenses like film, processing, assistants, models, location fees, travel costs, etc., were billed in addition to the service fee. Those expenses, called billable expenses, were related to a specific job, unlike indirect expenses like rent, insurance, etc. The photographer invoiced for fees and billable expenses, and the client owned the copyright to the work produced.

In those days the stock photography business was a back store operation in which a few photographers and a few agents sold outtakes from assignments for additional use. Of course that happened only when the commissioning party agreed to return some of the rights to the photographer. Oddly enough, that happened quite often. If it had not, it is unlikely that the stock photography business would exist in the size and scope it does today. The consciousness-raising effect on the value of copyright rights was not experienced until the mid 1970's. That is when some photographers

began to independently produce stock photographs so that they would have the rights to license it.

On January 1, 1978, the current copyright law went into force. It contained one dramatic change for photographers. The photographer became the owner of the copyright to anything and everything he shot unless he was an employee of the commissioning party, or unless he executed either a transfer of the copyright or a work for hire agreement with the commissioning party. Chapter 2, "Understanding Copyright," explains those terms.

That change would have been a perfect opportunity for photographers to establish a system for licensing the rights to assignment photographs because they then owned rights to license. Needless to say, that did not happen. No one knew the value of rights then. Photographers were busy doing what they loved to do, shooting photographs. Photography was not the big business it has become. The opportunity to create a paradigm shift in the way photography was priced was lost due to pure ignorance, lack of foresight, and a preference to make a living today and not worry about tomorrow. If that last sentence sounds to you to be a bit like the photography business of today, you are correct.

## EVOLUTION OF ASSIGNMENT PRICING

Regardless of how we got here, the basis of assignments pricing is time, materials, and direct and indirect costs. Skill and creativity separate photographers into classes with the upper classes being paid more than the lower. But photographers have become aware of the value of the images they produce to the people who use them. And while there is no system for determining that value, it is generally understood that the same factors that influence the pricing of stock photography are at play in the licensing of assignment photography. The more exposure the images produced on assignment will get, the more valuable they should be.

As that recognition has occurred, photographers have been trying to evolve some means of pegging assignment compensation to use. Many photographers base their fees on the level of use assignment images will receive. But fees have to be negotiated before the assignment begins so that level of use is a moving target because clients often expand or contract use after the images have been created. So photographers have a quandary when it

comes to pricing assignments because if the usage is not clear, the value of the rights is not clear. To the degree that those things are clear, there is no industry agreement on how to assign that value. The pricing of assignments is evolving to allow photographers to gain some compensation based upon the level of use of assignment images, but that evolution is not complete. The photographer has to develop his own system for pricing the value of rights into an assignment fee.

## CHARACTERISTICS OF ASSIGNMENT PHOTOGRAPHY MARKET SEGMENTS

The publication photography market is divided into advertising, corporate, and editorial segments. Advertising is the highest fee-paying segment, corporate is second, and editorial is at the bottom. The editorial segment is the closest to having a system for pricing photography. That is because publishers find a system to be to their advantage because of the high volume of assignments they make when compared to photography users in the other two segments. Publishers' budgets are based upon an annual business plan for specific publications. Long before they assign a photographer to do any work they have set aside an allotment for that work based upon their projected revenues and expense. An assignment pricing system helps them stay within budget.

As a whole, corporations probably purchase more photography than publishers because there are so many more corporations than publishers. But individually a corporation of average size is not going to use as much photography as an average-size publication will. A corporate communications department might give out a dozen assignments a year; a publication could easily be doing a dozen a month. A weekly magazine can give out a dozen assignments a week, and a daily newspaper can give out a dozen a day.

Advertising agencies give out the fewest assignments. Those assignments can range from a few hundred dollars in fees to tens, or even hundreds of thousands of dollars. But unlike corporations and publishers, the advertising agencies pass on the cost of photography to the advertisers so the agencies don't need annually predictable photography budgets. That makes a pricing system unnecessary. The advertisers have budgets for advertising and the agencies have to tailor their work, including the photography work they commission, within those budgets.

As an interesting aside, we point out that the publishers and the advertisers are mostly corporations. In an odd way, almost every photographer is directly or indirectly working for a corporation. But that is where the similarity ends.

## RIGHTS AND MARKET SEGMENTS

In the advertising market the common demand from buyers is for copyright or an exclusive grant of all rights. Advertisers want their images themselves to protect the perception of their products and services. In the corporate segment, the buyers will most often want the copyright or an exclusive grant of all rights to those images that identify the company or its processes. These are usually called *proprietary* images. In the editorial market the buyer usually wants limited rights. The exceptions would be prestigious magazines that want copyright or an exclusive grant of all rights only for photographs used on the cover of the magazine since the cover is its flag in the trade, and as precious as a logo is to a corporate buyer, and the product or service identity is to an advertiser.

Corporate photographers will often find complacency on the part of the buyers of their services. This complacency exhibits itself as an interest only in how many days of work are necessary and how much it all costs. The corporate photographer will most often be negotiating to retain useful rights, and for an appropriate fee for the level of rights demanded.

Editorial photographers will run into the problem that buyers will rarely negotiate since they are forced to adhere to day-rate fee schedules set by the publisher, and the only way to increase the fees to be paid is to increase the number of days that the assignment will take. This rarely happens because most editorial assignments are of a nature to require no more than a few hours to a full day on location. However, when a photographer has unique access or a unique capability it is possible to negotiate higher rates than the publication's standard rates.

## USAGE AND VALUE

As you will recall from chapter 1, "Licensing Concept and Reality," you can simplify dealing with usage issues by having a simple value chart. Figure 3 in chapter 1 portrays four basic factors influencing the value of rights: limited, unlimited, exclusive, and non-exclusive. The chart in Figure 12 portrays the relative value of the categories as does Figure 3 in chapter 1. However, Figure 12 adds a column that will allow you to have

## RELATIONSHIP OF RIGHTS AND VALUE

| Rights | Restrictions | Value | Price Factor |
|--------|-------------|-------|--------------|
| Exclusive | Unlimited | Highest | 4 × Base |
| Exclusive | Limited | Upper Middle | 3 × Base |
| Non-Exclusive | Unlimited | Lower Middle | 2 × Base |
| Non-Exclusive | Limited | Lowest | 1 × Base |

**FIGURE 12**

a basis for calculating the value of the four major categories of rights when it comes to an assignment.

The rights/value levels in the chart can be put into real-world terms easily. Looking at the editorial magazine marketplace we can see examples of the principle in action. Magazine's like *Time* and *Newsweek* deal in the exclusive categories of rights. For a cover, they insist upon exclusive rights for any purpose and for all time. That is exclusive unlimited. For inside use they insist upon exclusive use for a limited period of time, with additional payment for additional editorial use. That is exclusive rights limited by time and additional use. When purchasing stock photography they generally pay three to four times the inside, full-page space rate for the cover. That is, if they pay $500 for an inside full-page photo, they pay between $1,500 and $2,000 for the cover. So we can see that a jump from second place to first place warrants a multiplier of three to four times. You can model your system on their value systems. Here's how.

In Figure 13 we have added fees to the chart as seen in Figure 12. We considered that the lowest editorial assignment fee is about $300 per day, paid by a publication like a trade magazine or small circulation consumer magazine for the right to use assignment images one time in one issue with no exclusivity. As we did with stock photography we used the lowest fee as a base price. We then added multipliers for each rights/value level to increase the fee as the demand from the publishers increase. We arrived at the multipliers by researching the day rates paid by magazines with different levels of rights demands. We found that from top to bottom there were four tiers that fit nicely within our four levels based upon the specific deals the magazines offer. If you accept our approach, you are on the road to having your own system for determining assignment pricing.

| RELATIONSHIP OF RIGHTS AND VALUE | | | |
|---|---|---|---|
| Rights | Restrictions | Value | Price Factor |
| Exclusive | Unlimited | Highest | $1,200 |
| Exclusive | Limited | Upper Middle | $900 |
| Non-Exclusive | Unlimited | Lower Middle | $600 |
| Non-Exclusive | Limited | Lowest | $300 |

**FIGURE 13**

## MARKET SEGMENT PRICING RELATIONSHIPS

Many successful photographers started their careers doing editorial work. It offered more opportunities to get published quickly and in enough volume to prove to prospective clients that they could reliably make photographs when assigned to do so. The photographs made by editorial photographers are not very different from the kind that corporate photographers make. Once you work for corporations, advertising agencies will start to take notice of your credentials, and you can break into the advertising market. If you shot an annual report for a company, you certainly are good enough to shoot an advertisement for that company or a similar one.

That progression has been a path that many photographers have followed for decades. As a result, the fees charged for assignments in the upper segments of the publication photography business tend to be based upon the fees earned in lower segments. Now, before we step one step further, understand that we are talking about the average assignments that the average photographer receives. The photographer shooting fashion for Bill Blass or lipstick for Revlon is not average. He is well above average. If you are above average, you can stop reading this book right now and try to get a refund from the bookstore. If you are average or trying to get there, then read on.

The average corporate day rate is between two and three times the average editorial day rate. Bottom-level corporate work is paying $600 per day and top-level work is paying $3,000 per day. OK, we know that Pepsi and Coke might be paying $5,000 per day, but we are talking about average, not top of the line. So when you want to construct a pricing chart for corporate work you only have to take the editorial fee chart and increase it by a fac-

| RELATIONSHIP OF RIGHTS AND VALUE | | | |
| --- | --- | --- | --- |
| Rights | Restrictions | Value | Price Factor |
| Exclusive | Unlimited | Highest | $3,600 |
| Exclusive | Limited | Upper Middle | $2,700 |
| Non-Exclusive | Unlimited | Lower Middle | $1,800 |
| Non-Exclusive | Limited | Lowest | $900 |

**FIGURE 14**

tor between two and three. In Figure 14 we have used a factor of three. You see that we have created a logical transition from editorial rates to the next higher segment of corporate rates. Now the challenge is to come up with a system for pricing advertising photography rates.

Advertising photographers run the gamut from the most creative to average shooters. Top advertising photographers can be involved in assignments that cost as much a half a million dollars. Those jobs are focused on major campaigns of major advertisers. Photographers at that end of the spectrum have their own way of arriving at prices. If you progress to that point in your career, you won't need this book anymore. What we are writing in terms of advertising pricing is directed to those who are engaged in day-to-day advertising photography for clients who require photographs for local, regional, and limited national advertising. That is the kind of advertising work that the most advertising photographers engage in. Many photographers in that group calculate their fees on a day-rate basis.

Once again we use the same pricing grid that we used before for editorial and corporate photography assignments. We just change the "1 × Base" number to reflect the higher rates that advertising work justifies. In Figure 15 we have taken the corporate base rate of $900 and double it. We did that because we know many photographers who do just that to come up with their fee. It seems to accommodate the greater expense that advertising photographers have in addition to adding some compensation for the creative levels needed to do the work.

The pricing grid covers the broad range of rights in broad categories. It reflects the reality of a marketplace in which assignments can vary from one-time nonexclusive use of one image to perpetual-exclusive use of many images. It is practical, reasonable, and it can even be explained

| RELATIONSHIP OF RIGHTS AND VALUE | | | |
|---|---|---|---|
| Rights | Restrictions | Value | Price Factor |
| Exclusive | Unlimited | Highest | $7,200 |
| Exclusive | Limited | Upper Middle | $4,800 |
| Non-Exclusive | Unlimited | Lower Middle | $3,600 |
| Non-Exclusive | Limited | Lowest | $1,800 |

**FIGURE 15**

to a client who asks: "How did you come to that price?" Still it is just a simple matrix that has to have a base number placed into it to work. It is up to you to determine what that base number ought to be. In the high-rent district of New York City the base number is going to be higher than in the moderate-rent city of Tulsa. The base number has to be competitive with other photographers' fees unless you are so much better than they. If that is the case, you can charge more. In the end, pricing assignment photography is a personal decision based upon personal circumstances.

## PRICING RE-USE OF ASSIGNMENT IMAGES

On occasion, clients will want to reuse images taken on assignments for which the license has expired. The re-uses might be in exactly the same applications for which the assignment was done, an advertising campaign might be extended or a brochure might be reprinted. Photographers usually have two different ways to arrive at a fee for re-use licenses.

One way is to charge a percentage of the original fee (not the billable expenses). We have seen photographers who have charged as little as 20 percent and as much as 100 percent. How much should you charge? We think it depends upon your relationship with the client. If it is a good relationship that you want to protect, you do not want to drive the price to a point that makes the client think you are unfair. Remember, that client already paid you 100 percent to create the photographs and use them. What part of that fee was for rights? Since pricing assignments is not usually broken down that way there is no answer to that question. You will have to decide what is

fair. Many photographers charge 25 percent of the original fee for a re-use that duplicates the original use.

On some occasions, your client might want to reuse an assignment image in a new application. A very common way of dealing with that kind of reuse pricing is to use stock photography pricing. The photograph is in your inventory so it is stock. There is logic to that approach. This is more common in the corporate market segment. Some photographers will discount the stock price since they had no marketing costs to sell the re-use license; it is a personal choice.

In the editorial segment the publisher often sets reuse fees by virtue of a space rate; that is, a fee it pays for use depending upon size of the reproduction. Frequently those rates are close to generally accepted stock photography prices. Sometimes they are lower. You don't have to accept the publisher's space rate. You can bargain for a higher fee. Again, it is a personal choice.

## THE FINAL STEP

You now have a way to construct your own pricing system for stock and assignment licensing. Perhaps you are not pleased with our systems offerings. If not, you need to find different options because the final step to effective licensing is to have some pricing system in place. Business revolves around trading value for value. The value of your photography is expressed in the price you charge to acquire or use it. That process is the revenue-generating process of your business. If that process is not efficient and predictable, the chances are that your business is going to eventually be in trouble. Licensing is an important key to profitability, and profitability, the way your business survives, is dependent upon pricing licenses correctly.

# C H A P T E R    7
## *Negotiating Licenses*

*T*he subject of negotiating for photographers is so important that an entire book has been written on the topic. One of this book's co-authors, Richard Weisgrau, is the author of *The Photographer's Guide to Negotiating* published by Allworth Press, the publisher of this book. It is strongly recommended that you read that book if you have not already done so, because this chapter will focus on the general principles and techniques of negotiating licenses, but it will not explore negotiating in all of its aspects. Meanwhile, your success in business depends upon your negotiating skills, so you ought to polish them to as bright a shine as you can.

Negotiation is a process of balancing the competitive interests of the licensee and the licensor. Each has something the other wants. Neither wants to give up more than necessary to get what he wants. OK, stop there. The word "want" is the killer word. We always want more than we need. If we have to settle for needs, we usually will. Needs provide for survival, and wants take care of luxury. In business, survival is the first priority. Luxury comes only after survival is guaranteed. The skillful negotiator knows that getting his or her counterpart to agree to minimally meet his needs rather than holding out for wants is the key to successful negotiating.

In the world of license negotiating, the licensee wants as many rights as he can get for the lowest price he can pay. The licensor has to have a way of connecting rights and value so that the more the licensee wants the more he pays and the less he wants the less he pays. The perfect example of such a system is the stock photography licensing business in which specific usage factors determine the price. Unfortunately, no such system exists in assignment photography so negotiating the value of assignment rights involves more give and take than negotiating stock photography licenses.

Negotiating during the selling process takes place as you try to close the deal. Your price quotation is in the prospect's hands. You can be greeted with an objection or two, maybe more. The usual objection is about the fee for the requested rights. It's part of the business culture, and you are not going to escape it. You have to deal with it, and you can, if you learn how to.

## NEGOTIATOR'S TRAITS

You have to have certain skills, knowledge, and attributes to be a good negotiator. Each can be acquired by study and practice, if you do not have them already.

You have to be a good decision maker and able to live with your decisions. Every negotiator has one or more decisions to make, and they have to be made quickly. You don't get to reverse those decisions so you had better be able to live with them, even the ones that you later wish you had not made. You also have to be a good listener. Your counterpart's point of view is very important. To understand it you will have to listen carefully as it is articulated. Understanding the prospect's reasoning is a key to offering alternatives that might afford the basis of a compromise to settle differences. And, finally, good negotiators know the value of what they do. They don't undersell themselves. Anyone can resolve a disagreement by cutting price or giving away something for less. Good negotiators don't sell out. They bargain for a fair deal.

## THE ASPECTS OF NEGOTIATION

Every negotiation has three aspects: the psychology, the methodology, and the substantive.

The psychological aspect is more related to mindset, confidence, and determination of the parties. The important thing to remember is that you cannot change the other person's reality, so you are unlikely to be able to change his psychological viewpoint. But having an insight into his point of view is helpful in knowing how far you can push the envelope.

Methodology has to do with the mechanics of the process. Finding out all the information needed, formulating offers and counteroffers, presentation of your offer and point of view, and the way you present your offer and make your counteroffers are all method related.

The substantive aspect is usually about rights and fees, although it can be about expense and fee advances, cancellation fees, weather days, deadlines, and any other of the substantive details of an assignment. The substance of a negotiation is always quite evident.

## THE PSYCHOLOGICAL ASPECT

The most important factors of the psychological aspect are the mindsets of the parties, the nature of the individuals, and the power equation.

Many negotiations take place immediately after creative discussions between the buyer and the photographer. It is a moment in time when the photographer is very invested in the creative aspects of the assignment, but the creative frame of mind is the worst frame of mind to be in when negotiating. To negotiate, you need to change to your business hat and think about your financial needs. Get psyched for the negotiation. That means being determined to meet your own needs. Always remember this is about paying your salary and the bills, and making a profit.

You also need to try to understand your counterpart's psychology. Are you dealing with the boss or an employee who would like to get it over with because he has too much work to do? Did this person impress you as straightforward during the steps that led up to the negotiation, or did he seem to have a hidden agenda? Is he using you as a bidder simply to justify the bid from another photographer that he really wants to do the job? You'll never be certain of the answers to any of those questions, but you ought to consider the other person's possible motivation and mindset. It has a lot to do with how flexible he will be as you negotiate.

## THE METHODOLOGY

The place that you negotiate is important. People are more likely to interrupt a conversation in an office than a telephone conversation. You don't want to be interrupted when negotiating. The interruption could be bad news that takes a person's mind off the task at hand and creates concern about something else he is handling. Avoiding distractions is one good thing about negotiating on the telephone. You have the advantage of speaking right into the other person's ear.

One of the best methods is to begin the negotiating process with a phone call to set up the parameters of the deal from your point of view. The

follow-up discussion is then conducted in an environment where there is likely to be a very direct conversation without distractions.

## PSYCHOLOGY OF POWER

An employee of an agency is more likely to be willing to compromise than its owner, because the owner has an investment to protect. A photographer's representative is more likely to make substantial compromises than the photographer because her 25 percent comes off the top even if the photographer takes a loss. The incentives of different parties can influence their psychological mindset in negotiating.

Some prospects try to intimidate the photographer in a negotiation. They hope to create a perception that it is their way or nothing. Usually this is done by a power display of some type. The most popular power play is one in which your competition is cited as the reason you should see the prospect's point of view. They want you to cave in because you don't want to lose the job to another photographer. However, if they wanted another photographer, it is unlikely that they would be negotiating with you. It is not that you can't lose a job to the competition. Of course you can, and you will from time to time. My point is that, if they wanted your competition, they would be negotiating with them. The balance of power in such a case is that you have been selected for the job. Now they are trying to get you to do it on terms more favorable to them. But the fact is, they want you, not your competition. Your power in the process stems from the fact that they really don't want to exercise their power to work with your competition.

Another form of power that you face is inherent power. Your counterpart controls the eventual decision to give you the job. That means that he has an upper hand if you really need the work. Obviously, when a stack of unpaid bills is growing, and the jobs are few and far between, your ability to shape the deal is diminished. The only way to balance inherent power is to have good financial reserves and/or a substantial sales effort underway at all times. If you are getting your fair share of opportunities to estimate work, than you know that any single estimate or job is not critical to your business.

The ultimate power in a negotiation is to say "no." It stops everything. When a deal is not acceptable to you, you should say "no" to it. You can

make a counteroffer on the heels of the word "no," and possibly save the day, but the word "no" tells your prospect what your boundaries are and that its position is outside of those boundaries.

## RISK AND FEAR

Another factor is in the ability to take risk. Can your prospect really trust the work to your competition? Are you prepared to gamble? The better your sales efforts and the more assets that you have, the more prepared you are to gamble. A strong marketing, promotion, and sales program—like money in the bank—allows you take reasonable risks in a negotiation; like saying no to a demand and offering an alternative as a compromise.

The most serious psychological element in a negotiation is your fear level. The risk of losing a job can lead to fear and then panic. Panic has been the catalyst for many bad deals in the photography business. It happens when you place too much importance on the outcome of the negotiation. Indeed, if not getting the job means you are likely to go out of business, you have a pretty good reason to be fearful, but it's the rare case in which the loss of an assignment is going to be the final straw in a business' demise. Those who place too much importance on a single job are usually those who have inadequate marketing, promotion, and sales efforts. The way to avoid fear of losing a job is to have many jobs for which you can make an offer. Once again, strong sales efforts cure most business problems including the fear of going out of business.

## NEGOTIATING TACTICS

Every skilled negotiator uses tactics to improve his effort in a negotiation. The need for tactics usually occurs when a negotiation bogs down and the parties are stuck on an issue. The most useful and appropriate tactics in the negotiation of assignments and stock sales are easy to grasp and employ, but the negotiation of an assignment fee is more complex than the negotiation of a stock photography license. That is because the assignment involves many value factors in addition to the license. Stock photography fees are based solely on the value use of the photograph. Accordingly, the negotiating tactics lend themselves to assignment fee negotiating more than to stock fee negotiating, and the examples offered below reflect that.

## Ask Why?

If you are presented with a demand that you cannot accept, rather than reject it immediately, it is better to ask why such a demand is being made. Then, using your good listening skills, take in the reasons for it. Understanding the reasoning behind a demand is the key to being able to create an alternative. If the answer you receive doesn't answer the question, simply point that out. This most often happens when a prospect answers your question with something to the effect of "because my client wants it." Indeed that may be true. But the next question from you has to be why does the client want it? Unless you know the reason for a disagreement, you cannot resolve it. Once you know that reason, you have a chance of resolution. If you don't get the answer, diplomatically repeat the question again, stressing how important it is to you to understand why a party wants something so you can try to understand why you should agree to it.

Be silent! After you ask the question why, be silent and wait for an answer. Listening is active. Hearing is passive. You cannot turn off your hearing. You can hear, but you can't listen while you're talking. Your silence also places all the pressure on your counterpart for the moment. You have asked a reasonable question, and she knows you are entitled to a reasonable answer. If her demand was more bluster than need, the prospect may be unable to give a good answer. This often results in her being more prepared to compromise, because you have shown her the weakness of her position with a simple tactical question followed by a silent demand for an answer.

## The Broken Record Tactic

This amounts to repeatedly asking for what you want until you get it. An example of this tactic is countering price objections. Once you quote our price for a certain level of rights you can expect an objection. You can answer that objection with a simple statement like "The fee I proposed is based upon the usage. I am just using a standard pricing method to determine the value." If the client continues to recite the fee objection (his broken record) you reply with yours.

## Trial Balloon

This tactic is used it to test the waters without putting your client on the spot. For example, "What would you say if I told you my fee for the usage you are asking for was going to be $3,000?" You have presented a "what if" question. By doing so, you minimize the risk and leave yourself a chance to recover from a rejection. You haven't presented it as a demand, but rather

as a test. If the reaction is favorable, you can adopt the position. If the reaction is unfavorable, you turn the table by asking something like "You obviously have a number in mind. Tell me, what do you think is a fair fee?" You try your position without standing firm. This gives you the opportunity to back down without looking weak.

## Nibbling

This tactic is employed after you've made the deal, and you have the job. You might come back at the prospect-turned-client and say something like "How would you feel about giving me half the expenses in advance on this one?" If you get "No" for an answer, you have not jeopardized getting the job. If you get a yes, you have an advance.

## Optional Offer

An example of an optional offer can be something on this order: Perhaps you are negotiating for an assignment that requires models and a stylist in addition to the routine material and other expenses. You have asked for an advance only to be refused on the basis that the company frowns upon making any payments to photographers until after the work is accepted. You are facing a substantial layout of capital for models and a stylist so you are not prepared to give up some sort of advance, but the prospect is unwilling to write you a check. You propose an option to replace your demand for an advance. The option is that the prospect will pay the modeling agency and stylist directly, thus, reducing your advance cash layout for the expenses. It is just as good as an advance to you, and it does not tax the prospect because he will not have to pay the others until after the work is done.

## Trade-Off

The substance of a trade-off is a conditional exchange of demands—if you will give to me, then I will give to you. There are not many opportunities to use this tactic in sales negotiation. It is a more common tactic in multifaceted negotiations like those surrounding labor contracts. However, it is possible. Here's an example. You have the good fortune to be the only photographer that the prospect can use on the assignment in question. Maybe it's because the prospect just doesn't have time to explore other options, or maybe it is because you are so uniquely qualified or equipped for the job. You have demanded a credit line with the picture and the prospect has absolutely refused to give it. You also want two days to do the

shoot. The prospect is pushing for one day but has not absolutely said no. The prospect says no to the credit line because its client isn't going to allow it to appear in print that way, and the prospect knows the advertiser will never change that view. You know that. So you offer a trade-off. You will drop the demand for a credit line, if the prospect will pay for the second day. You know that the prospect can get the extra money, while it cannot get the credit line approval.

## Red Herring

Herrings are fish that are mixed a gray and white color. Smoked herring turns reddish in color. In negotiating, a red herring is a demand that has been put up as a smoke screen. It is a demand that you make even though you will not be able to get it. Why would you do that? So you can trade it off later. In the example of the trade-off in the paragraph above, your demand for credit line was a red herring. You knew you would never get the credit line.

## Don't Look Weak

Look the prospect in the eye when you're talking. Stand or sit up straight. Don't lean up against the wall or hang your head down like you need support. Look confident. Speak with a strong voice. Slouching in a chair, leaning over a table, or burying your head in your hands can be seen as signs of weakness. Just as talking too loudly is a sign of aggressiveness, talking too softly is a sign of weakness. Avoid any behavior that makes you look less than absolutely confident that your position is sound, correct, and to be adopted by all.

## Don't Mince Words

Say what you have to say clearly, and don't send out confusing signals. For example, if you don't like a prospect's offer, and you have you an alternative as a counteroffer, say, "No, I can't accept that, but I have an alternative." If something is unacceptable, it's simply unacceptable, and that is OK in business. Don't try to sugarcoat the fact that you won't accept something. Doing so can make the prospect think that you might give in if he holds fast. It's better to let them know where you really stand and how firmly.

# COPYRIGHT DEMANDS

Many photographers have a very difficult time when it comes to negotiating copyright ownership with a prospect. One major reason for this difficulty is that those photographers do not know enough about copyright to be able to negotiate the details of it. Many photographers have a faulty understanding of the subject because they have gotten their education from other photographers who do not fully understand it. Rule number one in negotiating is that you cannot negotiate the terms of something that you do not understand. Hopefully, this book has increased your understanding substantially.

Before 1978, unless there was an agreement stating otherwise, when a photographer did an assignment all the rights automatically belonged to the commissioning client. Photographers were generally quite happy with the way things worked. We didn't quibble over rights. Sometimes, we received some of the rights back from the client, especially in magazine work, because the images could be marketed to other publications, and publishers didn't care if you did that as long as you did not market their images to a competitor. The law changed in 1978, and the U.S. Congress gave all creators the ownership of the copyright of work they create on the commission of others except under a few specific circumstances. Ever since then, there has been a contest between photographers and clients over the ownership of rights. The clients have the economic clout to freeze the photographers out. They hold the purse strings, and, if you want some of the purse's contents, you have to either comply with their wishes or be uniquely desirable for the specific assignment. Unfortunately, most assignments do not require unique talent. A competitor of equal talent who is willing to surrender more rights for the same fee as you offer is likely to get the job. It is just a value equation for the prospect. More similar quality for the same fee is better than less. That is difficult to overcome as economics is a hard reality in business, and better deals are more appealing to all of us. You cannot combat this in daily business. All you can do is accommodate the reality. Still you have to have some reasonable manner of dealing with the issue. One way to deal with it is by taking a different approach than your competition when he or she concedes without attempting to negotiate to retain some rights.

Differentiation can be achieved by dealing with the needs of the prospect rather than the wants of all those dispensing with copyright advice. You start

on that path by never using the word copyright in the negotiation of a proposal. You only refer to copyright after a deal is done or near done, and the issue of usage has been determined. Prospects generally want "all rights" or a "buy out" for very specific reasons. Understanding the reasons is helpful in trying to fashion usage to meet their needs. Let's look at a few of the reasons.

- Corporate image and proprietary information are very valuable. Companies want to protect both. They do not want their product or service associated with anything negative. They do not want their personnel's images used in any way that might be even remotely unflattering to the individual or company. These things have happened to companies, and they want to guard against it. Having "all rights" is a way to protect their interests.
- Liability is another concern. Prospects that buy substantial amounts of photography are aware that there can be lawsuits for lost or damaged original photographs. They do not want to defend a lawsuit for such a loss, especially when they paid to have the photographs produced in the first place.
- Prospects prefer to make as much use as they want (not need) and "all rights" gives them that right. Again, we all want as much as we can get for our money.
- Prospects often want to avoid negotiating any future usage because once they are committed to a photograph they cannot change easily or cost effectively. Their fear is that you will hold them up for an unrealistic fee for that future usage because you will have the power.

As you can see, it is possible to deal with the prospect's needs and wants when it comes to the rights they want and/or need to acquire. Understanding usage, and having a simple system for dealing with it, is a key to managing a negotiation.

## ALL RIGHTS AND BUYOUTS

Buyers of photography often use the words "all rights" and "buyout" to indicate that they want unrestricted use of the photograph(s) that they are commissioning. Buyers can also mean that they want the exclusive use in

addition to unrestricted use. While the term "buyout" is not a legal term, the term "all rights" is an imprecise legal term as in the phrase "all rights reserved" that often accompanies copyright notices on creative works. You should avoid the use of the term "buyout" because it is undefined in the trade. "All rights" means exactly all (each and every) rights that exist. Granted exclusively and without termination, "all rights" is the same thing as providing a copyright transfer.

If you limit the term that the client will own "all rights" or "all rights exclusively," you are retaining the copyright while giving the buyer the right to exercise all the copyright rights for a specified period of time. Granting a time-limited transfer of "all rights" is better than making a transfer of copyright because it keeps ownership in your hands.

## NEGOTIATING STOCK PHOTOGRAPHY LICENSE FEES

There is only one thing to negotiate when you are licensing stock photographs, that is, the price of the license. There are no expenses or creative fees. There is no risk about what the photographs will look like. Transfers of copyright ownership are not an issue. There is a pricing system in place for arriving at fees. You don't have to do much homework or preparation. Sounds like a dream world, doesn't it? But the fact is that it can be more of a nightmare than a dream. Since the only major factor is price, the competition over sales can be ruthless. As competition holds prices down, many stock photography sellers frequently accept low prices because the cost in time to them for negotiating a few dollars more in revenues is not worth it. In spite of the intense competition there is still an opportunity to negotiate licensing fees.

## ABSTRACT FACTORS

When you are negotiating a stock sale you should try to acquire and consider certain pertinent information at the beginning of the conversation. This information is used to help you sell the client on your image and price. Let's look at each one of the items.

### Type of Client
Who is the buyer? Does the name give you any indication of how deep the buyer's pockets might be or how reliable it might be for payment? You might

recognize the name as an upscale agency that works with prestige accounts or as a local business with a bad credit reputation. If the buyer is an ad agency or design firm, try to find out who the end user is. If you recognize it as a company that goes first class in the quality of its advertising and promotion, you know that your image stands out, and that you can probably get a good price for whatever rights the client wants.

## Competitive Images

What is the nature of the specific image the buyer wants to license? Is it a unique photograph, so that the buyer is unlikely to find many similar images shot by your competitors? If there are no or few similar images in catalogs, you are in a great position. You must evaluate the extent of the possible competition you will face in making the sale. The level of originality in a stock photograph is directly related to the level of competition it faces and its value in the marketplace.

## Timing

When is the client's deadline? A tight deadline is to your advantage. Remember, the buyer knows exactly what the image looks like. Coupled with a tight deadline, you can use those temporary assets as an insurance policy. The message to the buyer is buy now at the offered price and eliminate the risk of not getting the image in time.

## RISK FACTOR

You know that risk is a factor in business and in negotiating. You know that one hidden concern of an assignment photography buyer is that the commissioned images will not meet expectations. Stock photography eliminates that fear totally. The buyer can see the exact image he wants and will likely end up using. The risk is gone. Your competency is not a factor, and expressing your commitment to delivering high quality is not a useful tactic. Instead of asserting your competency to enhance your negotiating position when the buyer has the stock image he wants in hand you should understand that you have an advantage. That advantage is the simple fact the client has found the image he wants and you know it because he is trying to license it. In such a case, you can usually negotiate a better deal since people are willing to pay more for "wants" than "needs." Fulfilling needs is a necessity. Fulfilling wants is a luxury. Luxury always costs more.

## SELL THE IMAGE

When you are negotiating a stock price, take the time to look at a copy of the image. Ask the buyer what attracted him to it for the intended use. Listen carefully to the answer. Are there aspects of the image that make it uniquely suitable for his use? Are those aspects likely to be found in competitive images? Ask whether he has located other images that meet his needs. If he says no, you are ahead in the game. He is calling you because he has not found what he wants yet.

## PRICE LEVELS

Stock photography is usually licensed on a nonexclusive, limited-use basis. Occasionally, buyers need some kind of exclusivity such as print media or North America. Sometimes they need total exclusivity, that is, they don't want this image to appear anywhere else after they license it for a specified period of time. You have to be prepared for such demands by having a pricing schedule for nonexclusive with multipliers for different levels of exclusivity and for duration of use.

There are no rules for developing the factors for increasing price according to level of exclusivity and duration of use. I refer you back to the example in the previous chapter where you read about levels of exclusivity in periodicals and how they affect fees. It can serve as a starting point for your own calculations. You can also learn what percentage increase other photographers are using by participating in Internet bulletin boards for stock photographers. Photographers may or may not share their pricing, but they will usually share the factors that they use to calculate values above their base prices.

## STAY FOCUSED

When selling stock you have to determine what factors could influence the value of your image and whether any exceptions make those factors a price booster or buster. Remember you are ensuring the buyer's risk. Like insurance, ensurance has a premium attached to it. You get that premium by reinforcing in the buyer's mind why he wants your image. Only then are you ready to spar over the price level. At that time you can employ the tactics that fit and use those that might bring benefit after you close the deal. Stay

focused on one thing. Stock licensing means fee negotiation alone. Keep your eye on the price and factors, exceptions and tactics that can help you get the right price.

## THE BOTTOM LINE

You must have a bottom line when it comes to fees. That bottom line is usually based upon the costs of operating your business. Every day you work on assignments you have to earn a certain average of dollars to stay in business and pay yourself a reasonable salary. You should have calculated that in your financial and sales planning. This fee-per-job is your bottom line. When a job doesn't measure up to that level, you ought to pass on it. If it does, you have a reason to take it. Whether you take it or not depends on how badly you need it. In times of good business, we are inclined to pass on marginal jobs. When business is scarce, we are often happy to have them.

You should avoid thinking that it is OK to take a small loss on some jobs because the cash will come in handy, and you can make it up on another job. You are better off borrowing money to tide you over than financing operations with price cuts. History has proven over and over again that taking a loss is not a path to success.

Your bottom line is also a great decision-making tool in one special way. When a prospect puts an offer or counteroffer on the table and tells you that it is a take it or leave it proposition, it becomes quite simple to decide. If the offer is below your bottom line, you refuse it. When it is on or above your bottom line, you take it.

## FINISHING UP

The negotiating chapter was purposefully made the last chapter of this book because negotiating is the last interactive process between the licensor and the licensee. When the negotiation is over, the deal has either been abandoned or been made. All that remains is to use the knowledge gained in the previous chapters of this book and to draft the language of the license to meet the terms agreed upon into a licensing agreement, and send it off to the licensee.

However, the last chapter of this book should not be the end of your learning about how to improve your business practices and skills.

Licensing is one aspect of the photographer's business. To be successful at licensing you have to be successful at pricing, selling, and negotiating. Your next step should be to read more about those subjects. The more you learn and practice what you learn the more successful you will become. That is a simple fact that has been true in business throughout the ages.

# INDEX

DISCARD

# Books from Allworth Press

Allworth Press is an imprint of Allworth Communications, Inc. Selected titles are listed below.

**The Photographer's Guide to Negotiating**
*by Richard Weisgrau* (paperback, 6 × 9, 208 pages, $19.95)

**The Real Business of Photography**
*by Richard Weisgrau* (paperback, 6 × 9, 256 pages, $19.95)

**Photography Your Way: A Guide to Career Satisfaction and Success, Second Edition**
*by Chuck Delaney* (paperback, 6 × 9, 304 pages, $22.95)

**Profitable Photography in the Digital Age: Strategies for Success**
*by Dan Heller* (paperback, 6 × 9, 256 pages, $19.95)

**ASMP Professional Business Practices in Photography, Sixth Edition**
*by the American Society of Media Photographers* (paperback, 6 3/4 × 9 7/8, 432 pages, $29.95)

**Photography: Focus on Profit**
*by Tom Zimberoff* (paperback, with CD-ROM, 8 × 10, 432 pages, $35.00)

**Business and Legal Forms for Photographers, Third Edition**
*by Tad Crawford* (paperback, with CD-ROM, 8 1/2 × 11, 192 pages, $29.95)

**Legal Guide for the Visual Artist, Fourth Edition**
*by Tad Crawford* (paperback, 8 1/2 × 11, 272 pages, $19.95)

**The Photographer's Guide to Marketing and Self-Promotion, Third Edition**
*by Maria Piscopo* (paperback, 6 3/4 × 9 7/8, 208 pages. $19.95)

**How to Shoot Stock Photos That Sell, Third Edition**
*by Michal Heron* (paperback, 8 × 10, 224 pages, $19.95)

**Pricing Photography: The Complete Guide to Assessment and Stock Prices, Third Edition**
*by Michal Heron and David MacTavish* (paperback, 11 × 8 1/2, 160 pages, $24.95)

Please write to request our free catalog. To order by credit card, call 1-800-491-2808 or send a check or money order to Allworth Press, 10 East 23rd Street, Suite 510, New York, NY 10010. Include $5 for shipping and handling for the first book ordered and $1 for each additional book. Ten dollars plus $1 for each additional book if ordering from Canada. New York State residents must add sales tax.

To see our complete catalog on the World Wide Web, or to order online, you can find us at ***www.allworth.com***.